Pennsylvania
Waterfalls

D1435905

Pennsylvania Waterfalls

A Guide for Hikers and Photographers

Scott E. Brown

STACKPOLE
BOOKS

Published in 2004 by
STACKPOLE BOOKS
5067 Ritter Road
Mechanicsburg, PA 17055
www.stackpolebooks.com

Printed in the United States of America

10 9 8 7 6 5

FIRST EDITION

Cover design by Caroline Stover

Library of Congress Cataloging-in-Publication Data

Brown, Scott E., 1962–
 Pennsylvania waterfalls : a guide for hikers and photographers /
Scott E. Brown.– 1st ed.
 p. cm.
 ISBN 0-8117-3184-7 (pbk.)
 1. Hiking–Pennsylvania–Guidebooks. 2. Photography of water–
Pennsylvania–Guidebooks. 3. Pennsylvania–Guidebooks. I. Title.
GV199.42.P4B76 2005
917.4804'44–dc22
 2004008835

 ISBN 978-0-8117-3184-3

*To Diane, for the countless hours you sat
on your little camp stool, magazine in hand,
while I had all the fun.*

Contents

Introduction

Waterfalls. We love to look at them, stand under them, photograph them, be photographed near them, listen to them, or simply stand in awe of them. Everyone who takes pictures, even as a casual hobby, takes pictures of waterfalls, and Pennsylvania has more than 170 of them.

As a photographer or a hiker, how many times have you gone to someplace beautiful, been overwhelmed by the number of things to see or do, and come away having felt like you missed something? Or how many times have you felt as though you've spent all your time in the car trying to find something and run out of time? Finding good places to photograph is difficult when you're pressed for time in an unfamiliar area. My goal is to help you get to Pennsylvania's waterfalls; it's your job to make good photographs of them.

I've been shooting seriously since 1997, and I've learned one very important thing about photography. Making a good photograph requires only five simple things: a worthy subject, appropriate light for that subject, good conditions, a pleasing foreground, and a background that doesn't detract from the subject. If you have those five elements, then it all comes down to composition. It's easy to get lost in the knobs and dials of a modern camera and forget that *photography* means "to paint with light." That's the mindset to get into, thinking like a painter, and not a technician. Sure, you need to be technically proficient, but that's only a small piece of the puzzle.

In this guidebook, I'll get you to the subject, advise you when the best light and conditions might be, and make a suggestion or two on how to get the best photograph you can. The rest is up to you.

As you read this book, you'll note that I use words like *experiment* and *play* often. Photography is a creative outlet, not a task to be mastered. It's play time, not drudgery. Experiment with compositions, exposures, and unique or odd perspectives. Go nuts, have fun—heck, it's only film, or if you're shooting digital, it's just electrons.

Pennsylvania is a beautiful and wonderful place to photograph. After you've read this book, it's my hope that you'll put on some comfortable

boots and go for a hike, with camera in hand, and let your creative juices flow. When you do head out, get up early, stay out late, and never, ever, give up.

Safety

I would be remiss if I didn't begin by talking about safety with this stern warning: You are solely responsible for your own safety.

My wife and I have been to most of the major national parks of both the East and the West, and it continues to amaze us how careless people can be in the great outdoors, particularly those from urban areas. Pennsylvania is a fairly benign environment compared with, say, the Grand Canyon. Yet both places have something in common: You can die if you're not careful.

Waterfalls are tall, moss- and algae-covered cliffs with water plunging down them. They are as slick as ice and less forgiving.

When standing at the head of a 20-foot-tall falls consider this: You're standing at the top of an ice-covered 3-meter diving board looking down into the deep end of a swimming pool *with no water in it*. Photographing streams and waterfalls requires that you take extreme care in your footing. A few years ago, a hiker was injured at Ricketts Glen in a fall from atop Ganoga Falls. That's a 94-foot tumble. He was seriously injured, with head trauma, and it took rescuers more than three hours to get the hapless hiker to an ambulance—and that was at one of the most popular state parks around.

Most of the falls in this guide are in undeveloped places with few improved (meaning graded) trails, poor cell phone service, and no easy way to get out if injured. You'll be hiking with camera gear on your back, crossing streams countless times, and walking a mile or more from your vehicle most of the time. Please observe the following precautions:

- Consider your fitness, experience, and time available before starting out.

- Dress warmly, in layers, and have raingear available.

- Wear appropriate footgear.

- Always hike with a partner whenever possible.

- Always let someone know where you're going and when you expect to be back. If you're at a campsite, tell the campground supervisor; when at a hotel, tell the desk clerk. When you come back from your trek, don't forget to check back in.

- Always carry ample water (at least 1 quart per person), and never drink from streams.

- Take along a snack.

- Take a map and bring a flashlight.

- Check the weather report before leaving, and always keep an eye toward the sky.

- Always be aware of the clock. Before descending to a falls, keep in mind that it will typically take twice as long to climb back up as it did to climb down.

- Never walk to the precipice of any waterfall.

- Never hike in high water or moving water above the knee.

- Never try to hike unimproved stream trails in the dark.

Some waterfalls are on state game lands, and many are in forest and park areas open to hunting. The State Game Commission recommends that everyone, not just hunters, wear 100 square inches of blaze orange above the waist year-round. For a list of hunting seasons, check the Game Commission's website (www.pgc.state.pa.us/).

Choose hikes that suit your time available, fitness level, and experience, and you'll be able to show your family and friends some amazing photographs. Use care, caution, and common sense to experience the landscape, and not become a permanent part of it.

Ethics and Etiquette

Time and again, I've seen amateur photographers arrive at a location and try to bully their way to a good spot. Some photographers tend to be very intolerant of nonphotographers. Respect and common courtesy go a long way toward getting what you want. Words such as "please," "thank you," and "may I" work wonders—use them.

Consider becoming a member of the North American Nature Photography Association. NANPA is a strong proponent of ethical behavior among nature photographers, and their ethics principle states:

> Every place, plant, and animal, whether above or below water, is unique, and cumulative impacts occur over time. Therefore one must always exercise good individual judgment. It is NANPA's belief that these principles will encourage all who participate in the enjoyment of nature to do so in a way that best promotes good stewardship of the resource.

To paraphrase some of NANPA's guidelines as they apply to photographing waterfalls:

- Stay on trails that are intended to lessen impact.

- When appropriate, inform resource managers or authorities of your presence and purpose.

- Learn the rules and laws of the location.

- In the absence of management authority, use good judgment.

- Prepare yourself and your equipment for unexpected events.

- Treat others courteously.

- Tactfully inform others if you observe them engaging in inappropriate or harmful behavior.

- Report inappropriate behavior. (Don't argue with those that don't care—report them).

- Be a good role model, as both a photographer and a citizen. Don't interfere with the enjoyment of others.

I feel very strongly that we should conduct ourselves in the field by the guiding principle that the natural world is not an inheritance given to us by our elders, but a sacred trust we keep for our children and grandchildren. Perhaps the National Park Service sums it up best: "Take only pictures, leave only footprints."

How to Use This Guide

This guide divides the state into regions, and within each region, it groups waterfalls geographically. These groups are designed to provide a central starting point for your trips.

Driving distances are provided in miles, and road names as well as route numbers are given. The best map to have when using this guide is DeLorme's *Pennsylvania Gazetteer*. In addition, before venturing into state forests or game lands, obtain a copy of the public use map.

Global Positioning System (GPS) coordinates for parking areas and waterfalls are given in degrees and decimal minutes. In many cases, the coordinates are from the U.S. Geologic Survey (USGS) Geospatial Information System database, known as GIS. National Geographic's TOPO! State series CD-ROM maps were used to get this information. These GIS coordinates were ground verified using a Garmin E-Trex hand-held GPS unit. For falls that have no USGS GIS location, the E-Trex was used to mark the location.

Round-trip hiking distances are in miles, and times are given as well. Hiking times do not include the time needed to set up, compose, shoot, and break down camera equipment. When planning a hike, consider how long you may take to photograph, based on past experience. The upper loop of the Ricketts Glen falls trail can be hiked in a comfortable three to four hours. If you try to shoot every waterfall, however, you can expect to spend a full day or more. Always be aware of the clock so as not to be caught in the dark.

Elevation changes are given in feet from the parking area and are the total elevation gain or loss for the route provided. If you go up 800 feet, then descend 200 feet, the elevation gain will be given as 800 feet.

Hikes are rated as easy, moderate, difficult, or strenuous. This is a subjective rating system that combines elevation gain, steepness, and trail conditions into a general statement of what to expect. Hike difficulties are rated on the conservative side. A very fit twenty-five-year-old may think I'm a sissy for rating a trail as difficult, whereas what I call a moderate hike may be a real bear for someone who's sixty, overweight, and smokes. Take your degree of fitness and experience into account when using these ratings.

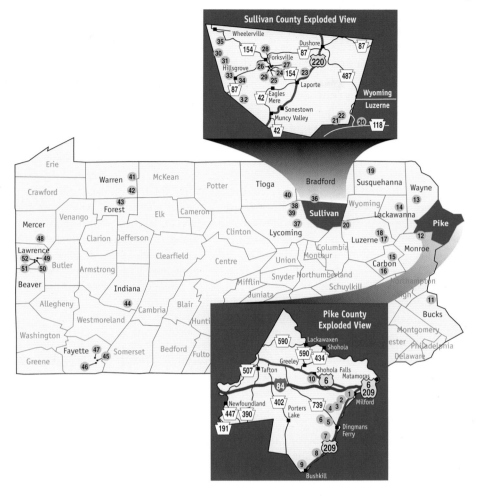

1. Pinchot Falls	19. Fall Brook	37. Jacoby Run Falls
2. Hackers Fall	20. Ricketts Glen	38. Hounds Run Falls
3. Raymondskill Falls	21. Sullivan Run	39. Miners Run Falls
4. Adams Fall	22. Heberly Run	40. Fall Brook Falls
5. Dingmans Falls	23. Dutchman Falls	41. Bent Run Falls
6. Fulmer Falls	24. Cottonwood Falls	42. Hector Falls
7. Indian Ladders	25. Mineral Spring Falls	43. Logan Falls
8. Tumbling Waters	26. Cold Run Falls	44. Buttermilk Falls
9. Bushkill Falls	27. Coal Run Falls	Natural Area
10. Shohola Falls	28. Rode and Lee Falls	45. Ohiopyle Falls
11. High Falls	29. Alpine Falls	46. Cucumber Falls
12. Skytop Lodge	30. Middle Branch Falls	47. Jonathan Run and
13. Tanners Falls	31. East Branch Falls	Sugar Run Falls
14. Nay Aug Falls	32. Angel Falls	48. Springfield Falls
15. Hawk Falls	33. Mill Creek Falls	49. Alpha Falls
16. Glen Onoko	34. Dry Run Falls	50. Kildoo Falls
17. Bear Creek Falls	35. Buttermilk Falls	51. Breakneck Falls
18. Seven Tubs	36. Bradford Falls	52. Hell's Hollow Falls

The terms *left-hand* and *right-hand,* when referring to stream sides, banks, or edges, are given from the perspective of looking downstream. For example, when I say, "Cross to the left-hand side of the creek," I mean the left side as viewed when looking downstream. Words such as *opposite, turn,* and *return* are from the perspective of the hiker. For example, "Turn right and look for an enormous boulder" means turn toward your right. In many cases, redundant notations are used to make sure there's no ambiguity. For example, "From this point, turn left (upstream) and walk for 2 miles."

Most Pennsylvania waterfalls are somewhat seasonal, and their power and character vary from spring snowmelt to summer heat. Also, their photographability changes from week to week and even day to day as a result of rainfall. Generally speaking, the best seasons are spring, during the latter portion of leaf-out, and autumn, after a good soaking rain. Anytime a big front moves through and soaks an area, however, be prepared to shoot.

According to the USGS, sixty-three accepted topographic names can be used to define a waterfall. Besides falls, they include ledge, slide, cataract, rapid, riffle, chute, plunge, and drop. As this small sample of names illustrates, not every falls is a vertical drop from a ledge or overhang. Many are tumbles down heavily terraced faces, nearly vertical slides, cataracts, or flumelike chutes. The naming criteria for this guide are as follows:

Falls—Water plunging from a ledge or precipice that is vertical or undercut.
Cascade—A vertical to nearly vertical terraced face down which water tumbles, and that is too steep to climb without special gear.
Slide—A near-vertical to less-than-vertical smooth or nearly smooth surface that is wider than the stream going over it and is too steep to climb without special gear.
Chute—A narrow slide or cataractlike feature that confines the stream flow and is too steep to climb without special gear.

Ratings and Measurements

I've tried to provide a sense of what's worth the time to visit and photograph, and what's not, by rating waterfalls on a scale from 0 to 5. This rating combines height, water flow, and a subjective aesthetic component to come up with an overall score. What I've provided is merely an opinion. When scouting waterfalls, and deciding how to rate them, I asked myself two simple questions: Would I come back again with my camera and how much time would I spend photographing? The more positive the response to the questions, the higher the rating given. A waterfall with a rating of 5 would be a must-see and a 0 would not be worth the effort. In fact, the only 0-rated falls in this guide is included as a hiking landmark, not a destination.

Waterfall heights are given in feet and measured from the plunge pool to the top. Since many falls have no distinct head or base, figuring out height is no easy trick, although the means of calculation is straightforward. The process is part science, part art, part guesswork, and in the end, it's an esti-

mate. For obvious safety reasons, walking to the head of any waterfall and throwing a plumb-line over is a bad idea.

There are several different ways to make a height measurement, and they all revolve around using a geometric method called similar triangles. In its simplest form, a scaled stick similar to those used to estimate the height of trees is employed. Walking a known distance from the base of a falls, the observer then holds the stick in an outstretched arm and a sighting from the falls' base to its head is made. The height is then read from the scale on the stick. The same method can be used when standing near a falls' head, by sighting a landmark in the tailwater area. A major problem with either method is in making an accurate distance measurement from a falls' base to the spot where the sighting is taken without going for a swim in the plunge pool or otherwise getting hurt in the process. There are ways to derive this distance by measuring stream width, but they have drawbacks as well.

Most of the heights provided, such as those from Ricketts Glen, are already well known. In a few, what I've provided is my best guess. To me, the height of a waterfall is secondary to its majesty. A powerful ten-foot fall coursing through a narrow moss-covered crevice can be a more enjoyable photographic subject than a sixty-foot trickle that drops over stone devoid of cover due to acid mine drainage. Simply put, I find the aesthetics of a location more important than the mere statistics for the waterfall.

There are hundreds of features like this in Pennsylvania; those that I've included here are a mere fraction. A lifetime could be spent exploring Pennsylvania streams without ever counting all the waterfalls or fall-like features—which, when I think about it, is probably not a bad way to spend one's time.

Footgear and Equipment

First, recognize this important fact: At some point, you're going to get wet. Although you can get most anywhere in a good pair of sneakers, I don't recommend them. Ankle and arch support are very important when hiking along uneven creek banks, and boots that cover the ankle area are important. A twisted ankle is a common hiking injury, and as my own orthopedic surgeon will attest, you can break an ankle anywhere, anytime. Stout high-top boots are a must. For working in water, use hip waders or quality outdoor sandals.

Toting around 30 to 50 pounds of camera equipment is not always easy. I carry my gear in Lowepro camera backpacks. With a lighter complement of gear, use a waist pack or a big fanny pack. In any case, the object is to keep your hands free when walking on uneven terrain.

Amazing photographs can be made with even the simplest of cameras. What camera equipment to use is beyond the scope of this guide. Here are a few things to consider, however. Use a camera with a manual exposure setting capability, and meter everything in the scene to be photographed *except* the white water in the falls itself. Lenses in the 17mm to 50mm range will be

used more often than any other, especially those wider than 35mm. Put a polarizer on the camera and leave it on, and don't bother with a skylight or UV filter—they're worthless. Use warming filters very sparingly. Exposures longer than 1 second will be common (between 1 and 15 seconds will be the norm), so a sturdy tripod that places the camera at eye level without extending the center post works best.

Helpful Hints

- Clean up the scene to make it look tidy. Remove or hide any debris, such as trash, dead leaves, tree bark, sticks, and twigs. Never remove plants or pick flowers, however.

- Check the edges of the viewfinder. Run your eye around the perimeter of the viewfinder in both directions, looking closely for twigs, leaves, or anything that juts into the edge of the frame. These are called "sneakers," and they are enormously frustrating. Don't let anything jut into the edge of the frame if you can avoid it.

- Look for merges and apparitions—trees that don't appear to go anywhere or rocks that appear to be sitting on top of one another. Since our eyes have binocular vision, we can tell if an object is in front of another. A photograph has no depth, so it must be created. If there is a cluster of three trees in the middle of the scene where the trunks overlap, move the camera around until three distinct trees are seen. The difference between a good photo and great photo is this kind of attention to detail.

- It's tempting to set up your tripod and shoot from one spot. Move around, even just a few feet, to ensure that you've picked a good spot to work from.

- Be comfortable behind the camera. Streamside rocks can be slick, wobbly, and uncomfortable to balance on. You can slip and hurt yourself or knock over your tripod, destroying your equipment. If you're not comfortable, find somewhere else to shoot from.

- Pray for rain, fog, or mist. Shooting waterfalls in bright sunlight is almost impossible. Overcast skies and flat lighting work best.

- Even when it's overcast, dry rocks near a falls will be rendered overly bright on film. To make them look better in your photographs, splash them with water (you may want to take along a bucket).

- Have fun! Making good photographs is hard work, and you can get caught up in the technical minutia. Stop, look around, and enjoy the location. The camera is just an empty box; the images come from the heart.

Hike 1 Pinchot Falls, Pike County

THE FALLS

Type: cascade	**Height:** 85 feet
Rating: 5	**GPS:** 41° 19.673'N, 74° 49.360'W
Stream: Sawkill Creek	**Lenses:** 20mm to 70mm
Difficulty: easy	**Distance:** 1.1 miles
Time: 1 hour	**Elevation change:** 70 feet

Directions: From the traffic light at PA 739 and US 209 at Dingmans Ferry, take US 209 north 8.2 miles to the first traffic light in Milford. Go straight at the light and follow US 6 west for .5 miles to a Y in the road; an oval gray sign with gold lettering is at the point of the Y. Bear left and pass behind the Apple Restaurant to the entrance of Grey Towers, .25 mile ahead. Turn left and proceed up the long, tree-lined drive to the parking area above the main house. GPS coordinates: 41° 19.721'N, 74° 49.156'W.

"Among the many, many public officials who under my administration rendered literally invaluable service to the people of the United States, Gifford Pinchot on the whole, stood first."
—THEODORE ROOSEVELT

Grey Towers is the estate where Gifford Pinchot conceived the idea of a national professional forest service. The hills surrounding the mansion had been extensively logged, as had most of Pennsylvania by 1870, and forest lands all over America were being clear-cut at an alarming pace. Young Pinchot felt that something had to change in order to ensure that future generations could enjoy, and profit from, the forests. Encouraged by his father, James, in 1885 Pinchot decided to pursue a career in the then unheard-of study of forestry. No schools or training programs existed in the United States, so after graduating from Yale in 1889, Pinchot studied forestry in France. A liberal from a well-to-do and well-connected family, Pinchot found a like-minded supporter of his conservationist cause in Theodore Roosevelt, who had become president after the assassination of McKinley. In 1889, the U.S. Forest Service was born, and for the next twenty years, Pinchot worked to expand the public land holdings of the national forest system. He succeeded in spectacular fashion. Although Roosevelt is credited with dramatically expanding the more visible national park system, Pinchot is the one responsible for the significantly larger holdings of the U.S. Forest Service, increasing them to 193 million acres over those twenty years. The only reason we have such incredible public lands to enjoy now is because of these two tireless conservationists.

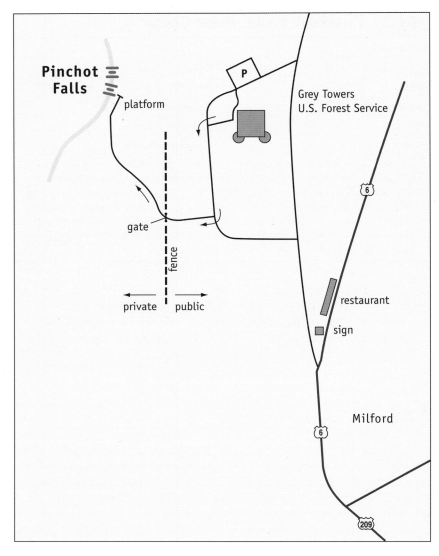

The easy trail to Pinchot Falls traverses the private lands of the Pinchot family that surround the Grey Towers National Historic Site, so do not leave the trail. From the parking area, walk down the tree-lined drive .18 mile to some No Parking signs at a small turnout, while taking in the expansive views of the upper Delaware River valley from the estate's front lawn. At the No Parking signs, turn right and head toward a tall deer fence with a gate. Pass through the gate, latch it behind you, and then walk along the wide grass pathway, keeping the woods to your left. About 150 yards from the gate, the path enters the trees at a large white Welcome sign; you are now the Pinchots' invited guest.

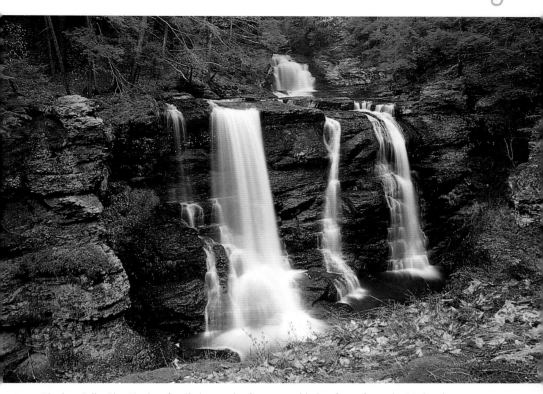

Pinchot Falls. The Pinchot family keeps the foreground ledge free of weeds. It's hard to shoot with a wide angle and make the foreground fit the composition, however. *Canon EOS Rebel Xs, Tokina 20–35, polarizer, Kodak E100VS, f/16 @ 2 sec.*

Proceed down a slight incline through a hemlock and pine grove, and listen for the falls, which should be audible if it's running with any power. Pass a second white private property notice. The trail now makes a sweeping right turn up a shallow incline, then angles left. At .5 mile, you come to a large green sign and a fence. This third private property notice states that you are an invited guest and asks you to respect all fences and handrails.

Pinchot Falls consists of two distinct drops: The upper, 25-foot cascade is separated by an expansive plunge pool from the lower, 60-foot main falls. The main falls is unique in configuration compared with other falls in the region. The tan sandstone caprock of the falls' precipice divides the flow of Sawkill Creek into three channels. The left channel forms a true falls, the center a horsetail cascade, and the right a wider cascade. The best view of the upper falls is from the right side of the viewing platform, and the whole falls is best seen from the middle of the platform. The upper plunge pool is clean, and the foreground is free of weeds. When your shooting is complete, take a tour of Grey Towers, which will not disappoint. If tours are not available, walk the grounds and enjoy the view.

| Hike 2 | # Hackers Falls, Pike County |

THE FALLS

Type: slide	**Height:** 8 feet
Rating: 2	**GPS:** 41° 17.962'N, 74° 50.305'W
Stream: Raymondskill Creek	**Lenses:** 20mm to 70mm
Difficulty: easy	**Distance:** 1.3 miles
Time: 1 hour	**Elevation change:** 100 feet

Directions: From Dingmans Ferry at the traffic light at the PA 739 and US 209 inter-section, take US 209 north 4.9 miles to Raymondskill Road (SR 2009) and turn left. Head uphill and drive 1.8 miles, passing by Raymondskill Falls, to Milford Road (SR 2001). Turn right and go .8 mile, passing Oak Manor Drive on your left, and then make the first available right onto the partially hidden dirt entrance road to Hackers Falls. The road, which looks like a private driveway, is marked by a beaver pond, two bushy cedars, and an old Park Service sign. It's also the only dirt road on the south side of Milford Road after passing Oak Manor Drive. GPS coordinates: 41° 18.366'N, 74° 50.376'W.

Although Hackers Falls is not very large, the trail is pleasant, and the falls makes a nice picnic and wading spot. Photographically speaking, the beaver pond and marsh at the trailhead are more interesting than the falls, if you don't mind the bugs. This smallish marsh provides a good view of how the upland meadows and bogs of the Pocono Plateau feed the streams that descend into the Delaware Water Gap. These wetlands areas are very impor-tant to the health of the water supply of all the adjacent communities.

The route to the falls begins by following a service road up a slight grade to an intersection with a narrower trail at .4 mile. Look for a small path that descends to the right. Turn right here, proceeding downhill. At .42 mile, you pass a large area of standing dead trees on your right. If it's breezy, stop and listen, as the wind moves the snags around, creating haunted-sounding squeaks and groans. (On the return, bear left at these dead trees, as another trail joins here.) At .5 mile, you arrive at the sizable plunge pool of an 8-foot slide, which provides a great little picnic spot that comes complete with trash cans.

The trail continues downstream on the left-hand bank for another mile to the Raymondskill Falls parking area, but this route is not well marked or maintained, so it's best avoided. A trail upgrade is planned by the Park Serv-ice as part of a trail improvement project.

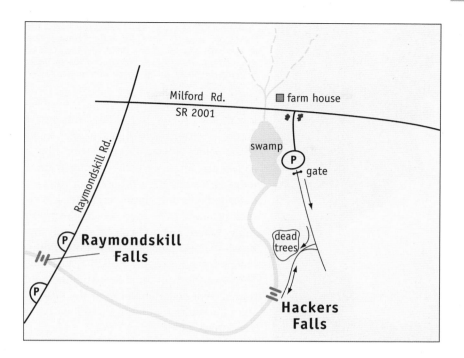

Hike 3 Raymondskill Falls, Pike County

THE FALLS

Type: cascade	**Height:** 180 feet
Rating: 5	**GPS:** 41° 17.322'N, 74° 50.493'W
Stream: Raymondskill Creek	**Lenses:** 20mm to 70mm
Difficulty: easy (many stairs)	**Distance:** .3 mile
Time: 20 minutes	**Elevation change:** 85 feet to lower viewing platform

Directions: From the traffic light at PA 739 and US 209 at Dingmans Ferry, take US 209 north 4.9 miles to Raymondskill Road (SR 2009). Turn left and proceed uphill for .7 mile to a marked parking area. GPS coordinates: 41° 17.396'N, 74° 50.474'W.

As the tallest waterfall in the state, and only 4 feet shorter than Niagara, Raymondskill Falls has always been a tourist attraction. The 100-foot-long rectangular mound surrounded with weeds near the turn off from US 209 is all that remains of the former Hotel Schanno. To get to the falls, exit the parking area to the right of the restrooms, and walk down the gravel path and stairs about 400 feet. There are two viewing platforms: one near the head of the falls, and one at a large step that divides the upper two drops from the

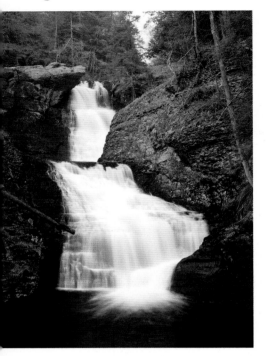

Upper Section, Raymondskill Falls. This is just the top 60 feet of a 180-foot falls. A tight composition is needed to keep all the dead hemlock out of the scene. *Tachihara 4x5, Schneider 150mm Super Angulon, polarizer, Kodak ReadyLoad Holder, Kodak E100VS, f/32 @ 4 sec.*

lower. Each divide in the falls indicates a harder sandstone layer that separates softer layers below. Adjacent to the lower drop is a thin horsetail cascade exiting from a ledge surrounded by rhododendron. This cascade flows only during and after a good rain. A fence at the lower viewing platform limits where a tripod can be set, and low brush makes managing a foreground difficult, so set your tripod as high as possible. Numerous logs in the middle plunge pool and several dead hemlocks at the head of the falls make this impressive location a very tough shoot.

Until 2003, a fenced trail led to the base of the falls, from which the entire 180-foot drop could be viewed. A keen look around the lower viewing platform will explain why the trail has been closed. The woolly adelgid, an invasive pest, has wreaked havoc on the hemlocks that line this ravine, which is the reason for the logs in the middle plunge pool and dead trees at the falls' head. Soil erosion caused by large numbers of visitors, combined with the drought of 2002 and an ice storm in February 2003, has made this hemlock grove particularly vulnerable to the adelgid. In order to preserve the trees that remain, the Park Service has been forced to close this lower portion of the trail. As a result, you'll have to be content with shooting just the upper two-thirds of the falls. The Park Service is doing everything that funding will allow to save this hemlock grove, and that means a certain degree of inconvenience for photographers.

Hike 4 Adams Falls, Pike County

THE FALLS

Type: chute	**Height:** 6 feet
Rating: 2	**GPS:** 41° 15.147'N, 74° 52.935'W
Stream: Adams Creek	**Lenses:** 20mm to 100mm
Difficulty: moderate	**Distance:** 2.3 miles
Time: 1 hour, 30 minutes	**Elevation change:** 220 feet

Directions: From the traffic light at PA 739 and US 209 at Dingmans Ferry, take PA 739 north uphill for 2.5 miles to Milford Road (SR 2001). Turn right, and drive 1.3 miles to Long Meadow Road, which is marked by a sign for Long Meadow Chapel. Turn right, and proceed .9 mile to a sharp left turn where the name of the gravel road changes to Schoolhouse Road. Park on the left. GPS coordinates: 41° 15.768'N, 74° 52.260'W.

Adams Falls by itself is not much of an attraction, but a lake near the trailhead and the Sproul Estate energy wheel at the falls make a hike more than worth the effort. Gov. William Cameron Sproul is called the "Father of Good Roads." Although some would doubt there were ever any good roads in Pennsylvania, it was Sproul as state senator who sponsored the state's first real highway construction bill.

Sproul and Gifford Pinchot were like-minded contemporaries. Governor Sproul's administration began in 1919 with Pinchot serving as head of the relatively new Bureau of Forestry. Decades of industrial logging had resulted in many flooding problems throughout the state, and Pinchot urged Sproul

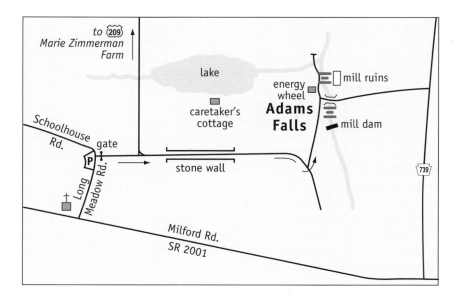

to invest in a forest restoration program to correct the damage. Sproul designated April 11 and April 25, 1919, as Pennsylvania's first Arbor Days, when thousands of trees were planted statewide. The Sproul estate, which the trail crosses, was just a summer vacation and hunting cottage. Little remains of the estate except for dry-fit stone walls lining the trail, a caretaker building near the lake, and the energy wheel at Adams Falls. Although well known, the trail to Adams Falls is still unofficial. The Park Service plans to name it the Sproul Road Trail when funding is available.

Cross Long Meadow Road and walk around the yellow gate. The trail you are now on is the dual-use Conasbaugh View Trail, so keep an eye out for road apples. At .1 mile, the forest road divides above a lake. This is a good spot to shoot fall foliage in the morning light. Continue straight, and walk uphill between two dry-fit stone walls. (Turning left at the divide follows the 1.1-mile-long Conasbaugh Trail, which descends to the Marie Zimmerman Farm and US 209.) The Sproul Road Trail is wide, the walk comfortable, and you can set a brisk pace.

Just as I wrote this notation in my field journal, I heard some rustling in the brush to my left, which I dismissed as a deer or an overzealous squirrel. I glanced briefly at my GPS, then looked up to see a bear pop its head and shoulders out of the woods not more than 25 yards away. It turned my way.

We made eye contact, and although I can't speak for the bear, I'd say we were both equally surprised to see each other. I tried to swing my camera off my shoulder, but the bruin turned and ran off into the woods.

At .75 mile, the trail curves right and begins a slow descent toward Adams Creek. At .79 mile, the woods road turns left and a footpath enters from the right. Proceed along the wider woods road. At .87 mile, the creek comes into view down a steep hemlock-covered embankment. The trail parallels the creek here, and the remains of a small mill housing the energy wheel are found at 1 mile.

Adams Falls consists of three natural falls and the remnants of a mill dam. The mill dam is built over a sandstone ledge that creates a 5-foot cascade. Although the second falls does not appear natural, it is, forming a 6-foot chute on either side of prominent ledge. From this position, it interesting to observe how the stone building that houses the workings of the energy wheel sits atop a radically undercut ledge. The third drop, below the mill, consists of two 5-foot chutes connected by an attractive kettle. This little cataract is the main attraction and the most photogenic part of the falls. From downstream, where the creek broadens into a gravel bar, the energy wheel appears to sit above the falls, making an interesting image. The fourth drop is a mere 2-foot shelf.

Adams Creek is named for Alexander Adams, whose family lived in the area around 1861, and several mill foundations can be found near the energy wheel. On the right-hand bank are the foundations of a large sawmill that dates from before 1861, and just below the falls are two more founda-

tions that may have been gristmills. It may never be known what most of the mills were used for, as the history of this portion of Adams Creek is obscure and lost to time.

Built between 1908 and 1915, the energy wheel provided electrical power to the Sproul estate. Rural electrification was still decades away, and people were fascinated by the new science of electrical power. The little hydroelectric plant became a local tourist attraction, and visitors came from all over to see this new force that man had harnessed. In 2001, the Park Service put a new roof on the energy wheel, and both it and the caretaker's shed by the lake are listed on the National Register of Historic Places. Bring a flashlight so that you can have a look around if the energy wheel is open.

You may be tempted to continue the hike downstream from Adams Falls to US 209. Don't do it. Below Adams Falls, the creek passes through badly stressed hemlock groves, and to protect them, the Park Service discourages anyone from hiking downstream of the falls. The route described above follows the proposed Sproul Road Trail, for which the Park Service was gracious enough to provide me a map. Two connector trails are in the works that will link with PA 739 near Dingmans Falls, and they will be called the Bride and Groom Loop Trail. Both will use old forest roads similar to the Sproul Road Trail. Check with the Park Service to see if this new loop is open, and if so, you can use it to add a 1.5-mile hike from Adams Falls.

Hike 5 Dingmans Falls, Pike County

THE FALLS

Dingmans Falls

Type: cascade over slide	**Height:** 130 feet
Rating: 5	**GPS:** 41° 13.839′N, 74° 53.510′W

Silverthread Falls

Type: slide	**Height:** 80 feet
Rating: 3	**Stream:** Dingmans Creek
Lenses: 20mm to 70mm	**Difficulty:** easy (boardwalk and stairs)
Distance: .75 mile round-trip	**Time:** 30 minutes
Elevation change: level to base of falls, 130-foot stair climb to head	

Directions: From the blinker at the intersection of Bushkill Road and US 209, follow US 209 north into the Delaware Water Gap National Recreation Area for 11.6 miles to Johnny Bee Road (the sign says Road, but it appears on most maps as "Johnny B. Mountain"). Turn left, and proceed for 1.1 miles to the falls parking area, taking the right fork about .5 mile up Johnny Bee Road. GPS coordinates: 41° 13.754′N, 74° 53.238′W.

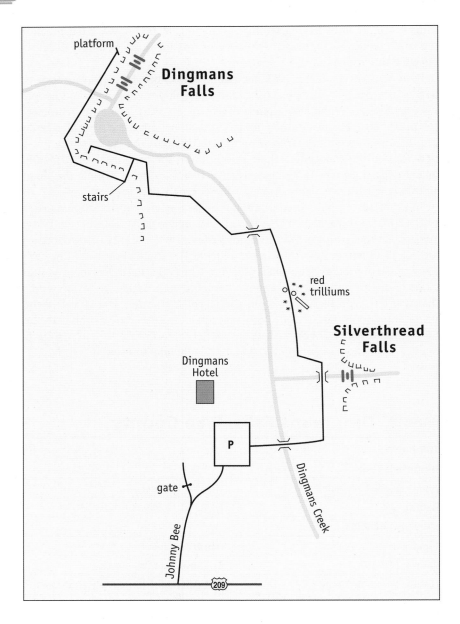

The pleasant walk into Dingmans Falls uses a 600-yard-long handicapped-accessible boardwalk trail. Note the buildings at the end of the parking lot. First opened to the public in 1888 as a scenic attraction, Dingmans Falls was a private enterprise for more than a century, until the Park Service acquired the site in 1975. The attractive chalet-style buildings were under restoration in 2003 and are to be part of an improved visitor interpretive center.

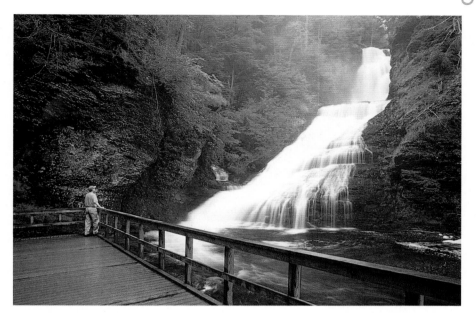

Self-portrait, Dingmans Falls. You need to stay very still when shooting self-portraits. This was the only shot out of ten where my head wasn't blurred. Note the heavy spray at the falls head; I also got drenched shooting this. *Canon EOS Rebel Xs, Tokina 20–35, polarizer, Kodak E100VS, f/11 @ 2 sec.*

Several mills once sat along Dingmans Creek from a point 2 miles upstream at the Geo. W. Childs Picnic Area to where the creek passes under US 209. The creek was used by sawmill, cider mill, woolen mill, and gristmill operators, and some faint evidence of their presence remains near the parking area. Industrial use of the creek peaked between 1820 and 1830 with the rapidly expanding lumber industry, which declined just as rapidly when the forests were cleared. Most of the region's mill operations were defunct by the Civil War. The head of Dingmans Creek is at Silver Lake near the village of Edgemere, where it passes just a mile from Little Bushkill Creek. Both creeks share similar upland swamp drainages, but there is no connection between them.

Begin the walk to Dingmans Falls by crossing a bridge, giving it a good rap with your knuckles as you pass. This bridge is made mostly of plastic, and as an engineer, I was impressed by the use of this unique construction material. I even jumped up and down a few times and found the bridge to be very sturdy.

Dingmans Falls is the second highest falls in the state, with a plunge of 130 feet. In heavy spring runoff, there is no way to get to the end of the boardwalk without getting drenched by spray. The boardwalk trail passes by a thin horsetail cascade called Silverthread Falls. Whereas Dingmans Falls slides down a sandstone face, Silverthread has sawed its way through a narrow fis-

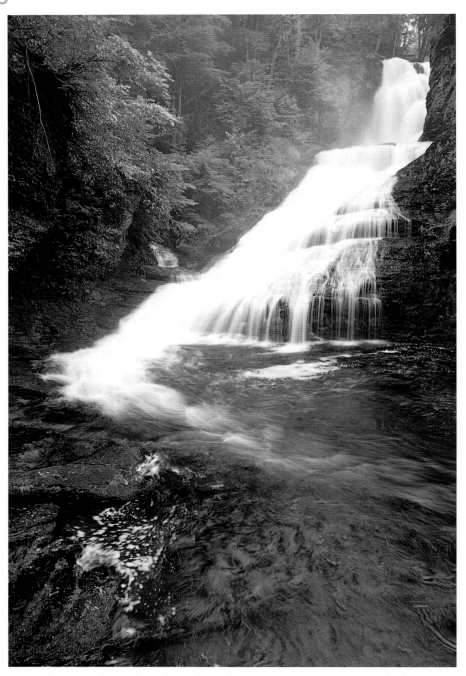

Dingmans Falls. It's almost impossible to keep your optics dry this close to the falls. Keep a dry, lint-free towel ready, and use a shower cap to keep your camera dry. *Canon EOS Rebel Xs, Tokina 20–35, polarizer, Kodak E100VS, f/8 @ 2 sec.*

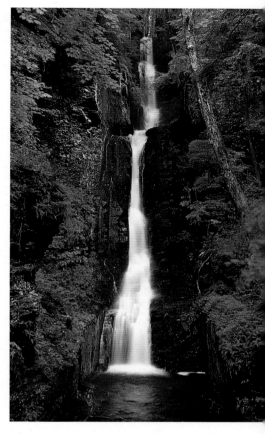

Silverthread Falls. The best time to shoot this horse-tail is in the rain when it's running full. *Canon EOS Rebel Xs, Tokina 20–35, polarizer, Kodak E100VS, f/16 @ 8 sec.*

sure of the same formation to reveal a cross section of the lower Pocono Plateau, with its many twisted and folded rock layers. Carrying much less water than Dingmans, Silverthread can be a trickle most of the year.

Several yards up the boardwalk from Silverthread, to the left is a tall stump and nearby to the right is a large log. Near this log is a patch of red trillium that blooms an intense blood red. If you visit in April, bring macro photography gear. Remain on the boardwalk when shooting these wildflowers. Continuing farther on, another bridge doubles back across the creek, and the boardwalk enters a rhododendron tunnel. During late June to mid-July, the entire area is in bloom. (To time a visit with the peak of bloom, contact the Park Service for an update around that time.) Rhododendron is profuse at the plunge pool as well and provides a dramatic foreground when viewed from the stairway to the head of the falls.

Once at the end of the boardwalk, linger awhile before making the 130-foot stair climb to the head of the falls. There are about 250 stairs to the top. The park map shows a trail continuing from the head of Dingmans Falls to Fulmer Falls at the Geo. W. Childs Picnic Area. In 2003, this trail had yet to be surveyed because revised plans called for installing a boardwalk most of the way to Fulmer Falls, subject to funding. This is a very sensitive ecological area, and the Park Service asks that you make no attempt to walk the 1.5 miles to Fulmer Falls. Rather, return to your car and drive around to the Geo. W. Childs Picnic Area to view Factory, Fulmer, and Deer Leap Falls.

Hike 6 Fulmer Falls, Pike County

THE FALLS

Factory Falls

Type: falls over cascade	Height: 17 feet
Rating: 2	

Fulmer Falls

Type: falls over chute	Height: 55 feet
Rating: 4	GPS: 41° 14.206'N, 74° 54.927'W

Deer Leap Falls

Type: falls over falls	Height: 30 feet
Rating: 4	Stream: Dingmans Creek
Lenses: 20mm to 70mm	Difficulty: easy (boardwalk and stairs)
Distance: .5 mile	Time: 30 minutes

Elevation change: 200-foot descent to Deer Leap plunge pool

Directions: From the blinker at the intersection of Bushkill Road and US 209, follow US 209 north into the Delaware Water Gap National Recreation Area for 11.8 miles to the traffic light at PA 739. Turn left, and proceed 1.2 miles to Lake Road (SR 2004). Turn left, and drive 1.6 miles to the Geo. W. Childs Picnic Area. GPS coordinates: 41° 14.235'N, 74° 54.909'W.

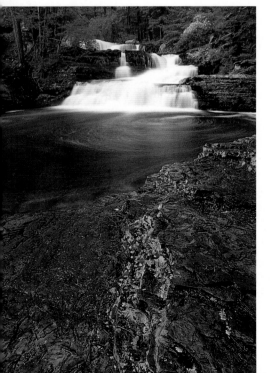

Three falls can be viewed on this hike. This simple walk begins at the ruins of a woolen mill near Factory Falls. The mill was built in 1826 by Joseph Brooks, who, like others, grazed sheep on the plateau. His mill carded and spun the wool into thread. The woolen mill venture failed shortly after his death in 1832. John Fulmer built a tannery upstream in 1851, and a small community began to thrive in the area. In 1866, the tannery was sold, and later it too failed, taking the little town with it. Evidence of mill dams exists all along the upper reaches of Dingmans Creek, but

Factory Falls. I found this lichen clinging to a quartz intrusion and just had to play with it. I wet the foreground ledge so that it would look black, and then set my 17mm lens just 9 inches from the lichen. *Canon EOS Rebel Xs, Tokina 17mm, polarizer, Kodak E100VS, f/22 @ 8 sec.*

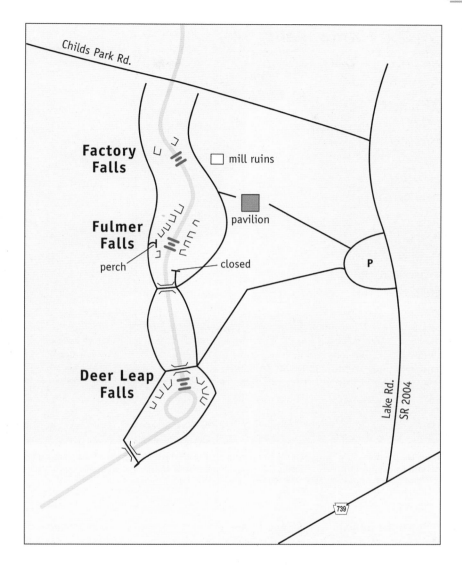

it's not possible to explore them, because above Childs Park Road the creek is on private lands until it enters the Stillwater State Natural Area 3 miles away.

The highest of the three falls is Fulmer, which is an impressive 55-foot chute. Fulmer can be difficult to photograph, because access to its plunge pool has been closed due to visitor impact. Factory Falls consists of two drops and sits immediately above Fulmer. Its plunge pool has a sweeping eddy that creates a nice swirl of foam. A wide expanse of stone fronting has interesting lichens that can be used as a foreground. Deer Leap is the most photogenic, with good shooting positions all along the gravel-filled shallows of its wide plunge pool.

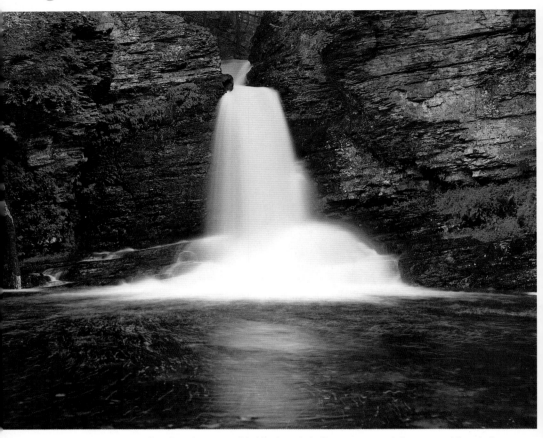

Deer Leap Falls. The plunge pool is blank and shallow, so use a tight composition, being careful to keep a footbridge close to the falls' head out of frame. *Tachihara 4x5, Schneider 210mm Super Angulon, polarizer, Kodak ReadyLoad Holder, Kodak E100VS, f/32 @ 6 sec.*

It can be difficult to take good photographs of any of the falls because of the large number of sawn logs that clog their tailwaters. These logs are not due to a lack of Park Service upkeep, but are the casualties of a battle against the hemlock woolly adelgid. This Asian insect was introduced to America in 1924, and it has ravaged the short-needle pine forests of the East ever since. Hemlock stands are critical to the health of stream sheds in the region, and their loss will be a severe blow to the state's ecological health. The Park Service has introduced a biological control insect called *Pseudoscymnus tsugae* at a number of sites in the Water Gap, but its effect on the adelgid population is hard to gauge. So far, it's clear that it's no magic bullet. Hemlocks normally live four hundred years or more, but unfortunately the Park Service is fighting a losing battle, and I wouldn't be surprised if the hemlocks of the Delaware Water Gap are all but gone by 2010.

Hike 7 Indian Ladders, Pike County

THE FALLS

First

Type: slide	Height: 18 feet
Rating: 2	GPS: 41° 11.651'N, 74° 54.583'W

Second

Type: chute	Height: 6 feet
Rating: 1	GPS: 41° 14.617'N, 74° 54.587'W

Third

Type: cascade	Height: 20 feet
Rating: 2 (partially accessible gorge)	GPS: 41° 11.555'N, 74° 54.533'W

Fourth

Type: cascade	Height: 40 feet
Rating: 4	GPS: 41° 11.529'N, 74° 54.515'W
Stream: Hornbecks Creek	Lenses: 20mm to 70mm

Difficulty: easy to moderate; trail is faint in many places

Distance: .7 mile	Time: 1 hour

Elevation change: 200 feet to fourth plunge pool

Directions: From Bushkill, at the blinking light, take US 209 north 6.8 miles and turn left onto Brisco Mountain Road, which is marked by signs for the Pocono Environmental Education Center (PEEC). Drive uphill .9 mile and bear right onto Emery Road and stop in at the PEEC visitor center on your right to pick up maps and brochures. From the PEEC parking area, turn right onto Dickinson Road (T 318) and follow it for 2 miles. This road is the boundary between the Delaware Water Gap National Recreation Area and private land on the left. Dickinson Road twists left and right several times; keep the green and white federal land markers on your right. At 2 miles, the road crosses a small culvert that carries it over Hornbecks Creek. A parking area is on the right-hand side of the road. This is one of two trailheads to Indian Ladders. GPS coordinates: 41° 11.770'N, 74° 54.530'W.

The relatively level trail makes its way through hemlock and white pine along the very top of the Pocono Plateau. The parking area is at an elevation of 796 feet, and the vegetation here is quite different from the lush rhododendron groves at nearby Dingmans Falls. Begin your walk by following a wide path through the brush on the creek's left-hand side. The path is prominent, though unblazed, for the next .2 mile. At .16 mile, the path enters an open forest of widely spaced pine trees with no understory. Continue through the trees for about 50 yards, then turn right toward the sound of rushing water. You will quickly reach the head of an 18-foot slide. This slide's flow splits near the base, creating an inverted Y-shaped plunge.

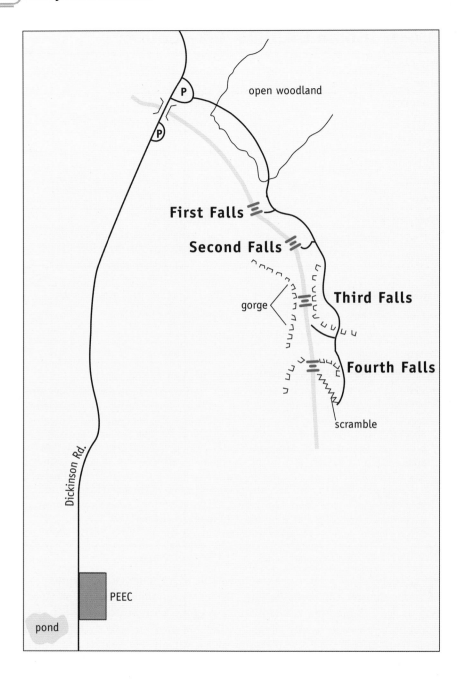

Returning to the path, continue downstream and at .19 mile find the second drop, a 6-foot-tall cascade where Hornbecks Creek cuts through a shale formation at an angle. Here the creek makes a sweeping turn to the southeast before joining a lesser branch and making a sharper turn northeast below the last fall.

At .21 mile, the path becomes faint near the head of a small gorge that has a series of drops within it. A better view into the gorge is from the far side of the creek, but that requires some scrambling to reach. A wide section below the gorge provides limited access to the gorge's last cascade.

Below this gorge, the trail is essentially nonexistent, but the widely spaced hemlocks make for easy going. At .27 mile, still almost within sight of the gorge, is a 40-foot-tall cascade. Several faint paths descend the loose soil of the hillside to the base of this falls. Small bits of pale green shale litter the surface, making the descent feel like a scramble down a ball-bearing-covered mattress. Firmly dig your boot edges into the hill to avoid sliding. This 60-foot scramble is the most difficult part of the hike. A small island in the middle of the creek provides the best shooting location. It's easy to get to by using a logjam at the base of the falls to ford the narrow run.

Hike 8 Tumbling Waters, Pike County

THE FALLS

Lower

Type: chute	**Height:** 70+ feet
Rating: 3	**GPS:** 41° 9.450′N, 74° 55.169′W

Upper

Type: slide over slide	**Height:** 30 feet
Rating: 4	**Stream:** Tumbling Waters

Lenses: 20mm to 70mm

Difficulty: easy, with moderate scramble to access upper falls

Distance: .8 mile	**Time:** 1 hour

Elevation change: 135 feet to upper falls

Directions: From the traffic light at PA 739 and US 209 in Dingmans Ferry, take US 209 south 5.6 miles to a large, unmarked parking area on the right (west) side of the road.

From the blinker at the intersection of Bushkill Road and US 209, follow US 209 north for 6.2 miles to a large, unmarked parking area on the left (west) side of the road. GPS coordinates: 41° 9.233′N, 74° 54.996′W.

Before walking up the unmarked footpath from the parking lot, look around the road culvert for stone walls lining the creek. These walls indicate that a mill once stood here. Mills of all kinds, such as sawmills, cider and woolen mills, and tanneries, occupied every creek in the Delaware Water Gap, and the ruins of an 1830s woolen mill can be found at the Geo. W. Childs Picnic Area. As you proceed up the footpath from the parking area, you'll see a low-slung, bunkerlike structure with a curved roof on the left. Built in the 1850s, this was part of a mill operation. Surrounding it is a large patch of purple periwinkle, which is not a wildflower but an escapee from someone's garden. Nearby are a few red trilliums.

After about 100 yards, the trail disappears as it braids around a series of deadfalls. Although you can easily get through the hemlock grove off-trail,

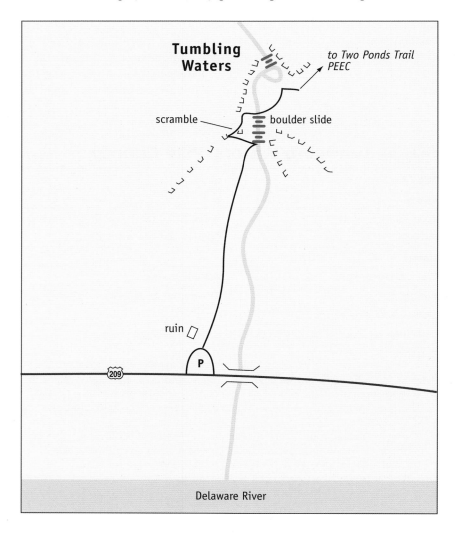

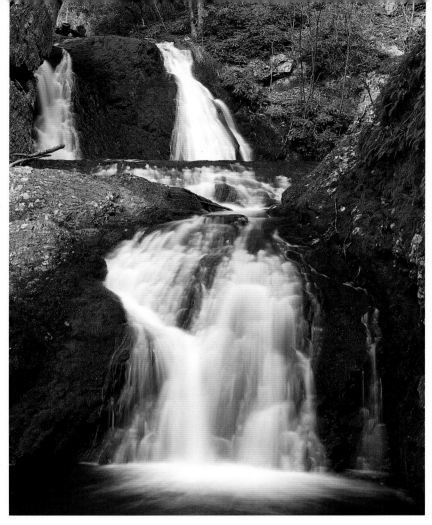

Upper Tumbling Waters. It's hard to get a good exposure when the rocks around the falls are dry. When that happens, wide-angle scenes are impossible. Instead, get close to remove offending highlights. *Tachihara 4x5, Schneider 210mm Super Angulon, polarizer, Kodak ReadyLoad Holder, Kodak E100VS, f/22 @ 4 sec.*

the sensitive red trillium habitat requires that you take a moment to relocate the footpath. Continuing on the path, at .2 mile, you can see the lower drop of Tumbling Waters through the forest, and at .3 mile, you reach the base of the lower falls. The lower drop of Tumbling Waters is difficult to characterize, because the creek slides over, under, and around a series of boulders that choke a 70-foot chute. It's hard to see the entire watercourse, and the bland surroundings make shooting this drop boring. If you want to shoot here, try playing with graphic compositions by isolating portions of the drop with a telephoto lens. Bring some macro equipment along, because there are about two dozen red trilliums within 100 feet of the falls. Unlike other specimens, which sprout closer to hemlocks, these trilliums

are in the open and quite close to the trail, so keep a close eye on where you step.

Getting to the upper falls requires a scramble up a steep slope on the right-hand side of the falls (the side the trail is on). In early spring, the path is covered with leaves, making it almost invisible; by mid-May, however, enough people have been through to make it distinct. From near the base of the lower falls, begin a switchback route by working away from the creek and then back again, until you've gained half the slope's height and encountered boulders. Then make a headlong, root-grabbing scramble straight up the slope between and around these boulders. It's not a hard climb, but it does take patience to pick a path of least resistance. Once at the top, cross the creek 10 yards above the lower falls' head.

You now enter a broad, flat area occupied by more hemlocks. Look here for orange blazes. These blazes mark the bottom of the Two Ponds Trail, which begins at the Pocono Environmental Education Center (PEEC). Following the orange blazes, at .4 mile you'll come to the shockingly deep, and cold, plunge pool of one of the more photogenic falls in the area. Bring bug repellent, as a large, damp gravel bar provides an ample supply of gnats and mosquitoes.

PEEC offers a wide range of environmental classes, from single evening seminars to multiday accredited courses, along with cabins and camping for organized school groups. Stop in and take a look around, and if you feel it is appropriate, make a small contribution to their worthy cause.

Hike 9 Bushkill Falls, Pike County

THE FALLS

Bushkill Falls (main falls)

Type: cascade	Height: 100 feet
Rating: 5	GPS: 41° 7.048′N, 75° 0.561′W

Pennel Falls

Type: slide	Height: 8 feet
Rating: 1	

Upper Bridesmaid Falls

Type: cascade	Height: 20 feet
Rating: 3	

Bridal Veil Falls

Type: falls over cascade	Height: 25 feet
Rating: 3	

Lower Bridesmaid Falls

Type: cascade	Height: 20 feet
Rating: 3	

Lower Gorge Falls

Type: cascade	Height: 45 feet
Rating: 4	
Streams: Little Bushkill Creek and Pond Run Creek	
Lenses: 20mm to 100mm	Difficulty: easy to strenuous
Distance: 2 miles round-trip	Time: 2 hours
Elevation change: 200 feet	Admission fee: $8 for adults in 2003

Directions: From the interchange of I-80 and US 209, take US 209 north 3.9 miles to Marshalls Creek, where Business Route 209 and US 209 merge. Turn right, and continue on US 209 north for 7.7 miles to the blinker at Bushkill Road. Turn left, and head up the hill for 1.8 miles to the Bushkill Falls entrance. Turn left, and proceed to the parking lot. GPS coordinates: 41° 7.048'N, 75° 0.414'W.

Bushkill Falls is a privately run scenic attraction that's been in the Peters family since 1904. It's an impressive operation run by an attentive staff of forty-five, and there is no doubt that the beautiful glen of Bushkill Falls is in good hands for another hundred years. Because the 300-acre property and its six waterfalls are a very popular attraction, photographers are asked to be mindful and respectful of other visitors on the narrow stairs and walkways around the main falls. Be quick with your tripod, and never let a traffic jam form around you.

The stair climbs in and around the main falls are strenuous, with a nearly 140-foot ascent from the Lower Gorge Falls Bridge to the head of the main falls' west side. But the ascents are short and the views incredible, so a little huffing and puffing is a small price to pay to experience the best waterfall in eastern Pennsylvania.

The trails are color-coded, well-marked, and lovingly maintained. The yellow trail is the most popular route and can be walked in as little as twenty minutes. But Bushkill has so much to offer that it's best to combine the yellow, red, and blue trails into a 2-mile loop to fully appreciate the scenic beauty of this place. Begin by descending the main falls' east side (tour stop 3 on the visitor map) to Lower Gorge Falls Bridge (stop 5), and then climb to the main falls' west side (stop 12). Proceed up Laurel Glen and the Upper Canyon (stops 13 and 14) to Pennel Falls (stop 17).

This first portion of the loop takes you along the walkway that hangs above and faces the main falls, and then it descends to the falls' base at the exit of its huge plunge pool. At high flow, spray will reach anywhere along this section, and on a hot day, it's refreshing. A good shooting spot is near

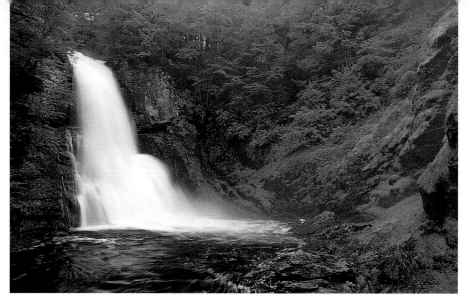

Bushkill Falls. From the footbridge below the main falls. Note how the wet weather makes the moss look so vibrant. *Canon EOS Rebel Xs, Tokina 20–35, polarizer, Kodak E100VS, f/16 @ 4 sec.*

a trash can at one end of the bridge, but have a cover, such as a shower cap, ready for your camera, because spray reaches here routinely. The main falls is impressive at high flow, and a look downstream from the Lower Gorge Falls Bridge makes you wonder how the boardwalk along the gorge was installed.

On the way to Pennel Falls, linger at Adams Flats (stop 15) and observe the sudden change in the forest. In just the 100 yards from Upper Canyon, the forest has changed from dense eastern hemlock to mixed hardwoods. This sudden forest change is repeated everywhere in the Delaware Water Gap near shallow sandstone formations. Besides the change in tree species, look carefully for older stream channels that Little Bushkill Creek has abandoned in favor of its present course; they'll have the look of filled-in drainage ditches.

Continuing on the red trail, turn left at Pete's Corner (stop 19) and head for the Delaware Lookout (stop 11). This promontory sits 450 feet above the Delaware River and provides a nice southerly view. Little Bushkill Creek runs below you on a southeasterly course, and afternoon light creates interesting shadows on the overlapping ridges. In the distance, you can see the ridge of Kittatinny Mountain in New Jersey, the crest of which is 776 feet above you. A dip seen in the distant ridge is called Catfish Pond Gap and is perhaps an abandoned channel of the Delaware. Left (north) of this dip in the ridge is large radio tower that sits above the Appalachian Trail, which is only 5.2 miles away.

Returning to Pete's Corner (stop 19), turn left and continue on the red Bridal Veil Trail to the Lower Gorge (stop 5), then return to main falls' east side (stop 3). Numerous signs on the Bridal Veil Trail warn of the difficult

walk. These are geared more toward elderly visitors. This is a very pleasant walk interrupted only by the main falls' west–east stair climbs. This trail route loops past the main falls twice to give you a chance to photograph it in different lighting.

Bushkill is the most popular attraction in the Water Gap. Peak visitation is during July, August, and October, with as many as forty thousand visitors per month. These happen to be lower stream flow months, making shooting more difficult. April and May are good photo times, as stream flows are high and visitation is as low as two hundred per day. Get here by 9:30 A.M. and you can pretty much have the place to yourself, because most visitors arrive between noon and 4 P.M. The native rhododendrons lining the gorge bloom from late June until as late as mid-July, depending on the weather (these native plants are not to be confused with the hybrids in the parking lot that bloom in late May).

The boardwalk around the main falls' east side provides a stunning view of the falls and its huge plunge pool. As you move along, the perspective varies, and it's fun to shoot the changing view every dozen feet or so. From this catwalk perch, you will see visitors ascending the stairs along main falls' west side. Wait for someone in bright clothing to get halfway up, and shoot with a wide-angle lens for an impressive perspective to the main falls. Besides the grand landscapes provided by the main falls, there are many subtle compositions to play with, and I spent considerable time experimenting in the Upper Canyon.

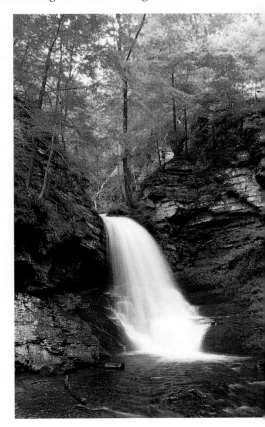

Little Bushkill Creek begins life at Bald Hill Swamp, located in state forest lands 12 miles north. It's impounded at Lehman Lake and Lake Maskenozha, just 4 miles north, and its 850-foot descent to the Delaware achieves its scenic best at Bushkill Falls. If you're a novice outdoor photographer, I strongly recommend visiting Bushkill before shooting other falls in the Water Gap. Bushkill is great fun and more than worth the eight-dollar admission price.

Upper Bridesmaid Falls. It's common to tilt down and emphasize foregrounds. Don't forget to tilt up and play with a nice background as well. *Canon EOS Rebel Xs, Tokina 20–35, polarizer, Kodak E100VS, f/13 @ 3 sec.*

Hike 10 Shohola Falls, Pike County

THE FALLS

Type: slide	Height: 70 feet
Rating: 3	GPS: 41° 23.457'N, 74° 58.164'W
Stream: Shohola Creek	Lenses: 20mm to 70mm
Difficulty: easy	Distance: 100 yards
Time: 10 minutes	Elevation change: 40 feet

Directions: From the interchange of I-84 and US 6 west of Milford, take US 6 west 8.5 miles. Shohola Lake will be visible on the left, and a bridge that carries US 6 over Shohola Creek will come into view while you're descending a hill. Turn left just before the bridge at a sign for Shohola Inn and Cabins. Proceed up the drive 300 yards to a fork, and turn right into a large parking area for State Game Lands No. 180 and a Fish and Boat Commission boat ramp. GPS coordinates: 41° 23.426'N, 74° 58.160'W.

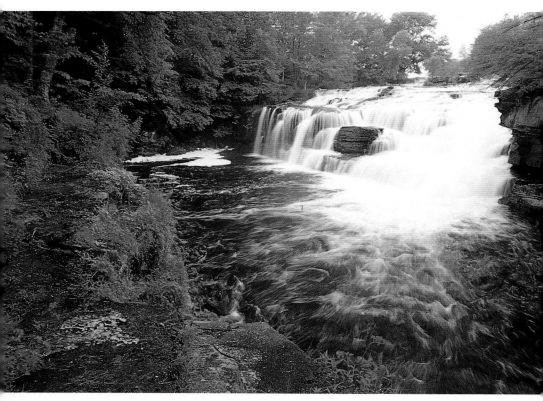

Shohola Falls. The narrow algae-covered ledge tilts toward the plunge pool of this wide and powerful falls. Take extreme care in damp weather, because once you start sliding, there's no stopping. *Canon EOS Rebel Xs, Tokina 20–35, polarizer, Kodak E100VS, f/8 @ 1 sec.*

Shohola Falls is very popular fishing spot, and it's a madhouse during the first few days of trout season. Don't bother trying to see the falls then, because there will be 150 people lining the surrounding ledges.

To view the 50-yard-wide slide, follow the stairs down to a series of ledges facing the falls. Take extra care in damp weather, as these slick, algae-covered ledges tilt toward the churning plunge pool. Located just downstream of the Shohola Lake dam, the wide creek fans out to an impressive width as it descends the falls. In high water, the entire slide is covered; at low water, the right side becomes the dominant channel. Shohola Creek slides 60 feet down a variegated stone face before dropping over a 10-foot ledge into a cavernous plunge pool, which fishermen told me is only 5 feet deep. It certainly looked much deeper than that.

Forming the background of a landscape scene is a third- or fourth-growth woods sitting well behind the falls. In early spring, it looks awfully stark, so it's best to shoot Shohola Falls in late spring after leaf-out is complete. Drooping limbs tend to protrude into the top of the frame, but even more problematic are bright red and yellow fishing floats suspended in the limbs like forlorn Christmas tree balls. As a result, careful framing and examination of your viewfinder edges is a must. A stone viewing platform visible on the creek's far bank is accessed from a second parking area 200 yards west along US 6. This parking area has picnic tables and a pit toilet.

Hike 11 High Falls, Bucks County

THE FALLS

Type: falls	**Height:** 30 feet
Rating: 3	**GPS:** 40° 33.697'N, 75° 7.614'W
Stream: High Falls Creek	**Lenses:** 20mm to 200mm
Difficulty: easy; moderate below the falls	
Distance: 1 mile round-trip	**Time:** 40 minutes
Elevation change: 60 feet elevation decline to head of falls	

Directions: From the interchange of PA 611 and US 202 at Doylestown, take PA 611 north 18.4 miles to the village of Ferndale, and turn right onto Center Hill Road. Drive 3.1 miles, and turn right onto Ringing Rocks Road. Proceed .9 mile to the park entrance on left.

From the interchange of PA 611 and US 22 in Easton, take PA 611 south 13.8 miles to the village of Ferndale, and turn left onto Center Hill Road. Drive 3.1 miles, and turn right onto Ringing Rocks Road. Proceed .9 mile to the park entrance on left. GPS coordinates: 40° 33.650'N, 75° 7.750'W.

The 128-acre Ringing Rocks County Park is a very popular spot for "rock musicians," rock hounds, and families who just want to take a stroll in the woods. High Falls is located an easy .4-mile walk from the parking area. Since High Falls Creek drains just several hundred acres of rocky soils, it usually runs with power only after soaking rains.

A well-worn trail is clearly visible at the end of the small loop parking area. Proceed down the level trail, and at .2 mile you will see a large boulder field on your left. These are the ringing rocks, and you likely will see people with hammers trying to beat out tunes on the rocks. Most of the rocks just make a dull thud, but many make pleasing, bell-like tones, and it can be fun to try.

Just after the ringing rocks, boulders appear to block the trail, but the trail turns right and begins a slow descent to the head of the falls. From this point, the falls can be heard if it's running with any strength. The number of boulders increase all the way to the head of the falls.

The first view of the head of High Falls is from the west (left-hand) side, from the top of a large boulder slide. Boulders fill the entire west side of the amphitheater the falls has created, and there are no good shooting positions from this vantage point. Take a moment, however, to look for a 5-foot ledge on the far side of the amphitheater about 40 yards downstream from the falls.

The boulders present two choices for getting to the base of the falls. You can pick your way down through the boulders on a well-worn path that's easier than it looks. (If you're not sure on your feet, you may want to shimmy down on your backside for the first few feet.) The other alternative is to work your way upstream through the boulders about 40 to 50 yards. The creek here is a flume that rides against the rocks along the left-hand bank. At several points, it practically disappears below the rocks, and it's possible to cross at these points. Once over the stream, cross the large, open expanse of stone slab to the woods beyond, turn left (downstream), and follow the natural profile of the land to the 5-foot ledge below the falls that was visible from your starting point.

When looking downstream from this ledge, you're presented with a nice landscape of the creek shed, and you'll also notice the extent of the boulder field that fills the valley. These boulders are remnants of the hard sandstone formation forming the flume above the falls. This formation rests at an angle and is lower on the valley's left side, so only that side is filled with boulders. The boulders are rounded off, rather than square or blocky in shape, indicating that they have been exposed to the elements for a very long time.

From the base of the falls, you will find a couple of interesting shooting locations. As you face the falls, look for a large patch of moss to the left below an overhang. A smaller portion of the falls' outflow runs this way. The stream flow, moss patch, and wonderfully faceted rock face create extraordinary leading lines that can be shot with a wide-angle lens. This position also

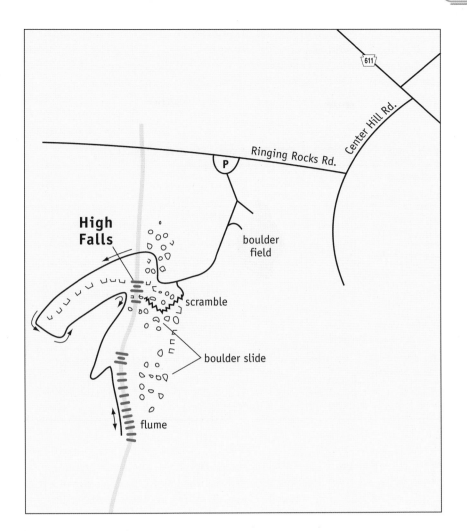

High
Falls

boulder
field

scramble

boulder slide

flume

provides the only view of the ballistic arc of the falls. You can get quite close, and when the wind is right, it's possible to look up into the arc from below.

There is no improved trail downstream from below the falls, but from the right-hand bank, near the 5-foot ledge, a faint footpath follows the stream. Take this path downstream about 200 yards, to a point where three drops and cascades are bunched together, and pick your way down to a stone slab that forms the second drop. From this position, you will be able to create compositions where the flumelike water flow creates a nice **S** curve going over the first drop.

I suggest bringing macro equipment to photograph the mosses, lichens, and liverworts that abound in the area. Even though High Falls can be a trickle many weeks of the year, there are still lots of macro subjects to play

with, and the lichen patterns in the boulders can be intriguing. Look for intersecting lichen rings, and if you can find three overlapping rings, work on compositions that create S curves or curvy Y shapes. There also are several seeps in the area that support small wildflower communities.

Hike 12 Skytop Lodge, Monroe County

THE FALLS

Indian Ladders

Type: two cascades	Height: 18 feet each
Rating: 3	

Leavitt Falls

Type: cascade	Height: 41 feet
Rating: 4	GPS: (privately owned, access through resort only.)
Stream: Leavitt Branch of Brodhead Creek	Lenses: 20mm to 75mm

Must be a guest at the lodge to visit the falls. Inquire at Activities Desk for hiking information.

Directions: Skytop Lodge is located on PA 390, 2.8 miles north of the intersection of PA 390 and PA 447 in Canadensis. GPS coordinates: 41° 13.728'N, 75° 14.304'W.

The management of beautiful Skytop Lodge Resort was very generous in allowing me to photograph their falls for this guide, and they are one of a handful of private landowners to do so. Standing at the crest of the Pocono Plateau, this impressive 5,000-acre private resort has been in operation for more than seventy-five years. The falls are open to lodge guests only, and although they appear on most topo maps, do not attempt to find them on your own. Rather, make a reservation to spend a couple of nights at Skytop, and take full advantage of what this world-class resort has to offer. If you want your hiking and photography to include some pampering, then Skytop Lodge is the place to come.

Indian Ladders is found along a level, meandering nature trail that passes through a pine plantation before entering a narrow valley culminating at the falls. This nature trail makes a great first-time outing for young children, and a trail brochure is available from the activities desk in the main lodge. The Leavitt Branch begins about 250 feet above the falls in a series of bogs and meadows that are fed by Lake in the Clouds, ensuring a fairly constant water supply. Indian Ladders is actually two similar-looking drops where the creek

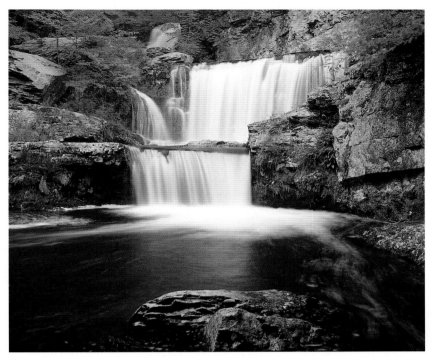

Indian Ladders. I liked these rocks, which reminded me of a Zen garden. I wet them so that they would look good on film. *Tachihara 4x5, Schneider 65mm Super Angulon, polarizer, Calumet 67 roll film back, Kodak E100VS, f/32 @ 8 sec.*

makes a twist as it falls over sandstone of the Pocono Formation. The upper drop is partially hidden from view, and is separated from the lower drop by about 30 feet. Large boulders have been placed in the lower falls' tailwater to create an expansive plunge pool that guests and residents use for wading. Two boulders that breach the surface of the pool on one side make nice foregrounds. Another large plunge sits above Indian Ladders and is accessed via a different trail.

Leavitt Falls is close to the main lodge and differs from Indian Ladders in several ways, due to a fold in the rock supporting it. A trail to Leavitt descends an incline of pale white Pocono sandstone, which confines the creek to a wide, swift-running flume sliding over long skeins of algae that undulate like yarn in a soft breeze. After making a ticklish crossing below Leavitt Falls, you'll see the reclined and intricately terraced cascade hugging a rock wall on the right side, with a large boulder slide caused by the flood of 1955 filling the left. Careful composition is required to keep this large mass of debris out of the frame. Back in the lodge, some pre-1955 photos are evidence of the dramatic changes caused by the 1955 flood, which destroyed a footbridge below the falls and washed out a wide, graded trail.

Hike 13 Tanners Falls, State Game Lands No. 159, Wayne County

THE FALLS

Type: cascade	Height: 15 feet
Rating: 4	GPS: 41° 39.698'N, 75° 17.329'W
Stream: Dyberry Creek	Lenses: 20mm to 75mm
Difficulty: easy	Distance: 50 yards
Time: 10 minutes	Elevation change: 25 feet

Directions: From the intersection of US 6 and PA 191 in Honesdale, take PA 191 north 3.8 miles to SR 4009. Turn left and drive about .3 mile, then make a hard right to continue on SR 4009. Proceed up the narrow, twisting paved road through State Game Lands No. 159 for 2.8 miles to a large road bridge where a gravel road (SR 4017) enters from the left. Turn left onto SR 4017, and drive .5 mile up the steep hill to a large parking area at a steel bridge. GPS coordinates: 41° 39.698'N, 75° 17.329'W.

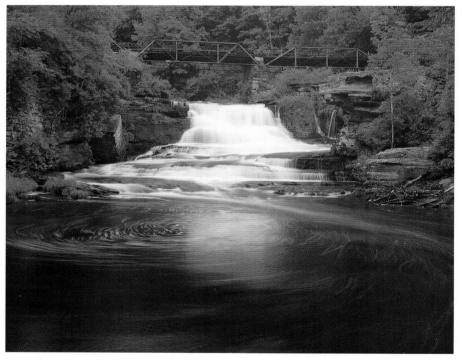

Tanners Falls. Film will often render what the eye doesn't see, and time lapse is a powerful compositional tool. I played with a number of exposures to emphasize the foam swirl in this eddy. *Tachihara 4x5, Schneider 90mm Super Angulon, polarizer, Calumet 67 roll film back, Kodak E100VS, f/32 @ 4 sec.*

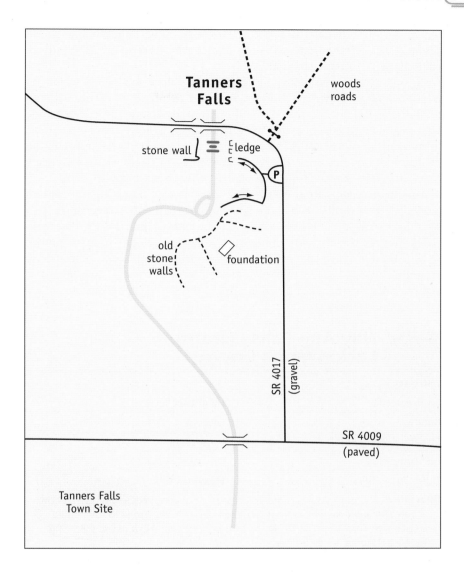

En route, you probably noticed a fairly new-looking highway sign marking Tanners Falls but couldn't locate a town. Although the town no longer exists, the sign is present to help direct hikers, hunters, and fishermen to this popular location. A village called Dyberry Falls was founded here around 1830 by mill owner Jason Torrey; it was renamed Tanners Falls in 1851. Tanning was a big business in the area, owing to a large supply of hemlocks, the bark of which supplied the tannin used in the leather-making process. Many sawmills, tanneries, and tannic acid factories lined upper Dyberry Creek in the midnineteenth century. Lumber was king, and clear-cut logging went on unchecked until Wayne County was denuded of trees in

the 1880s. With the demise of the forests, lumbering collapsed, and so did Tanners Falls. All that remains now are a few stone foundations and dry-fit walls along Dyberry Creek.

Crossed by a rickety-looking bridge, Tanners Falls is in fact the remains of a mill owned by either the Murphy or Reisler family. A dam once sat atop the falls, and water ran into the mill on the right-hand side. A long stone wall extends well downstream, and a large notch indicates where the mill's turbine once sat. The left-hand side of the falls is entirely natural, with no evidence of any masonry. Carrying the entire drainage of upper Dyberry Creek, this falls is wide, runs powerfully, and is very satisfying.

A footpath leading from the parking area passes through high brush to a large boulder near the head of the falls. Another path leads downstream to a bend in the creek that provides a wonderful view of the falls and its expansive tailwaters. Foam swirls around this bend, and an eddy near the middle traps foam in a swirl that will show up as a delightful spiral at exposures of around 1 second. Tanners Falls is a quick but very nice shoot, and the historical presence of the mill foundation adds to the fun of shooting here.

Hike 14 Nay Aug Falls, Scranton, Lackawanna County

THE FALLS

Type: cascade	**Height:** 22 feet
Rating: 4	**GPS:** 41° 24.088'N, 75° 38.375'W
Stream: Roaring Brook	**Lenses:** 20mm to 100mm
Difficulty: easy	**Distance:** .5 mile
Time: 30 minutes	**Elevation change:** 50 feet

Directions: Nay Aug Falls is located in Scranton's Nay Aug Park. From I-81, get off at Exit 184 and take the Scranton Expressway north for .7 mile to the double interchange for PA 307 north. At the bottom of the long exit ramp, follow signs for PA 307 north, Jefferson Avenue, and turn right onto Jefferson. Take Jefferson for four blocks (.4 mile), and turn right onto Olive Street. Follow Olive for .9 mile up a large hill to where it ends at the entrance of Nay Aug Park, but don't enter the park here. Instead, turn right onto Arthur Avenue, proceed two blocks, and turn left onto Mulberry to enter Nay Aug Park. Follow Mulberry to the end, about .1 mile, and make a left and then a quick right onto Nay Aug Park Road at the far end of the large parking area used by the Scranton University Hospital. GPS coordinates: 41° 23.969'N, 75° 38.513'W.

Swiftly flowing water winds its way through a narrow gorge where Roaring Brook is confined by Nay Aug Heights on one side and Moosic Mountain on the other. Nay Aug Gorge and Falls were designated a National

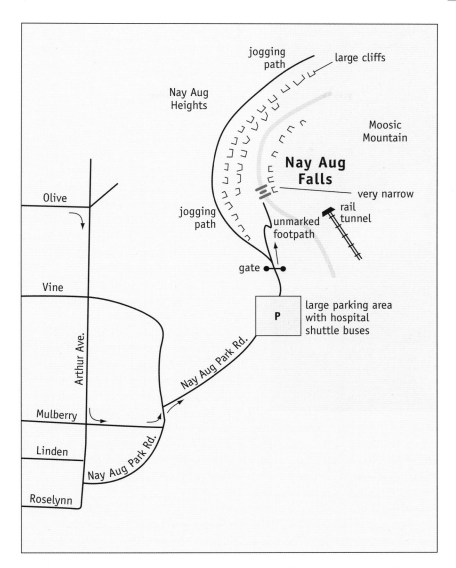

Natural Landmark in 1989. They're considered unique because Roaring Brook's perennial flow has eroded a soft underlying siltstone formation to form a gorge similar to the way the Niagara River formed its famous waterfall. In the Delaware Indian language, *Nay Aug* means "Place of the Noisy Waters," and that they are.

If you drive around Nay Aug Park's 142 acres, it's hard not to notice how uninviting the place looks in spite of all the improvements being made. This is due mainly to all the trash lying around, along with numerous police curfew signs that lend a disconcerting air. Founded in 1893, the park was a popular attraction for many years, until Scranton experienced an economic decline in

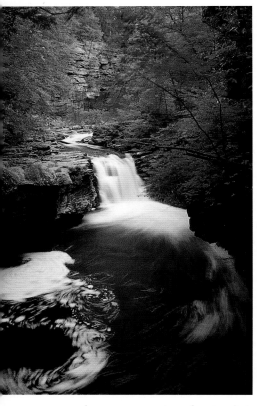

Nay Aug Falls. It's hard to tell how high the cliffs behind the falls in this image really are. Also, the foam in the foreground is almost a foot thick. *Canon EOS Rebel Xs, Tokina 20–35, polarizer, Kodak E100VS, f/8 @ 2 sec.*

the 1950s. For a time, the park even had a wooden roller coaster. Efforts to restore the park are slowly moving forward, as evidenced by the small zoo that reopened in 2003. Today the park is frequented by joggers and dog walkers, and in summer concerts are held at a bandstand in the middle of the park. A locally famous duck pond at the Everhart Museum is being restored, and Scranton's citizenry has gotten behind the effort with money and a number of volunteer programs. All in all, the future of Nay Aug Park looks bright.

From the parking area, the falls is reached by walking down a paved jogging path about 50 yards, and then turning right onto a faint footpath near a wrecked signpost. Follow the narrow woods path downslope toward the creek. It quickly becomes a series of natural stone stairs from which the falls can be heard. When the stone stairs end, proceed along the wide cliff ledges that hang above Roaring Brook to a promontory facing the falls. From here, Nay Aug Falls and its gorge are impressive indeed, and it becomes clear why they are worthy of federal landmark status.

Roaring Brook makes a wide turn above the falls, exposing beautiful tree-covered cliffs on the Nay Aug Park side, and even larger cliffs of well over 100 feet tall on the Moosic Mountain side. Though technically it's called a gorge, I think it's better defined as a canyon. A good view of the falls' unique geologic transition zone is seen at eye level to your right, where ledges overhanging from the brook's far side stand just 2 yards away. Note how the pale white conglomerate and its overlying layers are lightly folded, while the underlying siltstone layers are intensely folded and heavily fractured. Looking at the falls, observe how its tailwater slowly swirls, gathering up all the foam created by Roaring Brook's plunge into a thick mat resembling an immense latté head that sits in an eddy on the left. The falls itself drops over a fault in a thick layer of conglomerate, and the erosive action of the creek has left this layer radically undercut in several places, so watch your step.

Along the paved jogging trail above the falls are several signs marking areas where the hemlock groves lining the gorge have been treated for woolly adelgid infestations. A great deal of effort has gone into treatment, but I fear it's too little, too late. This is unfortunate, since Nay Aug Park has a bright future, and if these lovely trees lining Nay Aug Gorge are lost, they will take many years to replace.

Hike 15 Hawk Falls, Carbon County

THE FALLS

Type: cascade	**Height:** 12 feet
Rating: 2	**GPS:** 41° 0.389′N, 75° 38.029′W
Stream: Hawk Run	**Lenses:** 20mm to 70mm
Difficulty: easy	**Distance:** .6 mile
Time: 45 minutes	**Elevation change:** 60 feet

Directions: From the interchange of I-80 and PA 534 in White Haven, take PA 534 east (south) for 9.6 miles toward Tannery and Hickory Run State Park. The parking area is located just 100 yards from where the PA Turnpike (I-476) crosses over PA 534. GPS coordinates: 41° 0.638′N, 75° 38.038′W.

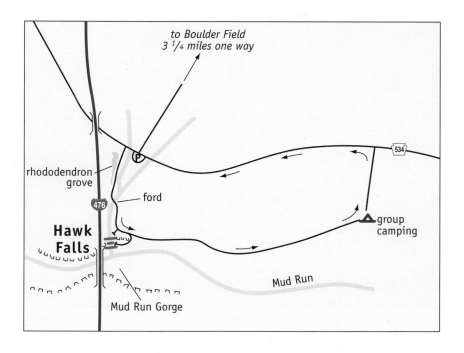

The .3-mile walk to Hawk Falls is flat and pleasant. A sign indicating the yellow-blazed trail for Hawk Falls stands near a culvert that carries PA 534 over Hawk Run. For .2 mile, the trail parallels the right-hand side of Hawk Run, which is audible over the turnpike traffic rushing along just a few dozen yards away. Rhododendrons hide the creek for the trail's whole length, and they are abundant at the falls as well. At the .2-mile point, the trail crosses Hawk Run over rocks provided for the purpose of fording, and as with all such crossings, some of these rocks will wobble or shift underfoot. The water at the ford is almost knee-deep; an extended tripod leg will help you keep your balance.

Once across, continue downstream about 100 yards to where Hawk Falls becomes audible, if it's running with any strength. When an enormous truss bridge that carries the turnpike over the Mud Run gorge comes into view, a small side trail to the falls' head diverges to the right. No clear path to the falls' base from the head exists; for that, a little flanking maneuver is needed. Continue down the yellow-blazed main trail about 50 yards to where a large depression appears on the right, along with boulders and a gray rock ledge. (You'll be more or less even with the large truss bridge.) Walk along the ledges, ducking under some overhanging rhododendrons, and follow your ears to the base of this small falls. Near where Hawk Run enters Mud

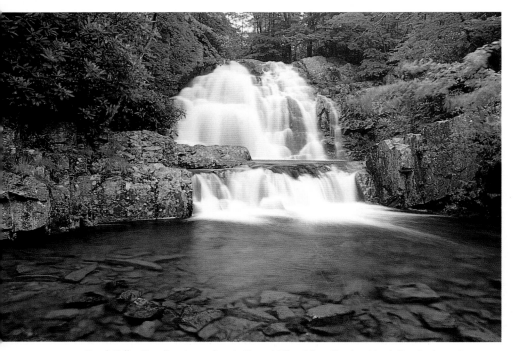

Hawk Falls. Standing in waders in the middle of fast-flowing Hawk Run is the only way to see the falls from this perspective. *Canon EOS Rebel Xs, Tokina 20–35, polarizer, Kodak E100VS, f/8 @ 1 sec.*

Run are numerous footpaths leading into Hawk Run, but they don't provide good places to shoot. The only good location is near a 3-foot drop below the falls. It's a good idea to bring waders, as it will be necessary to get well into the stream to avoid overhanging birch branches sneaking into the top edge of your photo. An easy scramble up a 5- or 6-foot rock ledge adjacent to the lower drop will place you at a large plunge pool of the falls' 12-foot main drop.

Hawk Falls is a nice shooting location, but the gorge of Mud Run is a *great* shooting location. I've been driving over the turnpike bridge for years and have always remarked at how pretty the gorge is in fall. Work Hawk and Mud Runs for all they're worth during spring runoff, rhododendron bloom, and fall foliage. If you want to extend your walk into a 1.25-mile loop, the trail continues downstream along Mud Run and loops back along the Orchard Trail, stopping at a campground just .25 mile east along PA 534.

Hike 16 Glen Onoko, Carbon County

THE FALLS

Chameleon Falls

Type: cascade	**Height:** 25 feet
Rating: 3	

Onoko Falls

Type: cascade	**Height:** 64 feet
Rating: 4	**GPS:** 40° 53.204′N, 75° 45.945′W

Hidden Sweet

Type: falls	**Height:** 15 feet
Rating: 4	**Stream:** Glen Onoko Run
Lenses: 20mm to 70mm	**Difficulty:** strenuous (steep climb, root scrambles, and blowdowns)
Distance: 1.7 miles	**Time:** 2 hours
Elevation change: 875 feet	

Directions: From the PA Turnpike (I-476) interchange at Lehighton, take US 209 south 2 miles toward Lehighton and Jim Thorpe. After crossing over the Lehigh River, turn right and continue on US 209 south 4.3 miles, passing through the historic district of Jim Thorpe, to the traffic light at US 209 and PA 903. Turn right onto PA 903, and cross over the Lehigh River again. Once across, PA 903 makes a sharp left, and .2 mile after, at a stop sign where right-turn traffic keeps moving (a small sign opposite says Glen Onoko Access), stop at the stop sign and continue straight down a steep hill. Turn left into the park, and follow the park road 1.8 miles to the parking area. GPS coordinates: 40° 53.004′N, 75° 45.617′W.

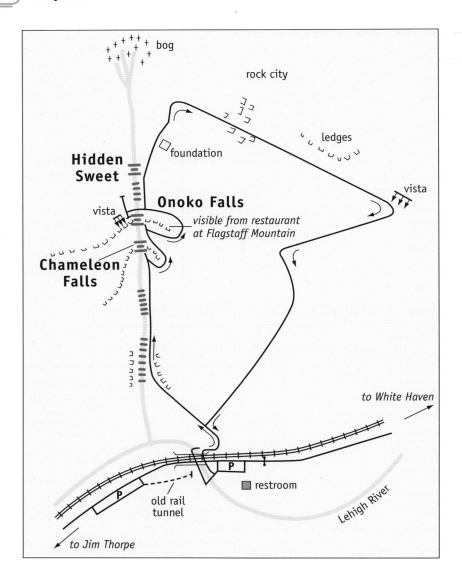

Jim Thorpe is a fun town in which to wander, eat lunch, rent a bike to ride around Lehigh Gorge, take a white-water rafting trip, play paintball, or just hang out and watch the world go by. A trip to the falls should be part of a day trip exploring the interesting, sometimes odd and tragic history of coal country.

Standing in the parking lot, it's hard to imagine that the opulent forty-seven-room Wahnetah Hotel once stood here. In the 1880s and 1890s, Glen Onoko was a popular attraction. As many as eighteen thousand visitors a day arrived by rail each weekend, with up to a million in a summer, trudging

up the glen in their Victorian finery to "take the waters" of Onoko Falls. More falls were recognized back then than could be claimed today, and they were given names like Hidden Sweet, Lovers Bath, Heart of the Glen, and Home of the Mist. The hotel saw its peak during the Victorian era and operated well after that, until it was destroyed by fire in 1911. In 1921, the ornate railroad station serving the hotel burned, and an era of genteel splendor went with it. Today Glen Onoko and the Lehigh River are the domain of hikers, kayakers, and mountain bikers.

The hike begins at the concrete stairs next to the Lehigh Gorge State Park map pedestal and picnic table. The 1.7-mile loop trail to the falls starts by descending these stairs. The Game Commission sign at the bottom reads, "Hike at your own risk. Sections of this trail are steep and treacherous." This emphatic warning is here because several people have fallen to their death over the years. Onoko Falls is not in the state park, but in State Game Lands No. 141. Very little trail maintenance is performed by the Game Commission, and several portions of the trail have been washed away over the years. Take your time, and always be aware of your footing.

At the base of the stairs, turn right and pass beneath two railroad bridges. Then turn right again, away from the river, and walk parallel to the railroad tracks to climb a small embankment straight ahead of you. Stop when you get level with the railroad tracks. At this point, you're directly opposite the parking lot, not more than 100 feet from where you began. Look around for a low stone wall with a wide trail on top that runs away from the railroad tracks. A few faint orange blazes might be found to mark the start of a 600-foot climb to the main falls. This portion of the trail is in good shape as it climbs steadily away from the Lehigh to enter Glen Onoko.

When you pass a graffiti-covered ledge on your right, beautiful Glen Onoko Run comes into view well below to the left. The trail remains somewhat level, and the run rises quickly to meet it. From where they join, the trail gets progressively worse, becoming a series of difficult rock scrambles and root climbs while clinging to the left-hand creek bank. At places you'll see remnants of stone stairs built by the Wahnetah Hotel, but their retaining walls have long since collapsed, leaving behind a trail better suited to a billy goat. Scrambling along trying not to trip forces you to keep looking down, and you may not notice how pretty this steep-sided ravine really is. Glen Onoko Run drops over numerous large boulder slides, and an argument can be made that the glen's upper section is just one immense segmented plunge, but in fact it's really five plunges, three of which are worth taking time to photograph.

Continue along the steep root-filled creek bank, and at .4 mile you'll reach the lower 25-foot cascade of Chameleon Falls. To get to the 64-foot Onoko Falls, backtrack several yards downstream and find a route to scramble up the talus slope of the left-hand bank, then turn upstream to follow the run. In about 50 yards, you come to the base of Onoko. If a chill runs up your

spine, it may not be from the cool spray emanating from the falls. Legend has it that Delaware Indian Princess Onoko's spirit can be seen gliding about the falls' base on any clear morning at 9:15. Forbidden by her father to marry her great love, the warrior brave Opachee, she ascended the highest falls of the glen, from which she could view the river valley of her homeland, and in her grief flung herself from the falls' stone precipice. Hang around a while to see if you feel anything spooky.

To experience Princess Onoko's last view of this world, more scrambling is required. Backtrack from the falls several yards, and scramble up this more navigable talus slope to where a series of ledges disappears into the hillside. Don't try climbing any of the ledges directly; go around them. Walk carefully along the well-worn, narrow ledges to where the run exits a rhododendron grove; there may be a guiding orange blaze or two, but don't count on it.

Right of where the trail meets water, the narrow run churns around several large boulders. Follow the weak flow as it glides to your left, and observe how it burbles onto a large stone slab fanning out to cover its sur-

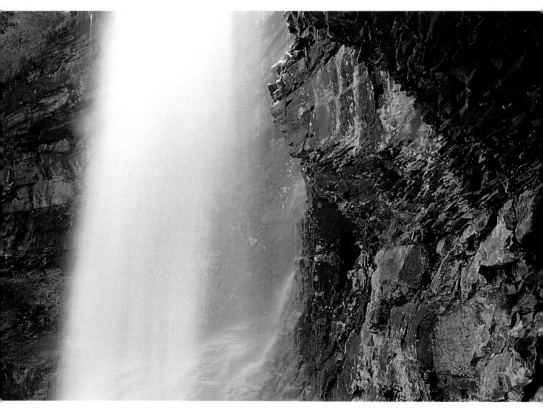

Onoko Falls. Glen Onoko is a tight area to work in, and it's not easy to shoot here. I found myself playing with graphic designs until I found this backlit veil of water. *Canon EOS Rebel Xs, Tokina 20–35, polarizer, Kodak E100VS, f/8 @ 1 sec.*

face in a thin layer of water. This slab of polished conglomerate, which tilts toward the precipice, is slicker than ice. It's also the reason for the dire warning at the trailhead: "People Have Died Here." From this vista, east Jim Thorpe can be seen, and the view is impressive, although it's painful to see so many dead or dying hemlocks that have succumbed to the woolly adelgid dotting the ridges. You may have observed that most of the large deadfalls in the glen were hemlocks; this is why.

Another vista point is just across the run; however, under no circumstances should you walk across the flat stone slab. Instead, use the boulders to cross, then return to the left-hand bank.

Proceed upstream on the left-hand bank, picking a way through the claustrophobic rhododendron grove. In about 70 yards, you come to a 15-foot falls called Hidden Sweet, which is .5 mile from the trail head. Along the way are several gaps in the rhododendrons where the creek can be accessed, and you may notice a small plunge or two. It's tight shooting, but if you have the time, these boulder drops are fun to photograph.

To finish the loop, continue upstream to .55 mile, where the steep trail levels off as it enters a grove of scrubby hemlock and pitch pine. Nearby are an open area, a Wahnetah Hotel outbuilding foundation, and a fire ring. Faint blazes appear on the trees where the path turns away from the creek, and a board with an arrow may be found guiding the way along a well-worn rock-strewn path. At .6 mile, you come to a large number of randomly spaced car-size stone blocks. This rock city is periglacial in origin, and the gray Tuscarora sandstone blocks, at more than 430 million years old, are some of the oldest exposed formations in the state.

Follow the path through the rock city, keeping an eye out for intermittent orange blazes. The trail rises slightly, with boulders and gray sandstone outcrops remaining on your left. It then begins a slow descent, leaving the rocks behind, when suddenly, at .9 mile, another vista point comes into view. Standing 886 feet above the Lehigh, this small rock outcrop provides a better view of east Jim Thorpe, with its grand flagpole rising high above town. In the distance, less than 3 miles away, the restaurant atop Flagstaff Mountain can be seen as well.

From the vista point, the trail descends steeply, becoming rather rocky as it passes through a haggard-looking forest filled with scrub oak, pitch pine, and mountain laurel. At 1.1 miles, the trail turns left and makes a few very steep switchbacks before joining with the inbound portion of the loop at 1.5 miles. Descend to the Lehigh River and pass under the railroad bridges to return to your car.

Hike 17 Bear Creek Falls, Luzerne County

THE FALLS

Type: cascade	**Height:** 34 feet
Rating: 2	**GPS:** 41° 10.011'N, 75° 44.604'W
Stream: no name, adjacent to Bear Creek	**Lenses:** 17mm to 70mm
Difficulty: easy	**Distance:** 50 feet
Time: 15 minutes	**Elevation change:** none

Directions: From the interchange of I-80 and PA 115 at Blakeslee, take PA 115 north 13.5 miles to the village of Bear Creek. Immediately before PA 115 crosses Bear Creek, turn left onto White Haven Road (SR 2041). (Signs for Francis E. Walter Reservoir mark the turn.) Follow White Haven Road for 1 mile, to where a yellowish beige split-level house sits below the road on the right. Bear Creek Falls is opposite the home's driveway, and there's parking for a few cars near the falls. GPS coordinates: 41° 10.011'N, 75° 44.604'W.

Hurricane Floyd's power to change the landscape is readily apparent at Bear Creek. Bulldozers were needed to shift the small run back into its natural course after it began flowing into the driveway across the road. From what the locals tell me, the large stone slabs clogging the plunge pool at the base of the falls dropped from above on the afternoon Floyd let loose 10 inches of rain. It must have been unnerving for the people living in the house across the road.

Bear Creek Falls is visible from White Haven Road, but save your film unless it has rained very hard in the last twenty-four hours. With a drainage area of less than 1,500 acres, this falls won't run with any power without a good rain event. The partially drained Francis E. Walter Reservoir is a more interesting photographic destination, with its stark white trees and surreal-looking landscape.

Hike 18 Seven Tubs, State Game Lands No. 292, Luzerne County

THE FALLS

Type: seven chutes and pools	**Height:** 70 feet
Rating: 2	**GPS:** 41° 10.093'N, 75° 48.670'W
Stream: Wheelbarrow Run	**Lenses:** 17mm to 70mm
Difficulty: moderate	**Distance:** .4 mile
Time: 45 minutes	**Elevation change:** 135 feet

Directions: From the interchange of I-80 and PA 115 at Blakeslee, take PA 115 north 18.8 miles past the village of Llewellyn Corners. The entrance to Seven Tubs Natural Area is on the left just after PA 115 crosses a railroad. Making the left turn can be very difficult, however, because a set of median barriers begins near the park entrance. For safety's sake, proceed downhill another 1.1 miles to the traffic light to a large corporate center on the right, turn into it, and then make a U turn in the first available parking area. Then backtrack uphill 1.1 miles to Seven Tubs and turn right, following the park road .4 mile to a parking lot on the right. GPS coordinates: 41° 14.131'N, 75° 48.635'W.

Seven Tubs appears on topo maps as either the Whirlpool or Whirlpool Canyon. Nothing so dramatic as that is found here, however. Rather, what's found is a series of small cataracts of profound subtle beauty, so much so that I ended up spending four rainy hours when I had planned to spend just one. The Tubs is open from 8 A.M. to 7 P.M. on weekends from Labor Day to Memorial Day and daily during the summer.

Seven Tubs is appropriately named, as Wheelbarrow Run runs swiftly through a small chasm and makes seven chutelike drops into seven swirling, tublike pools. None of the drops is more than 6 feet, and the tubs don't carry much water. Nevertheless, the unique nature of Seven Tubs and its ease of access and photographing

Tub #3. When shooting the Tubs, look for sweeping curves and leading lines to play with. *Canon EOS Rebel Xs, Tokina 20–35, polarizer, Kodak E100VS, f/22 @ 10 sec.*

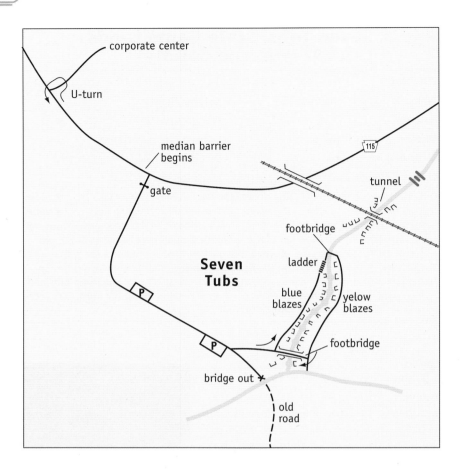

make it worth the effort. On summer weekends, it can be crowded with swimmers, so shooting is best done during cool, wet spring weekends when no one would be willing to swim. It's possible, but difficult, to photograph the shoulder-wide gorge from the ledges along the rim. To shoot from within the tubs, bring hiking sandals or water socks, swim trunks, and an insurance policy for your equipment. If you have an underwater housing for your equipment, use it.

Begin the .4-mile loop hike by walking about 100 yards along a paved, handicapped-accessible path to a 60-foot-long footbridge that crosses the run. Pause at the middle of the bridge to get a sense of what this narrow gorge has to offer. After crossing the bridge, turn right (downstream) and proceed downhill a short distance to the seventh tub. This pool is much deeper than it looks—almost 4 feet—so take care when planting a tripod.

Return to the bridge, cross back the way you came, then turn right (upstream) to follow the blue-blazed trail up a steep hill along the gorge's right-hand side. Small ledges that overhang the run can be used as shooting

perches. You can access the second tub by carefully climbing down the ledges. A small chute below this tub makes an abrupt turn, like an amusement park water slide, before disappearing into the third tub.

Continuing up the blue-blazed trail, at .1 mile you come to a steep steel stairway that descends to the creek, walk along the run for a short distance, crossing a small footbridge at .15 mile. Climb out of the creek shed, and turn right (downstream) onto a yellow-blazed trail. Proceed slowly downstream along the yellow-blazed trail, pausing often to play with all the available compositions, and at .3 mile return to the large footbridge found at the hike's beginning. Turn right to return to your car.

Hike 19 Fall Brook, Salt Springs State Park, Susquehanna County

THE FALLS

Lower Falls

Type: cascade	Height: 9 feet
Rating: 3	

Middle Falls

Type: cascade	Height: 9 feet
Rating: 3	

Upper Falls

Type: cascade and slide	Height: 6 feet
Rating: 2	GPS: 41° 54.703'N, 75° 51.901'W
Stream: Fall Brook	Lenses: 20mm to 75mm
Difficulty: easy	Distance: .6 mile
Time: 45 minutes	Elevation change: 275 feet

Directions: From I-81, take Exit 223 for New Milford. Follow signs for PA 492 west, and drive .6 mile to the intersection with US 11 at the south end of New Milford. Take US 11 south 1.2 miles to PA 706 in the village of Summit. Turn right onto PA 706, and proceed 2.6 miles to a sharp bend in the road. Do not follow PA 706 as it turns south toward Heart Lake; instead, go straight on township road T 593 toward the village of Williams Corner. Follow T 593 for 2.4 miles, passing through Williams Corner and crossing Williams Pond, then turn right onto T 670. In 1.5 miles, turn right on PA 29. Proceed north for 3 miles to the village of Franklin Forks, and turn left onto SR 4008 (a small sign for Salt Springs State Park marks the turn). Take SR 4008 west .9 mile, and then turn left onto T 601. The entrance to the park is marked with another small sign. GPS coordinates: 41° 54.703'N, 75° 51.901'W.

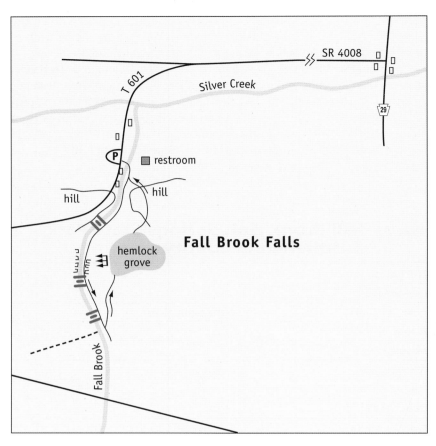

Hidden wonder or forgotten gem can be used to describe Salt Springs State Park. This is a good starter hike for kids, so bring them along. Blue-blazed Fall Brook Trail begins by crossing a small footbridge to a picnic area on the brook's right-hand side, and then turns upstream to follow a narrow footpath that hugs the right-hand bank. A broad 9-foot cascade is the first falls you encounter, just 100 yards in. Young hardwoods and softwoods line the brook's steep banks, and hemlocks cling to ledges high above. Deadfalls clog the base of this falls, and moss and ferns abound, along with odd-looking two-leaved wortlike plants I couldn't identify.

At the start of the hike, the brook exits a wide gap between two steep hills. By the time you reach the first falls, this wide gap has narrowed into a glen surrounded by impressive 60-foot-high ledges that appear almost without your noticing them. Flat sandstone forms the brook's bottom, filling it with numerous thin ledges. Careful examination of the thin ledges adjacent to the falls betrays their estuarine origin. Ripples on the tops of these flat rocks resemble the ripples that form at the bottom of a shallow pond or sandy creek bottom; these sandstone ledges were once the bottom of an

extensive river delta system called the Catskill Delta. When Europe collided with North America during the late Devonian period, between 345 and 395 million years ago, the collision gave rise to the Acadian Mountains, which stood roughly where Philadelphia is today. Rivers flowing down from them formed broad alluvial fans of fine silt and mud, which over eons consolidated into gray and red sandstone, siltstone, and shale. The Acadians were the third of four mountain ranges that formed the vast sedimentary deposits making up the Allegheny Plateau.

Safely getting over the first falls while staying dry presents a challenge. Just face the fact that getting wet is inevitable, and carefully climb an intricately terraced ledge adjacent to the falls. As you make the top of the first falls, the second 9-foot cascade comes into view. Continue ahead along the footpath, which is occasionally underwater.

The creek below the second falls is very wide and runs surprisingly deep at the edges. As with the lower falls, carefully make your way up the falls' right-hand face, taking care going over the top, because not visible from below is a large overhanging rock that's perfectly positioned to give you a large lump on the back of your head if you move too quickly.

Only 50 yards beyond the second, the third falls is found. It's actually two falls in one, with the left-hand face forming a cascade and the right a slide. A small seasonal run enters Fall Brook from the right just above the falls. A very wide, knee-deep pool sits above this falls, and it's this feature that makes Fall Brook such a popular wading spot for kids. As I made my way upstream, trying my best to keep dry, I saw mothers shepherding their happily drenched children downstream to the picnic area. When I arrived at this last falls, several youngsters were splashing around in a pool above the falls while their mothers looked on. Mud occasionally flew this way and that, and everybody looked like they were having the time of their lives. I wish I'd had a place like this to romp around in as a kid. In fact, had I known what lay at the end of my walk, I would have put on swim trunks and left my camera gear in the truck.

The creekside trail continues upstream another .3 mile to township road T 677, but there are no more falls above the third one. Instead, proceed 100 yards upstream to where the yellow-blazed Hemlock Trail joins Fall Brook Trail from the left. A carved sandstone marker indicates the left turn. Follow Hemlock Trail uphill into an impressive hemlock stand that was partially visible from the brook. In overcast light, mist, or fog, this hemlock grove will render beautifully on film. In fact, if you ever encounter fog here, don't bother with the falls; shoot the hemlock grove instead. Hemlock Trail is curbed by branches and deadfalls, so do not leave it.

At about .4 mile, you come to a boardwalk trail segment leading to a viewing platform that provides a view of the deep glen between the lower and middle falls. Pine scent fills the air, and the scene looking down is one of quiet beauty enhanced by white noise emanating from Fall Brook—quiet, that is, until another troop of boisterous youngsters starts splashing along the creek.

Hike 20 Ricketts Glen, Ricketts Glen State Park, Luzerne County

*Note—Falls are listed north to south in the correct glen and match up with the park map. They do not appear in order in which they are hiked.

THE FALLS

Mohawk Falls (Ganoga Glen)

Type: falls-over-slide	Height: 37 feet
Rating: 2	GPS: 41° 19.655', 76° 17.23'

Oneida Falls (Ganoga Glen)

Type: falls	Height: 13 feet
Rating: 3	GPS: 41° 19.605', 76° 17.23'

Cayuga Falls (Ganoga Glen)

Type: cascade	Height: 11 feet
Rating: 1	GPS: 41° 19.588', 76° 17.23'

Ganoga Falls (Ganoga Glen)

Type: cascade	Height: 94 feet
Rating: 5	GPS: 41° 19.505', 76° 17.113'

Seneca Falls (Ganoga Glen)

Type: slide	Height: 12 feet
Rating: 2	GPS: 41° 19.488', 76° 17.08'

Delaware Falls (Ganoga Glen)

Type: slide	Height: 37 feet
Rating: 3	GPS: 41° 19.480', 76° 17.063'

Mohican Falls (Ganoga Glen)

Type: slide-over-slide	Height: 39 feet
Rating: 3	GPS: 41° 19.338', 76° 17.063'

Conestoga Falls (Ganoga Glen)

Type: slide	Height: 17 feet
Rating: 2	GPS: 41° 19.271', 76° 16.93'

Tuscarora Falls (Ganoga Glen)

Type: cascade-over-falls	Height: 47 feet
Rating: 4	GPS: 41° 19.270', 76° 16.78'

Erie Falls (Ganoga Glen)

Type: cascade	Height: 47 feet
Rating: 3	GPS: 41° 19.205', 76° 16.596'

Onondaga Falls (Leigh Glen)

Type: cascade	Height: 15 feet
Rating: 2	GPS: 41° 19.871', 76° 16.43'

F. L. Ricketts Falls (Leigh Glen)

Type: slide	Height: 38 feet
Rating: 3	GPS: 41° 19.771', 76° 16.43'

Shawnee Falls (Leigh Glen)

Type: falls-over-falls	Height: 30 feet
Rating: 2	GPS: 41° 19.671', 76° 16.43'

Huron Falls (Leigh Glen)

Type: slide	Height: 41 feet
Rating: 3	GPS: 41° 19.605', 76° 16.48'

Ozone Falls (Leigh Glen)

Type: cascade	Height: 20 feet
Rating: 4	GPS: 41° 19.538', 76° 16.48'

R. B. Ricketts Falls (Leigh Glen)

Type: cascade-over-cascade	Height: 36 feet
Rating: 2	GPS: 41° 19.455', 76° 16.43'

B. Reynolds Falls (Leigh Glen)

Type: falls	Height: 40 feet
Rating: 5	GPS: 41° 19.404', 76° 16.48'

Wyandot Falls (Leigh Glen)

Type: falls	Height: 15 feet
Rating: 2	GPS: 41° 19.338', 76° 16.48'

Harrison Wright Falls (Ricketts Glen)

Type: falls	Height: 27 feet
Rating: 5	GPS: 41° 19.288', 76° 16.513'

Sheldon Reynolds Falls (Ricketts Glen)

Type: falls-over-cascade	Height: 36 feet
Rating: 4	GPS: 41° 19.205', 76° 16.48'

Murray Reynolds Falls (Ricketts Glen)

Type: chute	Height: 16 feet
Rating: 3	GPS: 41° 19.104', 76° 16.463'

Shingle Cabin Falls (Ricketts Glen)

Type: cascade	Height: 25 feet
Rating: 1	GPS: 41° 18.957', 76° 16.376'

Kitchen Creek Falls (Ricketts Glen)	
Type: falls	**Height:** 9 feet
Rating: 1	**GPS:** 41° 17.955', 76° 16.43'

Adams Falls (Ricketts Glen)	
Type: chute	**Height:** 36 feet
Rating: 5	**GPS:** 41° 17.904', 76° 16.379'
Stream: Kitchen Creek	**Lenses:** 20mm to 100mm
Difficulty: strenuous; many steep stair climbs	**Distance:** 8.2 miles for the entire falls trail
Time: 5 to 6 hours for entire trail	**Elevation change:** 1,240 feet

Directions: From Williamsport, take US 180 east to Muncy, and exit onto PA 405 north. Take PA 405 north into Hughesville, and follow signs for PA 118 east. Take PA 118 east for 24.6 miles to the PA 487 intersection at Red Rocks. To get to the lower parking area, proceed another 1.6 miles east on PA 118. To get to the visitor center and upper parking lots, turn left onto PA 487 north, drive up the steep grade for 3.4 miles, and turn right into the park.

From the Bloomsburg area, exit I-80 onto PA 487 north, taking it 23 miles to PA 118. Merge onto PA 118 east, and go 1 mile to the village of Red Rocks. To get to the lower parking area, proceed another 1.6 miles east on PA 118. To get to the visitor center and upper parking lots, turn left onto PA 487 north, drive up the steep grade for 3.4 miles, and turn right into the park.

From Wilkes-Barre, take US 309 north to PA 415 in Dallas. Bear left onto PA 415 north and proceed about 2 miles, then turn left onto PA 118 west. Continue for 16.4 miles to the lower parking area. To get to the visitor center and upper parking lots, continue 1.6 miles past the lower parking area to the village of Red Rocks. Turn right onto PA 487 north, drive up the steep grade for 3.4 miles, and turn right into the park. GPS coordinates: PA 118 parking, 41° 17.965'N, 76° 16.490'W; Lake Jean parking, 41° 20.335'N, 76° 16.775'W; Lake Rose parking, 41° 19.781'N, 76° 17.463'W.

R icketts Glen almost became a national park, but World War II ended the plan. The central portion of Ricketts Glen was sold to the state by the Ricketts family in 1942, and additional land sales in 1943 and 1949 brought the park to near its current size. First discovered by fishermen in 1865, Ricketts Glen has thrilled hundreds of thousands of visitors every year since it opened to the public in 1944.

Because there's so much to see and do at Ricketts Glen, time management is always an issue, but the park can be broken into several bite-size chunks to make it easier to photograph. Whether you have several days or just a couple hours, Ricketts Glen is *the* place to photograph Pennsylvania waterfalls. Combined with nearby State Game Lands No. 13, this small portion of Luzerne County has the highest concentration of waterfalls in the entire state.

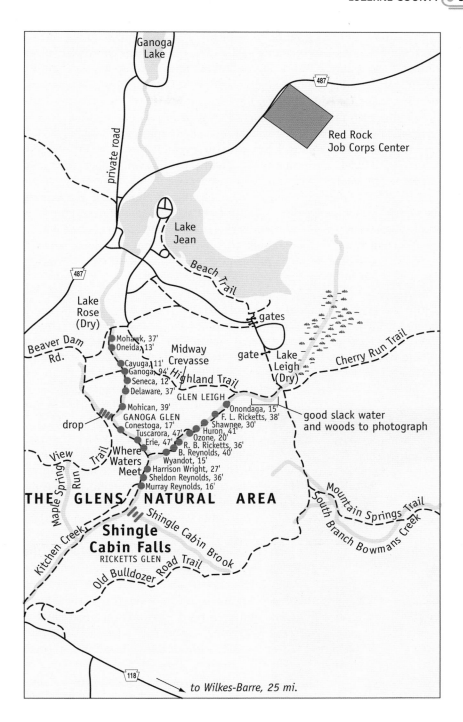

Ganoga
Lake

private road

487

Red Rock
Job Corps Center

Lake
Jean

Beach Trail

487

Lake
Rose
(Dry)

gates

gate Lake
Leigh
(Dry)

Cherry Run Trail

Beaver Dam
Rd.

Mohawk, 37'
Oneida, 13'
Cayuga, 11'
Ganoga, 94'
Seneca, 12'
Delaware, 37'

Midway
Crevasse

Highland Trail

GLEN LEIGH

Mohican, 39'
GANOGA GLEN
Conestoga, 17'
Tuscarora, 47'
Erie, 47'

drop

Onondaga, 15'
F. L. Ricketts, 38'
Shawnee, 30'
Huron, 41'
Ozone, 20'
R. B. Ricketts, 36'
B. Reynolds, 40'
Wyandot, 15'
Harrison Wright, 27'
Sheldon Reynolds, 36'
Murray Reynolds, 16'

good slack water
and woods to photograph

View Trail

Where
Waters
Meet

Maple Spring Run

THE GLENS NATURAL AREA

Mountain Springs Trail

South Branch Bowmans Creek

Shingle
Cabin Falls
RICKETTS GLEN

Shingle Cabin Brook

Kitchen Creek

Old Bulldozer Road Trail

118

to Wilkes-Barre, 25 mi.

If you have only an hour or so available, I recommend shooting Adams Falls, located at the lower parking area on PA 118, 1.6 miles east of the village of Red Rock. Stairs lead to a large stone platform that provides a shooting perch looking straight into the falls' 36-foot chute. Adams Falls is a narrow, twisting falls that ends at large, flat rock. At low flow, the tailwater exits around this slab to your left; at high flow, it covers the entire slab in a clear laminar curtain. It's possible to shoot the falls from below by wading across the fast-flowing Kitchen Creek to set up on several flat rocks on the opposite bank. If the creek is running up to the knees, however, a deep whirlpool (Leavenworth Pool) makes setting up a camera on the rocks too risky.

Having half a day gives you just enough time to photograph the falls on the upper portion of Ganoga Glen. Park at Lake Rose and descend the Falls Trail to Delaware Falls, and then work your way back up, shooting as you go. This makes for a 1.2-mile round-trip with a 230-foot elevation change. A downhill speed hike allows ample scouting time with a leisurely return pace. Leave yourself sufficient time to shoot Ganoga Falls.

If you have a whole day, shoot the upper loop of the Falls Trail, beginning with Glen Leigh. It's about a 3-hour hike, but it will take more like eight hours to shoot, so plan accordingly. Park at Lake Jean and hike the strenuous 5-mile loop going all the way down to Murray Reynolds Falls below Where Waters Meet. Use the Highland Trail on the return to Lake Jean. With two cars, one at each parking area, the hike can be shortened by 1.5 miles.

Should you be planning a trip to Ricketts Glen, I recommend allowing at least three full days in the park. On day one, bring a notebook and scout the 8.2-mile Falls Trail. Spend day two shooting Glen Leigh and then driving down to Adams Falls. On day three, shoot Ganoga Glen all the way to Murray Reynolds Falls. If time allows, another good location is Wild Fowl Pond, shown at the upper right of the park map.

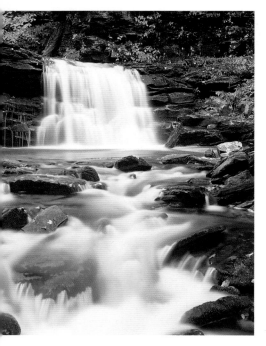

Here's how I recommend doing the entire Falls Trail. Begin the Falls Trail at the large paved Lake Jean lot. Walk back along the main road for about 100 yards, and turn left onto a wide gravel road passing the rental cabins. At .7 mile, the trail makes a sharp right turn to follow the Glen Leigh

Cayuga Falls. I put my 4x5 as close to the water as I dared in order to emphasize the foreground. *Tachihara 4x5, Schneider 90mm Super Angulon, polarizer, Kodak ReadyLoad Holder, Kodak E100VS, f/32 @ 8 sec.*

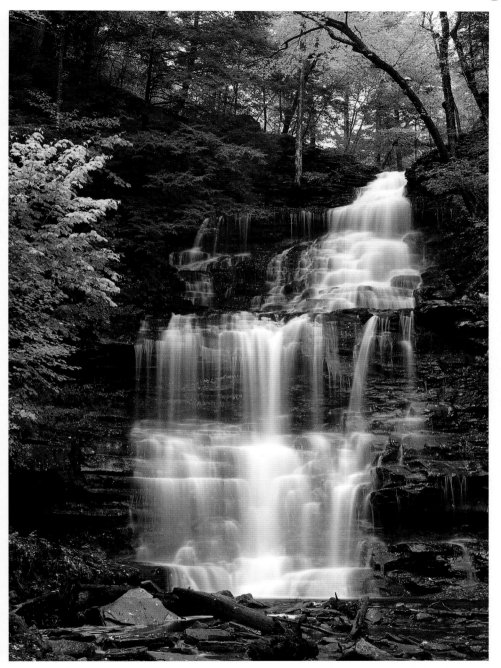

Ganoga Falls. Shot just ten days after Hurricane Floyd, this was the first weekend that the Falls Trail was reopened. Big rain events make for good waterfall photography. *Tachihara 4x5, Schneider 150mm Super Angulon, polarizer, Kodak ReadyLoad Holder, Kodak E100SW, f/32 @ 8 sec.*

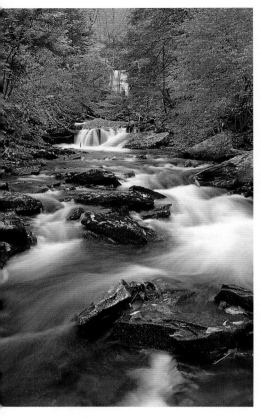

Erie Falls. I climbed into the creek just upstream of the Where Waters Meet footbridge, and rock-hopped around until the water and partially hidden falls looked to be balanced. *Canon EOS Rebel Xs, Tokina 20–35, polarizer, Kodak E100VS, f/22 @ 4 sec.*

Branch of Kitchen Creek. Here the creek is broad, running slowly through stands of hemlock and fir. The dark, tannin-filled water burbles softly around downed trees, becoming gradually darker as it goes. At 1 mile, the Falls Trail intersects the Highland Trail, which will be your return. Bear left and continue downhill.

Now within sight of the first falls at 1.04 miles, the creek has changed character entirely. No longer a babbling upland brook, the creek dives headlong down Glen Leigh in a series of glorious plunges, the first of which is the 15-foot cascade of Onondaga Falls. As the water makes its plunge, it turns slightly over the thin lamina of red rock for which the mountain and nearby village are named. Wider at the bottom than the top, the water fans out evenly before being gathered again by steep ledges lining the creek. The smooth-flowing tailwaters meander around numerous cobbles that provide a nice shooting location.

Next up, at 1.14 miles, is the long slide of 38-foot F. L. Ricketts Falls. This falls is a series of evenly spaced steps with roughly the same pitch as a flight of stairs. A tree trunk is stuck in the falls' slide, held in place by a logjam; this looks good on film only when it's wet.

Continuing to 30-foot Shawnee Falls at 1.26 miles, the trail has now descended 317 feet from the parking area. Shawnee is a falls-over-falls configuration, and it has a large plunge pool choked by debris that heads a narrow chute above 41-foot Huron Falls. Huron is a slide with a 90-degree turn so that the arc of the falls is visible from midstream. Ledges and cliffs above are very impressive, with their many thin layers of uniform red and gray Huntley Mountain Formation sandstone. Looking up at Huron and Shawnee from below makes one wonder whether the two were a single falls at some point. I think they were, and what an impressive sight it must have been.

Ozone Falls is at 1.42 miles, and this large cascade is bigger than the 20 feet indicated on the park map. Ozone leaps from atop a series of ledges as a

narrow horsetail that slowly expands into a wide veil. The small plunge pool below has several ledges that provide plenty of foreground options.

At 1.53 miles, a small but exceedingly pleasant cascade is found in R. B. Ricketts Falls, which is not 36 feet tall; I think the map has the heights of this and Ozone reversed. Several large deadfalls blanketing the face of the cascade make shooting this falls all but impossible. A hanging garden blankets one side of the glen, and I find it more fun to photograph than the falls.

The next falls is B. Reynolds, and this is one of my favorites. A nice shooting location is from near a tree where the falls can be set against a dark background formed by the ledges opposite. In minimal flow conditions, this falls is a thin horsetail that plunges over the far edge, requiring a 10-second exposure to fill in the arc. At high flow, the entire face of the plunge is full. In fall, yellow leaves contrast brightly against the black rocks of the falls' base. Regardless of season or flow, careful composition is mandatory to keep a yellow B. Reynolds sign out of frame.

After a descent of 615 feet, Wyandot Falls is found at 1.68 miles. Unfortunately, this 15-foot true falls is currently unshootable because of a large beech tree that dropped over the falls' face during heavy rains in June 2003.

At 1.77 miles, you cross a well-built footbridge leading to a long bench at Where Waters Meet. Take a seat, eat a snack, and take some time to look around at the glorious surroundings. The Glens Natural Area became a registered National Natural Landmark in October 1969, and Where Waters

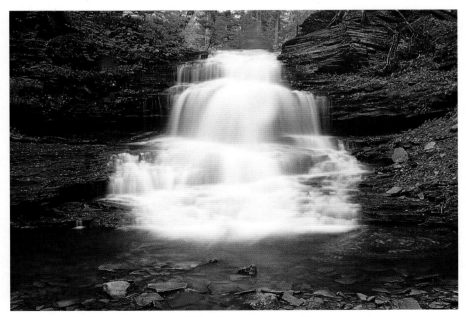

Onondaga Falls. There are many possibilities here beyond a traditional portrait shot. Move back and look for leaf-covered rocks to anchor the foreground. *Canon EOS Rebel Xs, Tokina 20–35, polarizer, Kodak E100VS, f/16 @ 6 sec.*

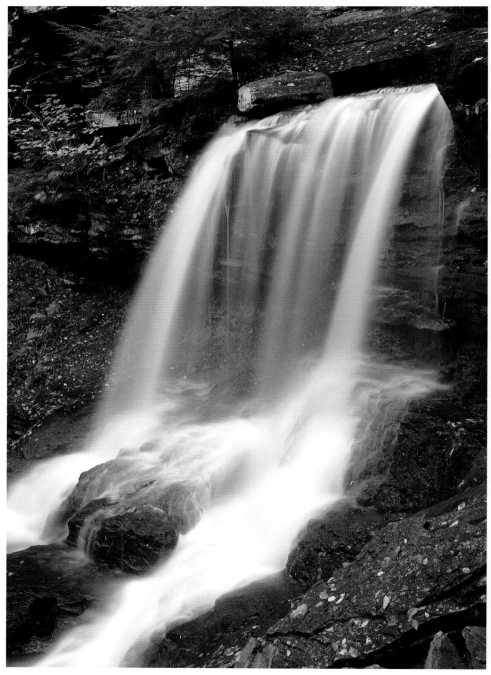

B. Reynolds Falls. Whenever I'm in Ricketts Glen, I'm always drawn to this falls. It's very special somehow. *Tachihara 4x5, Schneider 90mm Super Angulon, polarizer, 81A warming filter, Kodak ReadyLoad Holder, Kodak E100SW, f/32 @ 8 sec.*

Meet is its heart. From Where Waters Meet, both Wyandot and Erie Falls are visible upstream.

If you wish to abbreviate your hike, head up Ganoga Glen toward Erie Falls. But if you do so, you'll miss one of the best falls in the park, 27-foot Harrison Wright Falls. Walk downstream from Where Waters Meet, descending steep stairs to view perhaps the most photogenic falls in the park. Hard sandstone caprock over softer shale forms an even curtain of water, creating a wide and picturesque falls. Below the falls is a large and easily accessible gravel bar, which makes a good shooting location. Even in calm air, however, the glen's shape funnels surprising amounts of spray a good distance from the falls, so take care to keep your optics dry.

Continue downstream a short distance to Sheldon Reynolds Falls. At 36 feet, it is higher than Harrison, but its shape makes it harder to get a good image. This falls also carries a tremendous amount of spray when winds are from the north. From below the falls, look well above and to the right of the falls' head for some sandstone ledges about 70 feet up, and consider how big this falls may have been. It's always fun to look around at a glen's ledges to try to find ancient waterfall precipices. The headwall of a glen typically forms a smooth arc of stone similar to a band shell or a parabola. An ancient waterfall precipice will appear as an imperfection in this headwall, looking like a brick missing from atop an old wall. In this case, there's a scalloped imperfection in the headwall to the right of the falls.

About 2 miles from the parking area is the last falls in the upper section of the park: Murray Reynolds. Kitchen Creek corkscrews its way down the narrow chute, spreading into a wide curtain as it strikes a stone slab in the last 2 feet. The deep plunge pool is a favorite wading spot, but I don't encourage this sort of activity in Ricketts Glen. A gravel bar below the falls is a good shooting location, but it's difficult to get to without waders or a willingness to get very wet. It's difficult to see the falls' narrow chute from the trail, and peering over the falls' head doesn't provide a clear view either.

At this point in the hike, you've descended 739 feet down the front of the Allegheny Plateau through a geologic layer cake of sediment about 370 million years old. Most of the descent has been since Onondaga Falls, which is only a mile away. Continuing downstream to PA 118 at 3.4 miles, there are no other waterfalls except for a partial view of Shingle Cabin Falls on the bank opposite the trail. This falls marks the point where the small Shingle Cabin Creek drops into Kitchen Creek over a 25-foot cascade. Shingle Cabin is a small seasonal creek that's just .9 mile long and runs only after a good rain. The view of the falls is shrouded by large trees; the only way to get an unobstructed view is to ford a shallow spot in Kitchen Creek below Shingle Cabin. This is worth the effort only if you have nothing else on the agenda.

Along the 1.3-mile section from Murray Reynolds to PA 118, not much happens. Two trail options are given: staying above the creek or following it. At around 2.8 miles, the trail descends to rejoin the creek, and here some enor-

mous trees are found. In spring, you'll hear the deafening trill of spring peepers, and in summer, the gentle murmur of wood frogs. Dozens of species of birds flit among the trees, and the lilting tones of a natural orchestra surrounds you. Occasionally the scream of a belted kingfisher shatters the air as it flies up the wide, cobble-filled creek. Although the waterfalls are what draw the multitudes, this last mile of trail draws the birders and naturalists. This is a wonderful area to shoot woodland scenes and intimate landscapes.

Finally, Kitchen Creek Falls is encountered at 3.4 miles, where the creek drops over a ledge before passing under the PA 118 highway bridge. Cross the road to examine the 36-foot drop of Adams Falls, and then begin the return up Kitchen Creek, stopping again at Where Waters Meet, which is at the 5.1-mile mark. Bear left up Ganoga Glen to reach Erie Falls at 5.2 miles. Erie Falls is a 47-foot cascade formed where the glen narrows above Where Waters Meet. Don't attempt to get down into the creek to shoot this falls. There's been too much human impact here as it is. Stick to the trail, and shoot from near the log revetments reinforcing it. This narrow trail section tends to get clogged with photographers, and you may have to be patient. Stairs ascending the falls' right-hand side are rather narrow and slick. An overhanging rock near the top will whack the noggin of anybody over 6 feet tall who neglects to look up.

Between Erie Falls and Tuscarora Falls, the creek follows the trail's steep pitch. Numerous slides, drops, and burbles culminate in the 47-foot cascade over the plunge of Tuscarora Falls. The base of the falls is easily accessed using a rockslide.

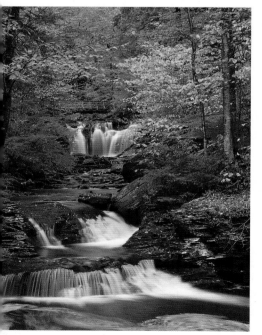

Next up is Conestoga Falls, which is a 17-foot slide that's not particularly photogenic. The stream's tight configuration makes it difficult to shoot anyway, so it's best to bypass this small chute and continue upstream to 39-foot Mohican Falls. Climbing above Conestoga, observe how the glen has widened as quickly as it narrowed below. Here the narrow glen has become a flat-bottomed valley, and the stream slopes less than it did before, now being filled with cobbles rather than ledges. Continuing forward, the glen begins to nar-

Wyandot Falls. As I was sitting on the bench at Where Waters Meet, this scene begged to be shot. Begin shooting a falls from well back, then work closer. Sometimes what you see first is the best. *Tachihara 4x5, Schneider 150mm Super Angulon, polarizer, Calumet 67 roll film back, Kodak E100VS, f/32 @ 4 sec.*

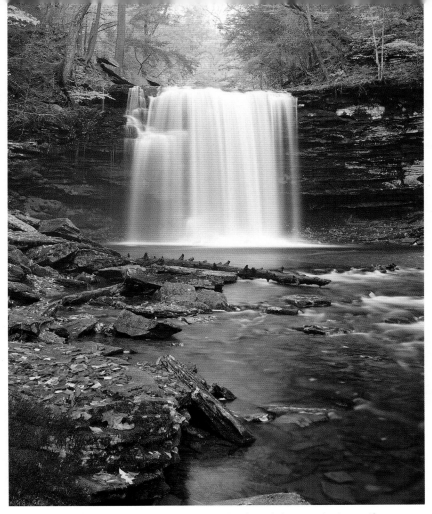

Harrison Wright Falls. In fall, keep tight to the bank, and dampen the leaves if you can—they'll look better on film. Add some darker leaves if you can find them, which will tone down the foreground a bit as well. *Tachihara 4x5, Schneider 150mm Super Angulon, polarizer, Kodak ReadyLoad Holder, Kodak E100VS, f/22 @ 4 sec.*

row again near a footbridge that carries the trail over a seasonal run that drains bogs and swamps south of Lake Rose just .6 mile away. Mohican Falls is a 39-foot slide-over-slide arrangement. It's almost impossible to get a good view of both drops except from the middle of the creek near the lower slide. Spray will dampen such a venture, and water coursing around your tripod legs will create just enough vibration to blur a long exposure. The best image here is an environmental shot from the trail in autumn.

From Mohican to Delaware Falls, the trail rises 150 feet. Delaware Falls is actually easy to miss, despite being 37 feet high. Kitchen Creek slides through a narrow chute into a crevasse that hides Delaware Falls. The same is true of Seneca Falls' 12-foot slide. I've walked past this falls many times

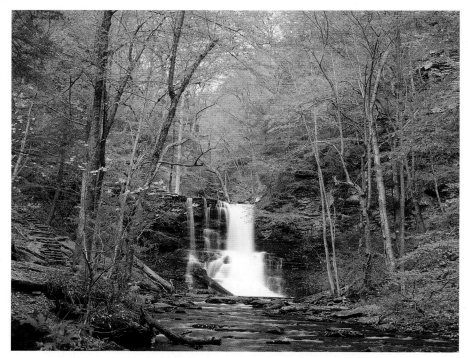

Murray Reynolds Falls. Although it doesn't appear that way, the camera was checked with a level. When fall foliage looks good, tilt up and add trees to the image, being careful of highlights above the falls. *Tachihara 4x5, Schneider 90mm Super Angulon, polarizer, Kodak ReadyLoad Holder, Kodak E100VS, f/32 @ 5 sec.*

without realizing it. One way to know you've walked by Seneca is to see Ganoga Falls come into view. It's best to bypass both these hidden falls and proceed rapidly up the trail, which clings to narrow ledges that hang over Seneca's frothing chute.

Just above Seneca is the park's crown jewel, the 94-foot wedding cake cascade of Ganoga Falls. Now 5.8 miles into the hike, it's probably time to sit for awhile anyway, and it's a good thing there's such a spectacular subject to relax with. Kitchen Creek makes a little twist near the falls' head, which causes the apparent size and shape of the falls to change with your perspective. From the middle of the creek, the head of the falls appears narrow and the cascade appears to widen as it falls. From the trail, the falls appears uniform in width. No matter where you stand, this is a glorious spot to photograph and have a picnic. Spray from the falls is refreshing in the summer heat, and bathers gather at a large hemlock near the falls. With or without people on it, this hemlock is a compositional challenge that can be cropped out by getting as close as you can while still remaining dry.

Shoot as much film at Ganoga as you can afford, beginning well below the falls and then gradually getting closer. Nearer the falls, the creek is wide

and shallow, and both creek banks can be worked comfortably. If you have a hiking partner who's willing to get wet, place him or her near the base of the falls to provide a sense of scale. When you're done shooting from the base, follow the trail about halfway up the falls and look for a side trail that leads to the falls' face. This spot provides a good location from which to shoot graphic patterns of water tumbling down the falls' stairlike ledges. There's also a spot farther up the trail that provides a view of the cascade through a gap in the trees. This shot makes a nice fall foliage image, with the bright yellow leaves standing out against Ganoga's dark face. Ganoga is a subject that changes constantly as you move around it, and if you can afford to spend a couple hours here, do it.

Cayuga Falls sits above Ganoga, and this 11-foot cascade just isn't photogenic. The 13-foot true falls of Oneida is, however, and very much so. Oneida is a fun little falls to shoot, and a deep undercut creates a nice, even veil of water. Stone ledges surrounding the falls are covered in fern and shrubs, which contrast nicely with the dark rocks near the falls. The trail waters are easily accessed, and numerous rocks provide comfortable shooting perches to work from. This is a fun spot to take a really wide-angle lens, such as a 17mm, and place it just inches from the foreground to make water burbling around the rocks look larger than the falls itself.

The last falls on your journey is Mohawk, which is difficult to get on film because this 37-foot falls-over-slide arrangement is really just a 9-foot falls with steeply descending, boulder-choked tailwaters. Even when falls downstream are running with exceptional power, Mohawk always appears to be just a vigorous trickle. I wouldn't bother trying to shoot it. Above Mohawk, the trail is very steep, and in places it can be quite slick before leveling off near the wide, dark brook that drains from Lake Rose.

A few hundred yards from Mohawk, the trail crosses the creek on a wide footbridge. Continue to follow the well-trodden path, and turn right at 6.25 miles onto the Highland Trail. After spending several hours so close to Kitchen Creek's roar, the quiet hemlock grove atop the plateau can seem almost painful to the ear. Rustling trees announce the approach of small breezes many seconds before you feel them. The odor of pine permeates the air, and in the damp, these hemlocks smell especially fine. Descending slightly, the trail crosses a seasonal run at 6.5 miles, and Midway Crevasse is encountered at 6.7 miles.

Midway Crevasse is a narrow passage through large blocks of Pocono sandstone, which, at a mere 325 million years of age, are the youngest rocks to be found on your hike. Frost wedging from an extremely cold climate along the Wisconsin ice sheet's glacial margin split the sandstone and conglomerate into large blocks, which migrated downslope due to soil creep. It's hard to imagine that mere soil could drag these blocks around, but given many thousands of freeze-thaw cycles and an immense time scale, anything can happen. The slabs and blocks south of the crevasse were 100 feet higher

up the ridge between ten and twenty thousand years ago. To determine whether the blocks are continuing their downhill trek, look for trees, lichens, and root networks surrounding them. Undisturbed tree communities are a good indicator that today nothing is wandering around.

The unblazed Highland Trail connects with the Falls Trail at 7.25 miles. Turn left and proceed up the wide gravel road back to the paved road, and then turn right, returning to the Lake Jean parking lot at 8.2 miles. On your hike, you have passed twenty-five waterfalls, of which twenty-four have names. You have descended and ascended a total of 1,240 feet and traveled through more than 350 million years of earth's geologic history. All in all, a great way to spend the day.

Hike 21 Sullivan Run, State Game Lands No. 13, Sullivan County

THE FALLS

Sullivan Falls

Type: cascade	Height: 34 feet
Rating: 5	GPS: 41° 20.096'N, 76° 20.495'W

Bear Run Falls

Type: cascade	Height: 11 feet
Rating: 2	GPS: 41° 20.028'N, 76° 20.107'W

Pigeon Falls

Type: falls	Height: 22 feet
Rating: 3	GPS: 41° 20.507'N, 76° 20.113'W

Ore Run Falls

Type: cascades and slides	Height: 23 feet
Rating: 2	GPS: 41° 21.097'N, 76° 20.527'W

Fifth Falls

Type: cascades and slides	Height: 50 feet
Rating: 4	GPS: 41° 20.992'N, 76° 20.520'W

Sixth Falls

Type: falls over cascade	Height: 13 feet
Rating: 2	GPS: 41° 20.816'N, 76° 20.459'W

Hunts Run Falls

Type: cascade over falls	Height: 30 feet
Rating: 2	GPS: 41° 20.704'N, 76° 20.452'W

Eighth Falls	
Type: cascade	**Height:** 12 feet
Rating: 3	**GPS:** 41° 20.646'N, 76° 20.405'W

Ninth Falls	
Type: cascade	**Height:** 9 feet
Rating: 2	**GPS:** 41° 20.605'N, 76° 20.376'W

Tenth Falls	
Type: slide	**Height:** 8 feet
Rating: 2	**GPS:** 41° 20.543'N, 76° 20.300'W

Stream: Sullivan Branch of the East Branch of Fishing Creek

Lenses: 20mm to 70mm

Difficulty: easy to Pigeon Falls, strenuous beyond, with many steep and potentially hazardous scrambles

Distance: 3 miles	**Time:** 4 hours

Elevation change: 560 feet

Directions: From the Ricketts Glen State Park visitor center along PA 487, proceed north on PA 487 for .3 mile to the Y intersection of Bear Run Road and Ganoga Road. Make a hard left onto the sometimes steep gravel Bear Run Road, and proceed 2.1 miles to a game lands parking area on the right side of the road. GPS coordinates: 41° 20.043'N, 76° 20.420'W.

Bear Run Road may give the impression that you need an SUV, but it's fine for passenger cars, as the residents of Central and Jamison City use it to detour around the village of Red Rocks. On the way down, you passed Bear Run Falls on your right, just after the road crossed the run. This 11-foot cascade is not accessible from the roadside pullout.

To get to Sullivan Falls, follow the wide footpath straight out the back of the parking area; it's only a 200-foot walk to the falls' head. A well-defined footpath switchbacks down to the falls' large bluegreen plunge pool. Once at the falls' base, look up and see how the gray sandstone ledges form a wide amphitheater. This gray sandstone from the upper Catskill Formation covers red sandstone and shale of the lower Catskill Formation, which is typical of many falls that drop over the front of the Allegheny Plateau. The reddish rocks at the falls' base are some of the oldest in the area, dating to more than 300 million years ago. A midstream gravel bar makes a nice shooting location, as do the bases of two birches near the pool. When you're done shooting Sullivan Falls, it's time to head up Sullivan Run.

There are two routes to Pigeon Falls. The first is to walk straight up the creek shed from Sullivan Falls. Although a moderate and damp walk, this section of Sullivan Run is incredibly beautiful and photogenic. In fact, I

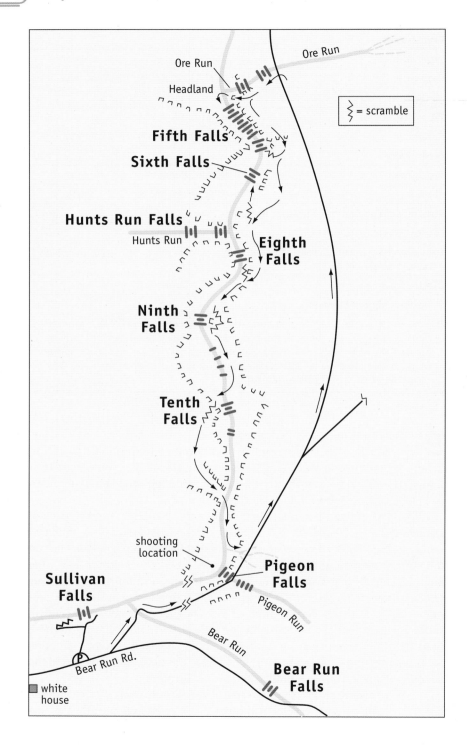

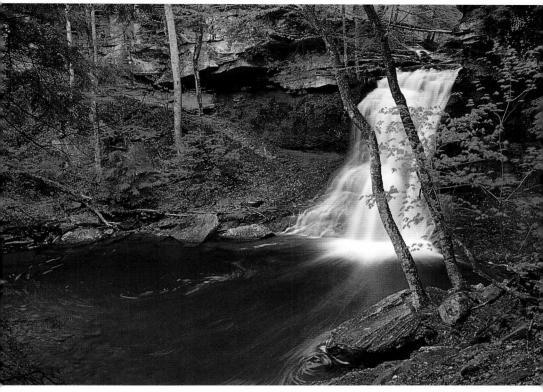

Sullivan Falls. The plunge pool is aqua green when seen from above. *Canon EOS Rebel Xs, Tokina 20–35, polarizer, Kodak E100VS, f/16 @ 6 sec.*

would go so far as to say it's the prettiest stream in Pennsylvania. The second, and drier, route is to follow an old woods road that parallels the creek all the way to the Pigeon Falls.

If you choose the dry approach, from the Sullivan Falls parking area, turn left and walk up Bear Run Road about 40 yards to what appear to be two more parking spots. This is the point where an old woods road joins Bear Run Road. The first few yards are overgrown, but you'll quickly come to a well-trodden path. Shortly after entering the woods, the path turns to the right, and several dozen yards ahead, it crosses Bear Run. To visit Bear Run Falls first, cross here and turn upstream, keeping to the creek as much as possible. After the trail crosses Bear Run, it rises slowly, remaining above the creek until it crosses Pigeon Run just above Pigeon Falls.

At .18 mile, the trail enters a field carpeted with ferns and diverts around a large, blown-down pine tree, becoming very distinct again beyond it. It was in this lush fernery that I found the largest bear print I have ever seen: a right forepaw print larger than the outstretched fingers of my hand, made by a very big animal indeed.

At .51 mile, the woods road divides; bear left to follow the more distinct footpath. At .6 mile, you come to a series of narrow photogenic slides where the trail crosses Pigeon Run. To get to the picturesque falls, cross Pigeon Run and walk uptrail a dozen yards, then turn left, working downhill toward Sullivan Run. A large seep and boulder slide will guide your way down. Cross to the far bank of Sullivan Run, and find a good location facing Pigeon Falls.

Pigeon Falls differs from other falls in the area because of its location at a sharp bend in Sullivan Run. The falls is tucked into a narrow gap in the stone ledges forming Sullivan Run's left-hand side. As a result, the area immediately around the falls will photograph darker than the surrounding glen. Small trees frame the falls, so an unobstructed view requires getting well into Sullivan Run, which is no easy task. Although I was there late in the season, I saw blooming wood sorrel along with ample evidence of many other kinds of flowers in the area, mainly marsh marigolds and other species that love damp, loamy soils.

Facing Pigeon Falls, Sullivan Run disappears within a narrow gorge to your left. What happens in that gorge is nothing short of magical. My hiking partner for the day, Ed Lease, and I were able to make our way upstream in waist waders, diverting up steep slopes to get around the falls in this glen. Although the woods road trail gains only another 320 feet, the total elevation gain of scrambling up and down is closer to 1,000 feet. To give you a good sense of what lies upstream of Pigeon Falls, consider trying to hike nearby Ricketts Glen State Park before the trail was built.

Return to the trail where it crosses Pigeon Run, and turn left. Proceed up the rocky woods path to 1.6 miles and the weakly running Ore Run. Do not cross Ore Run. Instead, turn left and follow close to it until you come to a headland where it meets Sullivan Run. Now turn to face upstream (of Ore Run), and scramble down about 10 feet to the water. Ore Run Falls is upstream of this point, and it is reached with a little bit of boulder hopping. If you can, cross Sullivan Run to the right-hand bank and face Ore Run.

Look around. To your left, Sullivan Run is a wide, cobble-filled series of shallows passing through a forest of birch and young hardwoods. To your right, ledges begin to encroach, and you can see the head of a fifth falls as a white line at the end of a run of glassy water. This is where the fun begins.

Warning: The next .8 mile of this hike should be attempted only by those who are fit and comfortable around heights, for what follows is a series of strenuous, nerve-wracking, potentially dangerous scrambles separated by shin-banging cliffside bushwhacks. Return to Ore Run and scramble back on top of the little headland, then head downstream along Sullivan Run, keeping as close to the exposed ledges as comfort and safety allow. In less than 100 yards, you come even with the head of the fifth falls. Continue downstream until all six drops of the 50-foot falls can be seen through the trees. About a dozen yards farther on, the ledges give way to a steep-sided ravine. Carefully

scramble downslope to the run. From near the falls' base, only the lower three drops are visible, and the falls appears much smaller than from above.

Scramble back up from the falls and continue downstream along the ledges about 400 yards, or until Hunts Run can be seen entering Sullivan Run. Once again, make a scramble down to the creek and head back upstream to see the two drops making up a 13-foot falls. Turning downstream will bring you to where Hunts Run joins Sullivan Run 200 yards below this sixth falls. Hunts Run drops over a tall ledge where it enters Sullivan, and above that point you will see a seventh falls: an interesting 30-foot-high series of cascades.

About 100 yards below Hunts Run stands a 12-foot cascade. To get this eighth falls, scramble out of the ravine and head downstream along the ledges about 140 yards below Hunts Run, or until the cascade is in full view. Then scramble back down.

At this point, it's possible to head downstream in the creek shed, fording as needed until you come to a ninth falls: a 9-foot cascade. The ravine narrows right at the slide, and to get past it another scramble is needed, this time to an intermediate ledge. Pass beyond the slide, and then scramble back down. In low water, it's a simple process to splash straight down the glen, reaching Pigeon Falls in about 450 yards.

The glen has one more trick to play, however, in the form of an 8-foot slide. Ledges on the left-hand side, which you've been using the whole way along, are impassable here, so in order to get around this tenth falls, scramble up the right-hand side. Head downstream a short distance beyond the falls, scrambling back down via a wide rockslide.

You can either continue downstream in the creek shed or return to the heights of the left-hand bank. Should you decide to remain in the creek, be warned that in high water, there are some very deep holes that will swamp even waist-high waders. You will reach Pigeon Falls again 260 yards below the tenth falls. Climb out of the ravine to the left of Pigeon Falls, returning to the trail where it crosses Pigeon Run, and turn right to head back to your car.

| Hike 22 | # Heberly Run, State Game Lands No. 13, Sullivan County |

THE FALLS

Big Falls

Type: cascade	Height: 34 feet
Rating: 5	GPS: 41° 19.610N, 76° 20.876'W

Lower Twin Falls

Type: cascade over falls	Height: 9 feet
Rating: 2	GPS: 41° 20.055'N, 76° 21.380'W

Upper Twin Falls

Type: chute over cascade	Height: 13 feet
Rating: 4	

Unnamed

Type: cascade	Height: 8 feet
Rating: 1	

Lewis Falls

Type: falls	Height: 22 feet
Rating: 4	GPS: 41° 20.304'N, 76° 21.863'W
Stream: Heberly Run	Lenses: 20mm to 100mm

Difficulty: difficult; off-trail hiking, creek fords, steep scrambles

Distance: 1.2 miles to Big Falls from gate; .4 mile to Twin Falls or Lewis Falls from Grassy Hollow Road; 2 miles for all three

Time: 5 to 6 hours	Elevation change: 400 feet

Directions: From the village of Red Rocks at the intersection of PA 118 and PA 487, near Ricketts Glen State Park, take PA 487 north .38 mile to the Y intersection of Big Run Road and Ganoga Road. Make a hard left onto Big Run Road, and proceed 4.6 miles down the sometimes steep gravel road to where Big Run Road ends at a T intersection in Jamison City near the red Jamison Hotel. Turn right and proceed up a paved, then gravel road for 1.3 miles to where the road ends at a gate. You'll pass an old brick chimney and a Game Commission maintenance facility on the left. From the gate, a white farmhouse you passed on the way in will be visible on the opposite side of Fishing Creek. The gate to Grassy Hollow Road is open during spring turkey season, from mid-April through late May, and during fall hunting seasons. Additional directions to shorten the hikes are noted below and are given as mileage from the gate. GPS coordinates: 41° 19.155N, 76° 20.633'W.

V oltaire once said, "Walk softly upon the rocks for you may injure them." After three days of photographing State Game Lands No. 13, I can safely say that Voltaire never tried bushwhacking up Heberly Run. This difficult

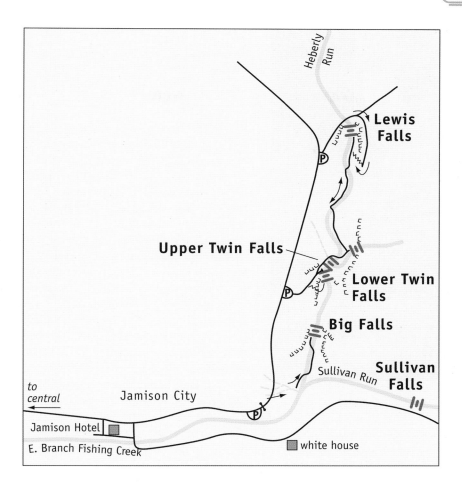

and sometimes strenuous series of hikes is mentally taxing, physically demanding, and immensely satisfying. Because imposing cliffs envelop all four falls, this hike is not a straight shot up Heberly Run, but a series of flanking maneuvers combined with a game of advance and retreat.

This is an amazing place to take photographs, and how you manage your time will be dependent on whether the road is open. If it is open and you have only an hour or so available, I would recommend shooting the upper drop of Twin Falls because it's easy to get to. With a half a day, you can easily do both Big Falls and Twin Falls. With a full day open, it's possible to shoot all four falls, although unlikely. Not because of distance or difficulty, but because there's just so much to shoot.

If the road is closed, and you have at least two hours available, I would recommend shooting the upper drop of Twin Falls. With more time, like half a day, concentrate on Big Falls, and don't worry about the others. To work Heberly Run thoroughly it will take a day and a half to two days. It's a lot of

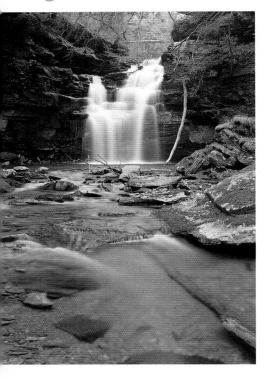

Big Falls. You need to sit for awhile before shooting here because this place is overwhelming. A calm mind leads to carefully crafted images. *Tachihara 4x5, Schneider 90mm Super Angulon, polarizer, Kodak ReadyLoad Holder, Kodak E100VS, f/32 @ 10 sec.*

time for just four falls, but this is perhaps the best place in Pennsylvania outside Ricketts Glen to photograph waterfalls. Plan accordingly, and do yourself a favor—take off your watch and carry lots of film. Stinging nettle abounds in the ravine, so long pants are a must.

To reach Big Falls from the Grassy Hollow Road gate, walk up the road .3 mile to where two small culverts pass under the road. These are marked by green poles, some with and some without white tops. At the second culvert, look for a large open area to the right. This unmarked food plot may be hidden by a tall veil of roadside weeds. Break through the weeds and pause with your back to the road to get your bearings. Then turn left, and walk parallel to the road for about 50 yards, or until you come to a small, cobble-filled drainage channel (possibly dry). Turn right, and follow this channel downhill to the East Branch of Fishing Creek. If you miss the small channel, which is easy to do, don't worry—simply work down the slope until you come to the creek. You will meet Fishing Creek just below the fork of Heberly and Sullivan Runs.

At the creek, turn left, and walk upstream to the fork of the runs. Heberly Run branches to your left and Sullivan Run to your right. Continue to follow the right-hand bank (the side you're on) up Heberly Run, staying on this bank as long as possible, about 200 yards. When the ravine closes in and the way ahead is blocked, locate a spot to ford and cross to the opposite bank. A word of caution: Footing can be unsteady with camera gear on your back, so use an extended tripod leg to help keep your balance.

Once you've managed to make it to the left-hand bank, stop for a while and carefully examine your surroundings. This bank is wide, with thick black soil covering the sizable cobble bar forming the embankment. Abandoned stream channels abound, and their marshy depressions are filled with numerous small wildflowers such as bishop's cap, snow flower, wood sorrel, red and painted trilliums, and marsh marigold. The intense smell of decay fills the air, and the ever-present white noise of the creek drowns out all other sounds; even the sharp whistle of a terrified ground squirrel is lost to the

creek. Downed trees litter the forest floor, and older ones are spongy, coming apart easily in the hand. Others are mere ghosts forming long humps in the soft soil. Root balls of fallen trees have left large, leaf-filled depressions that will swallow a wayward hiker up to the knees. The terrain is full of these pits, which are called hummocks. Younger blowdowns are numerous and can be a source of bruised shins. Saplings are everywhere, tugging at your legs and arms as you walk, and sometimes it's necessary to crash through a cluster of them like a linebacker (look for deer trails to make getting through the sapling groves easier). In light rain or mist, this place is a joy to fight through, because this is what a healthy forest community looks, smells, and feels like.

Follow the left-hand bank as long as possible, about 150 yards, until forced to cross back to the right-hand bank. The falls may be faintly in view or audible at this crossing. Once across, make your way the last 100 yards to Big Falls by working up the embankment in order to get away from the impeding stone slabs hanging into the creek.

When you reach the falls, find a comfortable rock, sit down, and don't open the camera bag. Big Falls demands a period of quiet to allow the magic

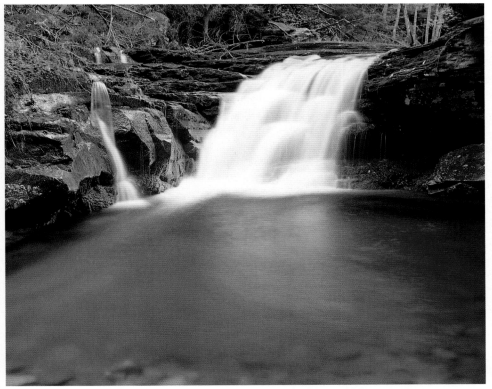

Lower Twin Falls. Although not very tall, the opal green plunge pool is what makes this falls special. *Tachihara 4x5, Schneider 65mm Super Angulon, polarizer, Calumet 67 roll film back, Kodak E100VS, f/32 @ 6 sec.*

to soak in, so rest awhile and explore this grand place. Between the last two crossings, the ravine has narrowed considerably, turning into a deep glen, and large cliffs now enclose the head of the glen, blocking passage ahead. Rising in a series of ledges almost 100 feet above you, the cliffs resemble the battlements of an ancient citadel. Complex communities of mosses cling to everything, and ferns abound. Stream cobbles that assisted your fording are gone, replaced by a fast-running flume. This place has a magical and daunting feel at the same time—magical in that the environment is lush and green, daunting because there's only one way out.

After a couple hours or ten rolls of film, whichever comes first, it's probably time to backtrack to the car. Once back on Grassy Hollow Road, it's tempting to continue directly to Twin Falls. I wouldn't recommend it. A better choice is to make the short walk back to the car and regroup with some water and a snack before deciding what to do next.

To reach Twin Falls, hike or drive about .7 mile up Grassy Hollow Road to the first parking area on the right. As you may have noted on the hike to Big Falls, Grassy Hollow Road is in bad shape. It will test the mettle of any vehicle, but it can be driven in a regular car, albeit slowly. Walk to the parking area's rear, and turn left to enter the woods, walking parallel to the road until

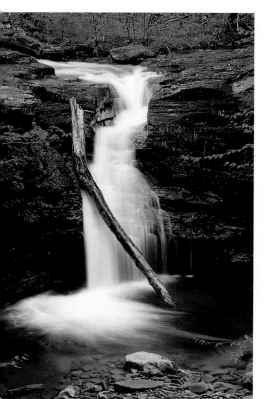

you come to a cobble-filled drainage (possibly dry) after about 25 yards; cross it and then turn downhill toward Heberly Run. In a short distance, perhaps 50 yards, the lower plunge of Twin Falls comes into view through the trees. Continue to work downslope, aiming for a point about 50 yards below the falls. Ledges that jut from the hillside will force you to keep to an easier-to-navigate slope, thus guiding your descent.

About halfway to the lower plunge, when you're still 20 to 30 feet above Heberly Run, an old woods road appears, heading off toward your left. This road or wide path will take you to the upper plunge of Twin Falls, which sits just 40 yards upstream of the lower plunge. Both falls are reached with short, easy scrambles down collapsed ledge sections.

Upper Twin Falls. From the undercut ledges adjacent to the falls. The background is very open, so background highlights will be a problem from below the falls. *Canon EOS Rebel Xs, Tamron 28–200, polarizer, Kodak E100VS, f/8 @ 2 sec.*

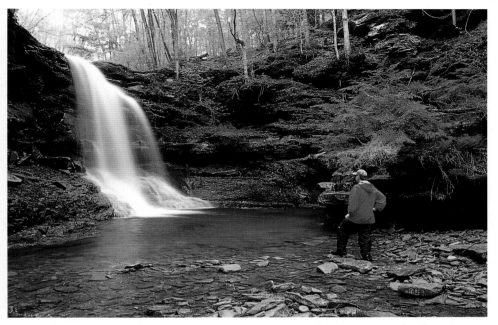

Self-portrait, Lewis Falls. Note how a red coat jumps out of the picture. Use red, yellow, or blaze orange on models so that they stand out in a photo. *Canon EOS Rebel Xs, Tokina 20–35, polarizer, Kodak E100VS, f/8 @ 2 sec.*

The lower falls is not very impressive, and the surroundings here are less impressive than at Big Falls or Lewis Falls. But many nice images can be made from the cobble bar below the falls. Twin Falls' upper plunge is an interesting chute formed at the apex of the bend in Heberly Run. In low flow, only the central chute will be filled, but at high flow, the entire falls will fill with water, along with a weakly flowing twin on your left. Opal green water swirls around a shallow plunge pool with large cobble bars on both sides that make shooting here quite easy. If it's not raining, or if rocks in your foreground are dry, splash water on them so that they won't over-whelm your photo with a bright foreground. There are nice shooting perches along the ledges facing the falls as well. The creek shed above the falls is rather broad, so background highlights may be a problem.

A small cascade near Twin Falls is reached by fording the creek not less than 20 yards above the falls. Twin Falls is headed by a sandstone flume, so it's safest to ford where there are cobbles. Once across on the left-hand bank, look straight ahead into the woods for an open area at the base of a small cliff where an 8-foot cascade emanates from a notch. The outflow of this cascade dumps directly into Twin Falls' left-hand side.

There are two routes to Lewis Falls: the hard way and the other hard way, meaning either a .7-mile one-way bushwhack with three wide fords, or a 300-yard walk with one very long, and very steep, ravine scramble.

Begin the .7-mile bushwhack by fording Heberly Run above Twin Falls. Proceed upstream, holding to the left-hand bank as long as possible, using abandoned stream channels and deer paths to aid your advance. Once the route ahead is blocked by collapsed ledges, cross the creek to the right-hand side and continue advancing upstream, stopping occasionally to examine the profuse spring wildflowers and vast array of mosses.

Continue upstream along the right-hand bank as long as possible, then cross to the left-hand side to finish your advance to Lewis Falls. But just when you think you've made it, there's one final surprise in store. As the falls comes into view, a collapsed sandstone slab appears to block the way forward. If the creek is running low, it's easy enough to go around; however, at high water, it's necessary to carefully pick a way over the top. Finally, walk up the widening creek bank to a large cobble bar filling the falls' left-hand side.

For the steep scramble method, drive up Grassy Hollow Road 1.7 miles from the gate, and park at a wide spot on the right where a narrow woods road descends into the forest. Walk down this rocky path about 50 yards to the head of Lewis Falls. Walk along the ledges downstream a few yards, and survey the ledges on the far side, noting where they disappear into the steep hillside near a blowdown that hangs into the ravine. Your descent will begin downstream of this point.

Return to the falls' head and cross Heberly Run well upstream of a flume heading the falls. Once across, turn right (downstream), working slightly uphill, and follow the ledges downstream, stopping several yards beyond where they disappear into the hillside. At this point, turn to face the falls and carefully angle your way downhill, aiming for the wide creek bank below the falls. This descent is easier than it looks. As with all such scrambles, however, some intestinal fortitude is needed, especially here, because you have a long, steep climb out.

When all is said and done, the true benefit of a hike up Heberly Run is not the exercise, tests of skill and patience, or even the amazing photography. Heberly Run provides an opportunity to experience nature on its own terms. Even with a couple bumps and bruises, it's impossible to leave Heberly Run without a strong sense of personal accomplishment and a song in your heart.

Hike 23 Dutchman Falls, Wyoming State Forest, Sullivan County

THE FALLS

Type: cascade	**Height:** 27 feet
Rating: 2	**GPS:** 41° 27.005'N, 76° 27.030'W
Stream: Dutchman Run	**Lenses:** 20mm to 100mm
Difficulty: easy to moderate; steep scramble to base of waterfall	**Distance:** .5 mile
Time: 30 minutes	**Elevation change:** 135 feet

Directions: From the intersection of PA 154 and US 220 near Laporte, follow US 220 north for 2.4 miles, and then turn left onto gravel-covered Mead Road. Proceed uphill for .3 mile, and turn right into a very large parking area for the Loyalsock Trail. GPS coordinates: 41° 26.904'N, 76° 27.184'W.

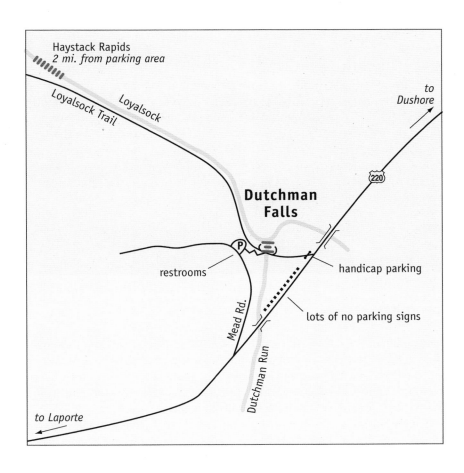

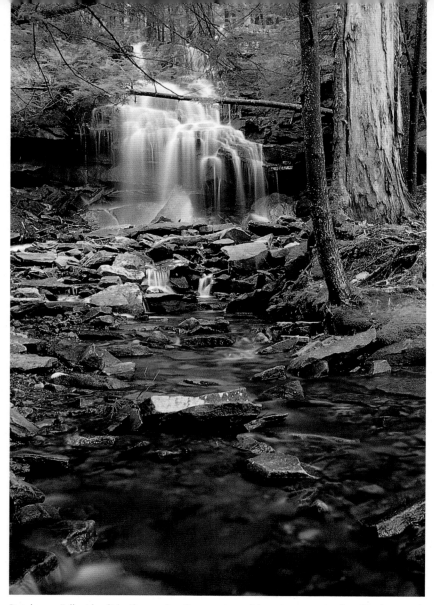

Dutchman Falls. I knelt in the creek with my rear end hanging over the fast-flowing Loyalsock Creek. Before I knelt down, I was careful to make sure the rock I was on was stable. *Canon EOS Rebel Xs, Tokina 20–35, polarizer, Kodak E100VS, f/22 @ 10 sec.*

Dutchman Falls sits very close to a set of Loyalsock Creek rapids known as the Haystacks, and on a summer day, the large parking area will be filled with hikers, bathers, and kayakers. The parking area is also the eastern terminus of the 59-mile Loyalsock Trail, so it can be crowded any spring weekend. Get here early to have the falls to yourself.

Follow the yellow-and-red-blazed Loyalsock Trail from the parking area down a heavily trodden, rock-strewn section of trail to where it intersects a

wide forest road at .2 mile. (About 1.6 miles to your left, down the forest road, are the Haystack Rapids. A handicapped-accessible parking spot sits where this road meets US 220, .1 mile to your right.) Turn right and pass over narrow Dutchman Run, then make an immediate left to follow a red-X side trail to the falls' head.

It's easy to scramble down either side of the falls to get to the cobble-filled base. The falls has a thick patina of algae on its face, and a camping area above it is filled with smallish hemlocks. The falls sits very close to where Dutchman Run enters the much deeper Loyalsock Creek, and where they meet is the best shooting location, particularly the right-hand side. A large hemlock with curiously pale bark sits on the falls' left side; include it in your photograph for a unique image.

Hike 24 Cottonwood Falls, Worlds End State Park, Sullivan County

THE FALLS

Type: slide over cascade	**Height:** 9 feet
Rating: 2	**GPS:** 41° 27.758'N, 76° 35.054'W
Stream: Double Run	**Lenses:** 20mm to 70mm
Difficulty: easy	**Distance:** 1 mile
Time: 45 minutes	**Elevation change:** 190 feet

Directions: From the town of Buckhorn, at the interchange of I-80 and PA 42, take PA 42 north 25.8 miles to US 220 in Beech Glen. Turn right and go 1 mile, then turn left onto PA 42 north again. Drive 4.3 miles and turn left onto Double Run Road (SR 3009) just south of Eaglesmere. In 5.7 miles, Double Run Road intersects PA 154 in Worlds End State Park. Turn left onto PA 154 north and go .4 mile to park visitor center.

From the Worlds End State Park visitor center on PA 154, turn left onto PA 154 south, and drive .5 mile to the Double Run Nature Trail parking area on the right. GPS coordinates: 41° 27.948'N, 76° 34.695'W.

This is a great hike for kids of all ages. Begin by selecting a good walking stick from the honor-system stack leaning against a fence rail (don't forget to return it when you're done), and proceed up the green-and-white-blazed nature trail. At .22 mile, Mineral Spring Run joins Double Run. Look for a well-constructed footbridge over Double Run and a makeshift set of boards over Mineral Spring Run several yards upstream from the merge. Cross the boards, then cross the bridge. After crossing the footbridge, turn hard left, following the green and white blazes to .5 mile and the 9-foot drop

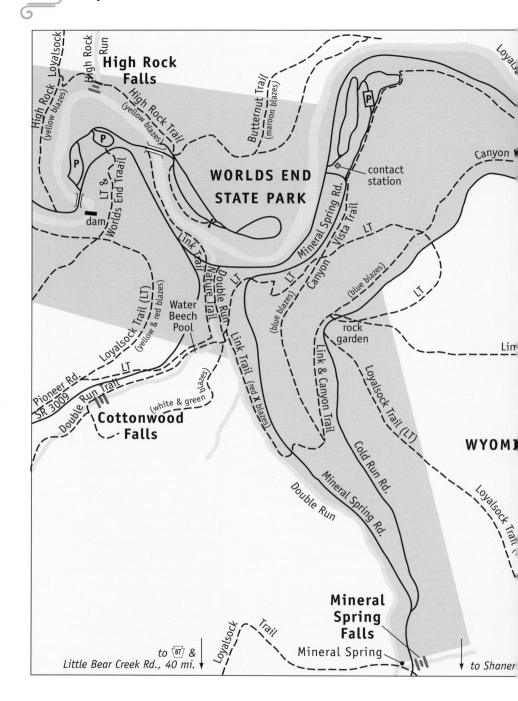

High Rock Run

High Rock Loyalsock

Loyalso

**High Rock
Falls**

High Rock (yellow blazes)

High Rock Trail (yellow blazes)

Butternut Trail (maroon blazes)

P

P

LT & Worlds End Traail

dam

**WORLDS END
STATE PARK**

Mineral Spring Rd.

contact
station

P

Canyon

Link Trail

Double Run Nature Trail

LT

Canyon Vista Trail

LT

LT

LT

LT

(blue blazes)

(blue blazes)

LT

Loyalsock Trail (LT) (yellow & red blazes)

Water
Beech
Pool

rock
garden

Lin

Pioneer Rd. SR 3009

Double Run Trail

LT

Link Trail (red X blazes)

Link & Canyon Trail

Loyalsock Trail (LT)

(white & green blazes)

**Cottonwood
Falls**

Cold Run Rd.

WYOMI

Double Run

Mineral Spring Rd.

Loyalsock Trail (

Loyalsock Trail

to 87 &
Little Bear Creek Rd., 40 mi. ↓

**Mineral
Spring
Falls**

Mineral Spring

↓ *to Shaner*

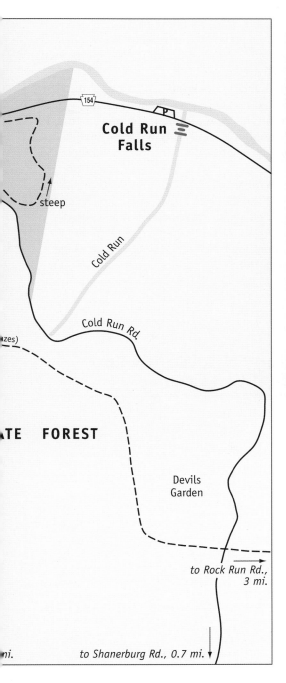

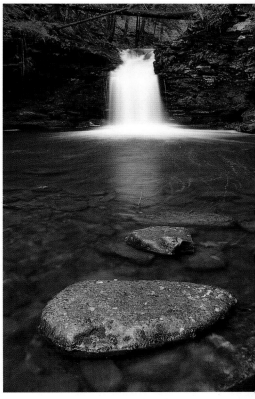

Cottonwood Falls. I purposely looked for two rocks of similar shape to create the foreground and placed them in the scene. Then I wet them down so that they would look good on film. *Canon EOS Rebel Xs, Tamron 28–200, polarizer, Kodak E100VS, f/22 @ 10 sec.*

of Cottonwood Falls. Don't be fooled by the 3-foot drop of Water Beech Pool (the sign may be on the ground), which is often mistaken for Cottonwood Falls. Cottonwood Falls is a distinctive 9-foot drop over a heavily faceted dark shale face with a 35-foot-wide plunge pool.

To the left of the falls, some undercut shale has long tendrils of moss hanging from it, forming wide green curtains. These interesting moss communities beg to be explored with macro equipment. Numerous moss-covered boulders fill the hillside above, indicating a spring higher up. Wildflowers, such as painted trillium, can be found near the falls despite the heavy foot traffic.

As I stood watching families with small children approach the falls, I couldn't help but sit and observe the children's reactions, which ranged from fascination to awe. Kids scurried about, presenting each new discovery to their parents with a shout of "Daddy! Come look at this!" Some kids skipped rocks, while others filtered mud and sand through their fingers. Throughout the raucous play, new things were being learned. If you have children, turn them loose on the Double Run Nature Trail. It's so much better than a Game Boy.

Hike 25 Mineral Spring Falls, Worlds End State Park, Sullivan County

THE FALLS

Type: slide	**Height:** 25 feet
Rating: 2	**GPS:** 41° 26.926'N, 76° 34.544'W
Stream: Mineral Spring Run	**Lenses:** 20mm to 90mm
Difficulty: easy	**Distance:** 100 feet
Time: 10 minutes	**Elevation change:** none

Directions: From the Worlds End State Park visitor center on PA 154, turn left onto PA 154 south, and drive .9 mile to Canyon Vista Road. Turn right onto Canyon Vista, a.k.a. Mineral Spring Road, and proceed 1.6 miles uphill, driving past the turn for Canyon Vista. The falls is set back from the road about 100 feet and is marked by a Loyalsock Trail crossing. Park at a small pulloff with two No Camping signs. GPS coordinates: 41° 26.926'N, 76° 34.544'W.

This thin but pleasant slide over dark sandstone sits just 100 feet from the road. On some maps, this falls is labeled Cold Run Falls, but that's along PA 154 well east of here. Mineral Spring Falls is visible from the road. The LT (Loyalsock Trail) follows the right-hand bank, so careful framing is needed to keep the red and yellow blazes out of your picture. When you're finished,

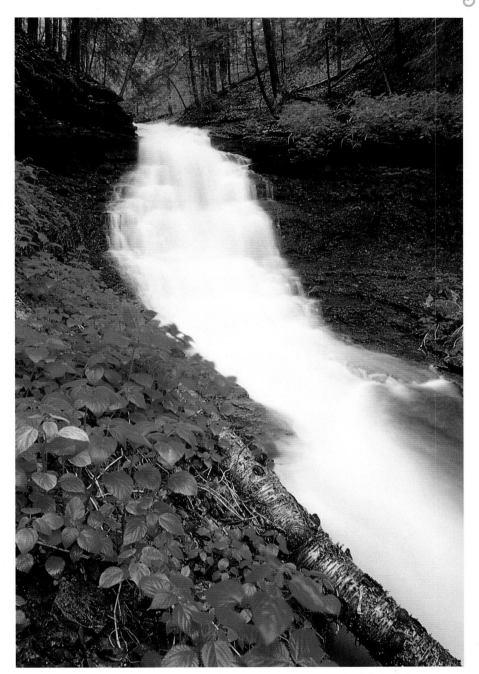

Mineral Spring Falls. Normally a garden hose trickle, on this rainy day the falls had almost too much water to shoot. I had to trade depth of field against shutter speed to keep the water from becoming a blown-out highlight. *Canon EOS Rebel Xs, Tokina 20–35, polarizer, Kodak E100VS, f/22 @ 2 sec.*

follow the trail downstream across the road for about 200 feet, and look for a 10-foot-wide damp area with orange and yellow rocks adjacent to Mineral Spring Run. This is Mineral Spring, for which the falls, road, and creek are named. A vague smell of rotten eggs hangs in the air. Note how algae in the creek have absorbed the spring's sulfur and iron effluent to form long ribbons of orange and brown.

Hike 26 Cold Run Falls, Wyoming State Forest, Sullivan County

THE FALLS

Type: cascade	Height: 9 feet
Rating: 1	GPS: 41° 27.555N, 76° 32.738′W
Stream: Cold Run	Lenses: 20mm to 70mm
Difficulty: easy	Distance: 50 yards
Time: 15 minutes	Elevation change: none

Directions: From the Worlds End State Park visitor center on PA 154, turn left onto PA 154 south, and drive 2.8 miles to a large gravel parking area on the left adjacent to Loyalsock Creek. The falls is tucked into a notch in large cliffs on the right side of PA 154 where a bridge carries the road over Cold Run. GPS coordinates: 41° 27.555N, 76° 32.738′W.

This little roadside falls makes for a fun shoot after a good rain. The entire falls is not visible from the road, and it's easy to drive past it, so keep an eye on the odometer. In order to see the entire falls, you have to cross PA 154 and hop the guardrail along the culvert that carries the creek under PA 154. The best shooting position is actually within the culvert. Before crossing the road, look both ways several times, as this is a hazardous section of PA 154 where drivers speed to make up for lost time after driving through Worlds End.

Hike 27 Coal Run Falls, Wyoming State Forest, Sullivan County

THE FALLS

Upper Falls

Type: cascade	**Height:** 19 feet
Rating: 2	

Lower Falls

Type: slide over falls	**Height:** 11 feet
Rating: 1	**GPS:** 41° 28.196'N, 76° 30.818'W
Stream: Coal Run	**Lenses:** 17mm to 90mm
Difficulty: difficult; steep scramble down a ravine	**Distance:** .25 mile
Time: 30 minutes	**Elevation change:** 60 feet

Directions: From the Worlds End State Park visitor center on PA 154, turn left onto PA 154 south and drive 5.6 miles to Rock Run Road, which appears where a guardrail ends on the left. Turn left onto Rock Run Road. From the iron bridge over Loyalsock Creek, drive 1 mile to a large grass parking area on the left. GPS coordinates: 41° 28.196'N, 76° 30.818'W.

Coal Run Falls sits just downstream of Sones Pond, so this small falls should be running most of the year. As with all upland falls, however, it's best after a good rain. The falls is audible from the parking area and visible from a few yards down the road. It's tempting to bushwhack straight to the falls, but don't do this, as there is a small wetland above the falls that's filled with wildflowers.

Rather, walk down the road about 400 feet, or 185 paces, past the hemlocks adjacent to the road, and look for an 8-foot-tall bark-free stump with a jagged top standing at the road's edge. From this stump (at GPS coordinates 41° 28.121'N , 76° 30.807'W), make a short, very steep, and difficult

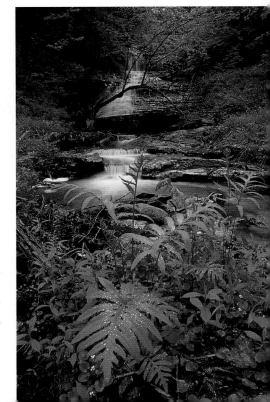

Coal Run Falls. Never pass up an opportunity to shoot dewdrops; they're a lot of fun to work with. *Canon EOS Rebel Xs, Tokina 20–35, polarizer, Kodak E100VS, f/22 @ 8 sec.*

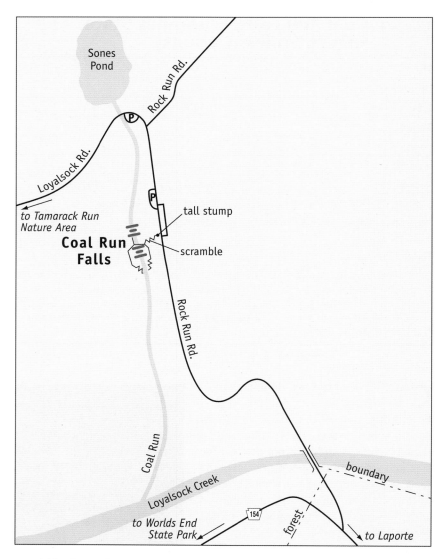

scramble down the ravine's slope, angling toward the head of the lower falls. Use only upright or growing trees as handholds, and take care not to plant a foot on any downed trees, particularly birches. Fallen logs are likely to collapse underfoot or the bark may peel away, flinging you headlong downhill.

Once at the run, turn right (upstream) toward Coal Run Falls. This little falls may not seem like it's worth the effort, but it is. A lush array of plants clinging to a cobble bar below the falls make incredible foregrounds, especially with heavy dew. Bring macro gear to shoot the mosses that hang from the falls' ledges. The only problem with shooting the upper falls is a thin birch sapling that has tilted to cover part of its face—that, and the gnats, which are quite a nuisance.

After returning to your car, head for Sones Pond to observe the barn swallows wheeling and diving over the water. I saw a least sandpiper scooting along the pond's bank, and it kept me company with its persistent *peep-peep-peep* call while I shot tree reflections in the pond's calm, glassy water. The little sandpiper even came within a dozen feet of me, which is highly unusual, but it skittered quickly away when I turned my 400mm lens on it. Unfortunately, I didn't have the time needed to habituate it to my presence.

Hike 28 Rode and Lee Falls, Wyoming State Forest, Sullivan County

THE FALLS

Rode Falls

Type: cascade	**Height:** 11 feet
Rating: 3	**GPS:** 41° 27.388'N, 76° 38.079'W

Lee Falls

Type: cascade	**Height:** 16 feet
Rating: 1+	**GPS:** 41° 27.291'N, 76° 37.993'W
Stream: Ketchum Run	**Lenses:** 20mm to 100mm
Difficulty: difficult and strenuous; long, steep climbs	**Distance:** 3.2 miles
Time: 4 hours	**Elevation change:** 700 feet

Directions: From the Worlds End State Park visitor center on PA 154, turn left onto PA 154 south, and drive .4 mile to the Y intersection of Double Run Road (SR 3009) and PA 154. Bear right up the steep hill, and follow Double Run Road south 2.1 miles to the second intersection of Coal Mine Road. Turn right onto Coal Mine Road, and proceed 2 miles to a large parking area on the left near where the Loyalsock Trail crosses Coal Mine Road. GPS coordinates: 41° 27.399'N, 76° 37.753'W.

A hike down into Ketchum Run Gorge is difficult and the return quite strenuous, yet it's an enjoyable bit of exercise. The hike begins easily enough with a level walk on the red-and-yellow-blazed Loyalsock Trail. From the parking area, walk along Coal Mine Road a short distance to where the trail crosses, and turn left into a small hemlock grove, following the trail along the gorge's rim. At .32 mile, you come to a grassy meadow and Upper Alpine View (there's a blue and yellow sign nailed to a tree). This is a popular camping spot, so if you're out early, make an effort to be quiet as you pass among slumbering campers. Upper Alpine View does not present a good vista of Ketchum Gorge, but it does provide a nice view of Loyalsock Valley around Hillsgrove. Passing Upper Alpine View, turn around and look

cliffs & ledges

forest boundary

LT

Ketchum Run

wetland

Loyalsock

Lower Alpine View

Upper Alpine View

Loyalsock Trail (LT)

area of confusing intersections

P

LT

Coal Mine Rd.

Rode Falls

Red Trail

LT

Lee Falls

rockslide

for two sanstone ledges jutting out into space. Growing along these ledges are numerous bleeding hearts, which bloom in early May.

Continuing on, at .6 mile the trail begins the first of two steep descents into Ketchum Run Gorge, this one dropping about 260 feet. The trail is stairway steep in places, and in any kind of rain, it is very slick as it descends through a hemlock grove. When the trail levels out again, you're actually paralleling your path on the ridge above. You may even hear voices from Alpine View. The trail traverses a very soggy wetland habitat. Sandstone ledges below the soil are higher toward the gorge's edge, so water is trapped in the rich black soil, creating excellent wildflower habitat. Look for the tiny bell-like flowers of bishop's cap, tightly packed clusters of white stars called snow flower, common and marshy violets, wide-leaved ladies' tresses, and several small yellow flowers that might be three-parted violets. A 5-foot-tall silver birch stump close to the trail has symmetrically spaced oval holes that match the cross section of the pileated woodpecker's beak. I heard two in the area during my hike but couldn't manage to locate either. Numerous species of warblers, dark-eyed juncos, a nuthatch, and numerous chickadees flitted about, and the lilting two-toned call of a veery punctuated the

air on a regular basis. All this diversity in a 100-yard section of trail was a wonderful experience.

A little farther on, at about 1.1 miles, you come to Lower Alpine View. This spot provides a better view of Loyalsock Valley than the upper vista point. Walk as close to edge as comfort and safety allow, and look 340 feet down into Ketchum Run Gorge. On my visit, misty rain softened the far ridge's outline, and fog slowly rose in swirling skeins of white from the unseen but audible creek far below.

Continue along the cliff edge, following the yellow and red blazes to where the Loyalsock Trail makes a sharp right turn to plunge into the gorge. Several old forest roads intersect the trail, and it's easy to be led astray, so keep a sharp eye out for blazes. When the trail reaches the creek, it becomes a narrow footpath that slices into soft soil heading upstream along the creek bank. Rode Falls is found at 1.5 miles. A large hump of earth and cobblestones makes shooting the plunge pool difficult, so this falls is best shot from the creek below.

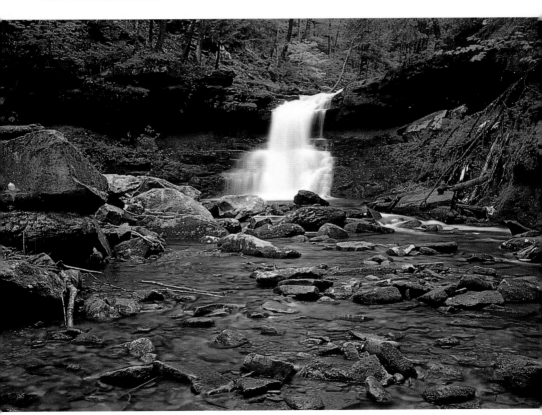

Rode Falls. The creek is wide and shallow below the falls, and the woods are lush green. Find a nice spot and have fun. Note the Loyalsock Trail ladder to the falls' left. *Canon EOS Rebel Xs, Tokina 20–35, polarizer, Kodak E100VS, f/22 @ 15 sec.*

Use the ladder provided to get around Rode Falls, and continue upstream on the Loyalsock Trail, which follows the right-hand bank. At about 1.6 miles, the trail turns left and begins a steep ascent to avoid encroaching cliffs forming the head of Lee Falls. Not more than 40 yards from this turn, a red-X side trail continues upstream slightly above the creek (the Loyalsock Trail continues to climb). Turn right and follow the red-X trail upstream, taking careful note of your position at this turn, as on the return it looks quite different. This red-X trail is difficult to follow, and there aren't many blazes. The trail stays above the creek until a crossing just below Lee Falls, where it then scrambles up ledges on the falls' left-hand side. The red-X trail crosses back to the creek's right-hand side right at Lee Falls' head. It's dangerous, if not impossible, to cross the head of Lee Falls in high water, so don't try. Photographing Lee Falls is a difficult proposition. Slick rocks near the falls, tree- and boulder-choked tailwaters, and a bare landslide on the far bank all make for difficult working conditions. Add to this the fact that this falls isn't very picturesque, and the decision not to shoot becomes pretty easy.

Ketchum Run Gorge is a place of impressive natural beauty, and this hike has rewards beyond simply photographing waterfalls. The delightful little wetland at Lower Alpine View, two impressive vistas, a lush creek shed, and the feeling of accomplishing something this physically challenging make the effort well worth it. Yes, it's a tough climb out, but the best locations often require some sacrifice to reach. You don't just take photographs here; you earn them.

Hike 29 Alpine Falls, Wyoming State Forest, Sullivan County

THE FALLS

Type: cascade	**Height:** 23 feet
Rating: 2 or 3	**GPS:** 41° 28.765'N, 76° 33.097'W
Stream: East Branch of Big Run	**Lenses:** 20mm to 70mm
Difficult: easy-to-difficult; steep scramble around falls	**Distance:** 2.2 miles
Time: 1 hour, 30 minutes	**Elevation change:** 230 feet

Directions: From the Worlds End State Park visitor center on PA 154, turn right onto PA 154 north, and drive .6 mile to Loyalsock Road. Turn right onto Loyalsock, and proceed 7.1 miles along the meandering road to the first parking area for the Crane Spur Trail (not to be confused with another parking area for this loop trail .1 mile farther on). GPS coordinates: 41° 29.073'N, 76° 32.720'W.

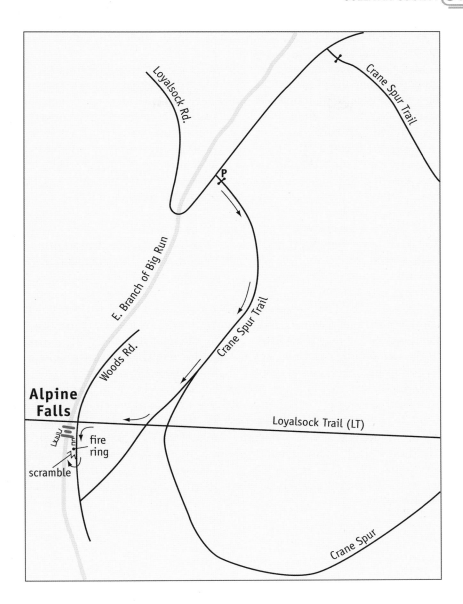

several trails crisscross the area, so pay close attention to trail intersections. Begin walking down the wide, red-blazed forest road of the Crane Spur Trail. At .5 mile, you come to a Y-shaped split in the trail marked by a red double blaze. Turn right onto the unmarked trail. (The red-blazed Crane Spur turns left to intersect the Loyalsock Trail). Follow the unmarked trail to .6 mile, where it intersects the red-and-yellow-blazed Loyalsock Trail. Turn right onto the Loyalsock Trail, and follow it to the East Branch of Big Run.

Just before the trail crosses the creek, it crosses an unmarked logging road; make a mental note of this.

At the creek crossing, look downstream for red-X blazes indicating a side trail descending the creek and the falls. Before attempting this tricky scramble, which goes straight down the falls' face, consider the conditions and your skill level. If it's raining, the first 20 feet of this side trail can be unnerving or downright dangerous and should not be attempted.

If the route over the falls appears unsafe, backtrack several yards to the old fire road you made a mental note of. Follow this woods road downstream past a fire ring to where you can see the base of the falls and a divide in the creek, about 60 yards. Now scramble down the steep, hemlock-covered ravine to the creek.

Neither of these descents is easy. I prefer the ravine for one simple reason: The penalty for slipping is markedly less painful. My first visit to Alpine Falls was in the rain, and I simply can't imagine safely navigating that red-X trail with a backpack on. Why the trail was built straight over the face of a waterfall is beyond me.

This woods road trail passes through second- and third-growth forest that alternates between hemlock and hardwood species. Numerous blowdowns foul the trail, but they're more of a nuisance than anything else. The mixed forest surrounding you is pileated woodpecker habitat, so pause often and listen for their extraordinarily loud, high-pitched *kik-kik-kik-kik-kikikik—kik-kik*. This call is startlingly harsh when one is very near. The pileated isn't easy to see, but once spotted, it's loads of fun to watch. It is a large bird, 16 to 19 inches tall, with a dark body and bright red crest, looking like Woody Woodpecker. I heard at least a dozen of these birds on my walk and observed four of them pounding away on downed trees in the woods. Should the falls not be to your liking, this enjoyable woods walk is certainly worth the effort just to experience the pileated woodpeckers and the upland woods of Wyoming State Forest.

Hike 30 Middle Branch Falls, Wyoming State Forest, Sullivan County

THE FALLS

Upper Falls

Type: cascade	**Height:** 11 feet
Rating: 2	

Lower Falls

Type: cascade	**Height:** 22 feet
Rating: 3	**GPS:** 41° 29.552'N, 76° 46.276'W
Stream: Middle Branch of Mill Creek	**Lenses:** 20mm to 50mm
Difficulty: moderate, with a steep climb	**Distance:** .25 mile
Time: 30 minutes	**Elevation change:** 60 feet to base of lower falls

Directions: From the Hillsgrove Ranger Station at PA 87 and Dry Run Road, take PA 87 north 1.75 miles to the narrow, gravel Mill Creek Road. Turn left onto Mill Creek Road, and drive 6 miles to the intersection with Camels Road. Turn right onto Camels Road, and drive 2 miles to a switchback curve over a culvert. There is ample parking near the culvert. GPS coordinates: 41° 29.605'N, 76° 46.366'W.

From the culvert, walk down Camels Road to where the guardrail ends, turn left into the woods, and walk a short distance to the creek's right-hand bank. Turn downstream, and follow the creek to the upper falls at .1 mile. The lower plunge is within sight of the upper. Both falls are accessible from either bank, and the narrow run is easily forded, so you can use either bank to get to the base of the lower falls.

The best view of the upper drop is from a large stone slab on the left-hand side that juts into the tailwaters. This side also provides the safest access to the lower falls should you decide to make a direct descent of the creek rather than divert through the woods. A word of caution before making a direct descent over the ledges: Many siltstone rocks of the glen are loose, so before using any rock as a handhold, give it a firm tug to make sure it won't come out of the wall at some untimely moment. The same thing goes before crawling under any overhangs.

Middle Branch Falls' upper drop is a heavily terraced cascade with a bulbous base that forces its flow into a pleasingly wide fan. This falls is surrounded by fragmented siltstone abutments 12 to 15 feet tall, creating a small hemlock- and birch-covered glen. The lower, 22-foot cascade is more impressive than the upper and has a much larger fan at the base. At low flow, most of the water exits via a channel on the left-hand side; at high flow, the falls' entire 30-foot-wide base is covered with an even veil of water.

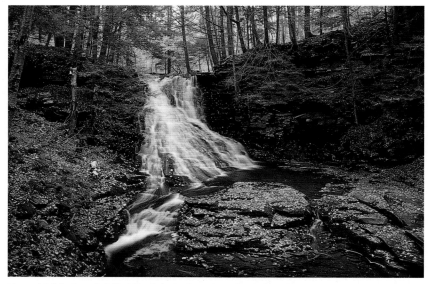

Upper Middle Branch Falls. I liked the leaf cover on the dark rocks. *Canon EOS Rebel Xs, Tokina 20–35, polarizer, Kodak E100VS, f/16 @ 8 sec.*

The smallish plunge pool is choked off by debris just a few feet from the falls. As a result, an extreme wide-angle lens must be used close to the falls. If shooting from anywhere downstream, you'll have to clear away a lot of debris. Several yards below the falls is a series of moss-covered slides and chutes that can be fun to photograph as well.

Hike 31 East Branch Falls, Wyoming State Forest, Sullivan County

THE FALLS

Type: cascade	**Height:** 17 feet
Rating: 2+	**GPS:** 41° 29.098'N, 76° 45.228'W
Stream: East Branch of Mill Creek	**Lenses:** 20mm to 70mm
Difficulty: easy to difficult; steep scramble down to falls	**Distance:** .2 mile
Time: 30 minutes	**Elevation change:** 120 feet

Directions: From the Hillsgrove Ranger Station at PA 87 and Dry Run Road, turn right onto PA 87 north, and drive 1.8 miles to Mill Creek Road. Turn left, and proceed 3.8 miles to the confusing intersection of Mill Creek, Camels, and Walker Roads. Turn right onto Camels Road, and make an immediate left onto Walker. Continue on Walker Road for .5 mile to a wide spot in the road on the left, large enough for perhaps two cars. GPS coordinates: 41° 29.115'N, 76° 45.180'W.

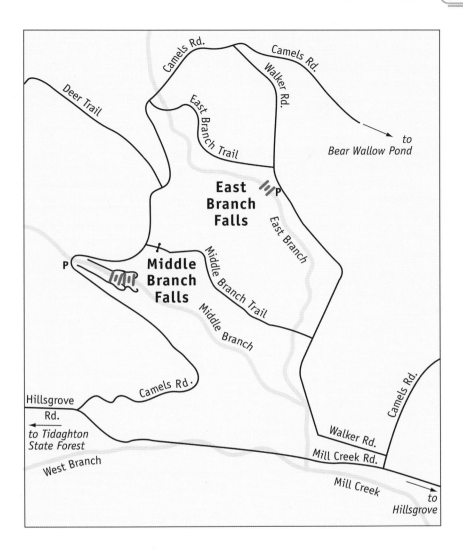

East Branch Falls was a pleasant surprise, and with a falls like this so near the road, it's a must-see no matter what the flow conditions. Although not overly photogenic, this falls has a special quality that is hard to put into words. After scouting more than 130 falls, this was one of the few that caused me to stop and say, "Wow."

If the falls is running with any power, it will be audible from the road. A small footpath descends from the road toward the creek, passing through hemlocks while advancing toward the distinctive sound of falling water. When a slot atop the falls comes into view, turn left to follow a wider and more level path downstream until you're out of the hemlock grove, maybe 30 yards. Look for a washout to your right where the ravine's side has col-

lapsed, creating a less steep slope; scramble down this rockslide to the creek. Turn right and work upstream to the falls. A wispy tree droops over the falls and intrudes on most photo compositions. Get very low and place this tree against a dark background to make it seem to disappear from view.

Hike 32 Angel Falls, Wyoming State Forest, Sullivan County

THE FALLS

Gipson Falls

Type: falls	**Height:** 12 feet
Rating: 2	**GPS:** 41° 23.542′N, 76° 40.646′W

Angel Falls

Type: cascade/slide/cascade	**Height:** 70 feet
Rating: 2	**Stream:** Falls Run
Lenses: 20mm to 70mm	**Difficulty:** moderate; no blazed route
Distance: 2 miles	**Time:** 1 hour
Elevation change: 290 feet	

Directions: From the Hillsgrove Ranger Station at PA 87 and Dry Run Road, turn left onto PA 87 south and drive .7 mile to Ogdonia Road. Turn left onto Ogdonia Road, and go 3.11 miles to the Y intersection of Ogdonia and Brunnerdale Roads. Bear left onto Brunnerdale, and drive .3 mile to a parking area on the left. GPS coordinates: 41° 23.116′N, 76° 40.098′W.

Even after several days of rain, which had every falls in the Wyoming State Forest running full, Falls Run wasn't much more than a vigorous trickle, running so weakly that it passed unseen through a cobble bar where it joined Brunnerdale Run to form Ogdonia Run. In fact, I walked right over Falls Run without knowing it.

From the parking area, enter the forest and walk along Brunnerdale Run, keeping the creek on your left. The route rises slightly through .1 mile, then descends slowly before leveling off at .5 mile. At .7 mile, it meets Falls Run, which enters from your right. Falls Run may appear dry, looking merely like a cobble bar of Brunnerdale Run. Turn right, and proceed up Falls Run's shallow incline to .8 mile and the 12-foot Gipson Falls. It can be hard to tell Gipson from Angel Falls, as they are so close together. Gipson is a distinct ledge, whereas Angel is an indistinct series of slides, cascades, and ledges that begins at the crest of the ridge above.

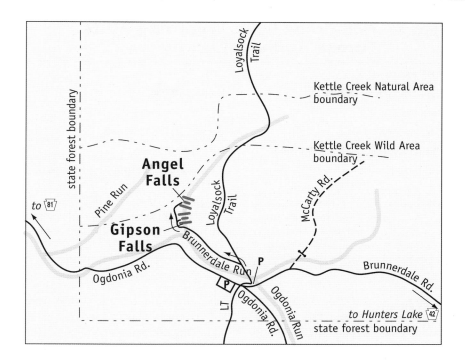

Cross Falls Run, which is not much more than a yard wide below Gipson Falls, to the right-hand bank. Work your way up the creek shed, or climb the slippery bank to get around Gipson Falls, and look up at the boulder-choked slide of Angel Falls. To make Angel Falls' head, it is necessary to work away from Falls Run a short distance, and then switchback your way up the steep slope, using rocks and roots as handholds. This 100-foot ascent is the hike's most difficult part. There's no safe access to any of the intermediate segments of Angel Falls.

Angel Falls is noted in several hiking guides as a must-see destination. One guide even lamented the rerouting of the Loyalsock Trail around Angel Falls, which was necessary because the area had been significantly abused as a result of its popularity. The Forest Service even closed the falls a couple years ago in an effort to revegetate it. This caused an outcry among some hikers, but quite frankly, I don't know what the big deal is. I had been led to believe that this was an immense falls, one of singular natural beauty rivaling its namesake in Brazil. It's not, and for me, Angel Falls actually was disappointing as a landscape subject, although there are lots of interesting graphic compositions to play with.

Hike 33 # Mill Creek Falls, Wyoming State Forest, Sullivan County

THE FALLS

Type: cascades	**Height:** 10 feet
Rating: 3	**GPS:** 41° 27.367'N, 76° 43.505'W
Stream: Mill Creek	**Lenses:** 20mm to 50mm
Difficulty: easy, with a steep climb	**Distance:** .25 mile
Time: 30 minutes	**Elevation change:** 100 feet to base of falls

Directions: From the Hillsgrove Ranger Station at PA 87 and Dry Run Road, take PA 87 north 1.75 miles to the narrow, gravel Mill Creek Road. Turn left onto Mill Creek Road, and drive 1.5 miles to a pullout on the left just wide enough for two cars. GPS coordinates: 41° 27.463'N, 76° 43.478'W.

Was this location a scenic attraction in days gone by? Perhaps. A deep depression next to the road is filled with neatly spaced moss-covered humps that are the remains of railroad ties. This railroad grade parallels the road for some distance and ends near the trailhead. There are faint remains of a walkway and three large holes drilled in the sandstone adjacent to the falls indicate that a handrail was present. If this falls was an old-time scenic attraction, the owners certainly picked a lovely spot for it.

From the pullout along the road, follow a wide footpath leading down-slope to the head of the falls. Crossing Mill Creek above or below the falls is easy, and a quick scramble down either bank will get you to the falls' base, which has an exceptionally deep plunge pool. Mill Creek runs with power even several days after a soaking rain, and as it lies downstream of East Branch and Middle Branch Falls, it can be used as a flow indicator for the other two.

Mill Creek's waters run unusually clear because there are few hemlocks and pines within the creek shed. With mixed hardwood species occupying the drainage basin, there is little tannin in the water to give it the weak tea color characteristic of most creeks in the region. The only real hemlock stand around is the one at the falls, which occupies a large sandstone head-land. As a result, foam in the tailwaters is rarely a problem. Moss grows with profusion from several seeps in the area, and I found a number of red trilliums, which were never more than a few feet from a hemlock. A sizable, perhaps 24-inch-diameter, hemlock leans precariously from a thin stone slab on the right-hand bank below the falls, and when it eventually topples over, it will bridge the plunge pool, making this falls difficult to photograph.

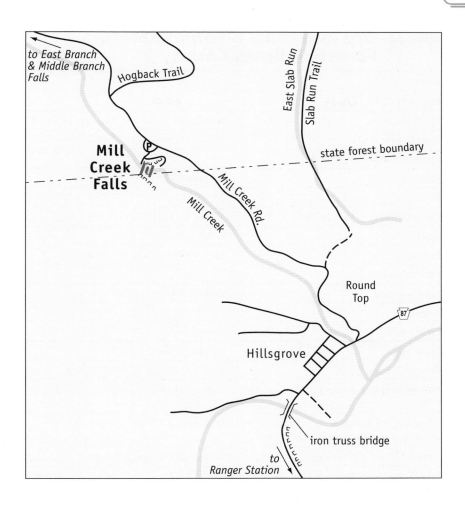

to East Branch
& Middle Branch
Falls

Hogback Trail

East Slab Run

Slab Run Trail

state forest boundary

Mill
Creek
Falls

Mill Creek Rd.

Mill Creek

Round
Top

87

Hillsgrove

iron truss bridge

to
Ranger Station

Hike 34 Dry Run Falls, Wyoming State Forest, Sullivan County

THE FALLS

Dry Run Falls

Type: cascade	Height: 14 feet
Rating: 4	GPS: 41° 25.805'N, 76° 40.230'W

Second Falls

Type: cascade	Height: 15 feet
Rating: 2	GPS: 41° 25.666'N, 76° 39.876'W

Third Falls

Type: slide	Height: 9 feet
Rating: 1	GPS: 41° 25.679'N, 76° 39.693'W

Fourth Falls

Type: cascade	Height: 9 feet
Rating: 2	

Fifth Falls

Type: falls	Height: 6 feet
Rating: 0	GPS: 41° 25.649'N, 76° 39.501'W
Stream: Dry Run and South Branch of Dry Run	Lenses: 20mm to 70mm
Difficulty: moderate to difficult; steep scramble around falls	Distance: 2.2 miles
Time: 2 hours, 30 minutes	Elevation change: 500 feet

Directions: From the Hillsgrove Ranger Station at PA 87 and Dry Run Road turn right onto Dry Run Road. Proceed west 2.1 miles, and park at the Dry Run Falls picnic area on the right. GPS coordinates: 41° 25.805'N, 76° 40.230'W.

A picturesque falls just 50 feet from a picnic area with a barbecue—what more could a hungry photographer ask for? Dry Run Falls is locally famous and quite distinct in appearance. This 14-foot cascade divides around a projecting sandstone slab to form two parallel veils of water that cascade over a bulbous projection at the base, making the falls look like two weeping eyes with a Jimmy Durante–like nose. Dry Run has a large drainage basin that captures all rainfall south of High Knob Vista. As a result, the falls runs well with only moderate rains. After heavy rain, it becomes difficult to shoot because of the high volume of water—exposures of more than about one second come out looking like overexposed, blank white space. Dry Run Falls occupies a mixed hardwood forest with noticeably fewer hemlocks

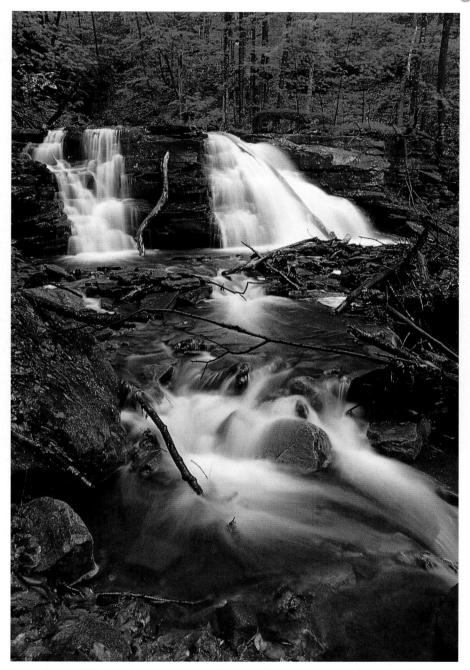

Upper Dry Run Falls. I had to do a lot of preliminary cleaning here, removing pale white birch branches. But the one on the falls' face was unsafe to reach. Sometimes you have to work with the hand you're dealt and hope for the best. *Canon EOS Rebel Xs, Tokina 20–35, polarizer, Kodak E100VS, f/16 @ 20 sec.*

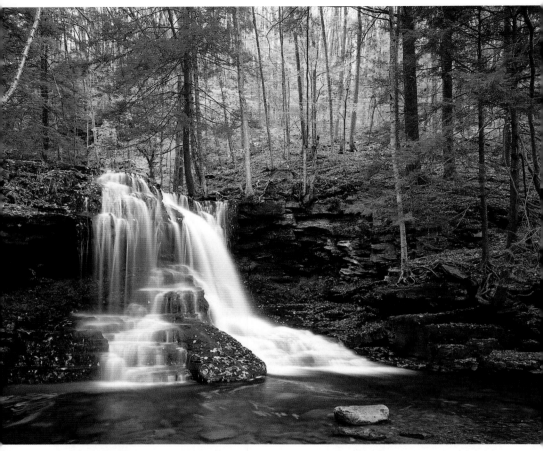

Dry Run Falls. I waited for a rain squall to wet the area down before shooting this. Otherwise the leaf litter in the background would have overwhelmed the film. *Tachihara 4x5, Schneider 90mm Super Angulon, polarizer, Kodak ReadyLoad Holder, Kodak E100VS, f/27 @ 6 sec.*

than most other falls. Its proximity to the road and the well-used picnic area make finding wildflowers difficult. For 50 yards downstream around the tailwater area, all I found was some wood sorrel.

To determine whether the falls of the South Branch of Dry Run are worth visiting, take a hard look at Dry Run's left cascade (the one away from the road). If water on that side is hitting the stone proboscis less than 2 feet from the plunge pool, then there's enough water in the South Branch to make carrying camera gear worth the effort.

Begin by walking up Dry Run Road to the second culvert, and double-check the flow of the South Branch. Walk past the culvert a short distance, about 30 yards, looking to the right for an opening in the trees that appears like a long depression, an old woods road grade, or an abandoned stream

channel. Turn right and follow the depression to the creek, but don't enter the creek. Instead, keep to the high ground along the right-hand bank, continuing upstream until you are forced down into the creek between .15 and .2 mile. At .3 mile, you come to a 15-foot cascade with a minuscule plunge pool. In damp weather, portions of the trail are quite boggy, and blowdowns along the creek can slow your progress.

The falls' small but picturesque glen has numerous little slides, cascades, and burbles to photograph, so take your time getting to this first falls shooting along the way as the spirit moves. To get around the 15-foot cascade, backtrack down the creek a few yards and make a short, strenuous ascent up the right-hand bank, aiming toward a point just upstream of the cascade's head. At a safe distance upstream of the head (about 10 yards), cross the small run and continue upstream along the left-hand bank to .4 mile and a 9-foot slide. Climb the left-hand bank out of the creek, and turn uphill to rejoin the creek about 25 yards above the slide. Continue upstream along the left-hand bank, keeping an eye out for the trail on the opposite bank. Then cross the creek to the right-hand bank, and follow this footpath upstream to .5 mile and a 9-foot cascade. The Loyalsock Trail descends from your left to join the creek near this third falls. While walking between the 9-foot cascade and the Loyalsock Trail junction, look for the distinctive hand-size forepaw prints of black bears in the seeps and boggy places. I found ample evidence of bears in the area, including prints, scrapes, and spoor at several places along the way.

Proceed upstream on the right-hand bank, following the red and yellow Loyalsock Trail blazes to a 6-foot falls and campsite at .7 mile. Besides looking for bear sign, observe how the glen changes as you ascend the ridge. The sides of the ravine become less steep and the vegetation less lush, until the ravine peters out into a broad depression at the campsite.

To return to your car, follow the Loyalsock Trail uphill away from the campsite. At 1.2 miles, the trail crosses an old woods road which is the combined Dutters and High Landing Trails. Turn right to follow the red-and-orange-blazed woods road. At 1.7 miles, the orange-blazed High Landing Trail bears left, climbing away from the descending red-blazed Dutters Trail. Bear right, following the red-blazed Dutters Trail to 2.1 miles and Dry Run Road. Turn left onto Dry Run Road, and walk back to Dry Run Falls' picnic area at 2.2 miles.

A return loop via the Dutters Trail provides a chance to observe the difference in forest habitat between the creek shed and the uplands. The trees of the creek shed are larger and the forest floor vegetation lusher; the upland forest ranges from saplings to widely spaced mature second-growth trees. There's also ample opportunity to look for more bear sign at a wide grassy area where the Loyalsock Trail and High Landing Trails intersect.

Hike 35 Buttermilk Falls, Shunk, Sullivan County

THE FALLS

Type: cascade	**Height:** 43 feet
Rating: 5	**GPS:** owners provide directions, as noted below.
Stream: Fall Run Creek	**Lenses:** 20mm to 90mm
Difficulty: moderate	**Distance:** 100 yards
Time: 20 minutes	**Elevation change:** 100 feet

Directions: From the intersection of PA 154 and PA 87 in the village of Forksville, take PA 154 west for 10 miles to the village of Shunk. In Shunk, PA 154 turns right at the Shunk General Store. Go straight onto SR 4002 toward Tomkins Corner. Follow SR 4002 for .5 mile to the Buttermilk Falls Campground on the left. Admission fee of $15/night for camping. GPS coordinates: 41° 32.317'N, 76° 44.776'W.

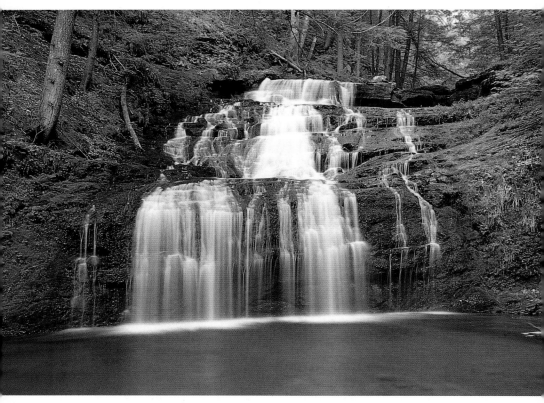

Buttermilk Falls. The bare rocks in the foreground did not complement the falls well, so a more traditional portrait was in order. *Canon EOS Rebel Xs, Tokina 20–35, polarizer, Kodak E100VS, f/16 @ 8 sec.*

Buttermilk Falls is open only to campers and guests, and if you've never camped before, this is a good time to start: This 43-foot cascade is one of Pennsylvania's hidden gems. In fact, I would say it's the best falls in the Tiadaghton area. It's uncommon to have a broad creek running with such power at this elevation. Drainage basins aren't normally this large, so Buttermilk Falls is a rare thing lying 1,600 feet above sea level. The steep descent to the falls is short, and the Minniers will have to direct you. The family-oriented campground is large, with the camp's office doubling as the Ellington area's general store. You can even get a pizza, and a darned good one at that. All in all, this falls is well worth the $15 price of admission for a night's camping.

Beginning its drop as a 10-foot-wide chute, this cascade fans out to more than 50 feet wide as it cuts through a series of red sandstone and shale ledges. With the falls' base and tailwater area free of debris, the compositional possibilities are endless. Large stone slabs occupy several spots in the creek and make perfect shooting perches. This falls is a popular spot for summer bathers, so the slabs are free of moss.

A narrow glen filled with large hemlocks and dry loamy soil surrounds the falls, with tall, healthy hemlocks framing the fall's head. Undergrowth is sparse and wildflowers are few. Flagging ledges that you pass near the base of the falls are parabolic in shape and reflect the falls' roaring sound remarkably well, causing an odd tone to appear to emanate from deep within, as if the groaning stone face itself were alive and angry.

After you've seen Buttermilk Falls, I recommend a quick hike around the 3-mile-long blue-blazed loop trail at nearby Devils Elbow Natural Area, which is just 6 miles away in Tiadaghton State Forest just north of Ellenton on Ellington Mountain Road (SR 1013).

Hike 36 Bradford Falls, State Game Lands No. 36, Bradford County

THE FALLS

Type: cascade	Height: 63 feet
Rating: 3	GPS: 41° 38.799′N, 76° 35.767′W
Stream: Falls Creek	Lenses: 20mm to 50mm
Difficulty: moderate to difficult	Distance: 1.6 miles
Time: 1 hour, 30 minutes	Elevation change: 300 feet

Directions: From the intersection of PA 154 and PA 87 in the village of Forksville, take PA 154 west for 2 miles to the village of Estella. In Estella, turn right onto SR 4009 and drive 2.6 miles to the village of Bedford Corners. Turn left onto SR 4011, taking it 1.6 miles to the village of Hugo Corners. At the intersection of SR 4011 and SR 4016, turn left onto SR 4016 and drive .7 mile, then turn right onto T 445. Follow T 445 for .8 mile, then turn right onto Minersville Road. Follow Minersville Road for 4.8 miles to where Laquin Road intersects from the left to become Schrader Creek Road. Continue ahead on Schrader Creek Road for 1.4 miles, and look for a large pile of crushed limestone on the left just as you cross Falls Creek. Park in front of the pile of stone. GPS coordinates: 41° 38.486′N, 76° 35.608′W.

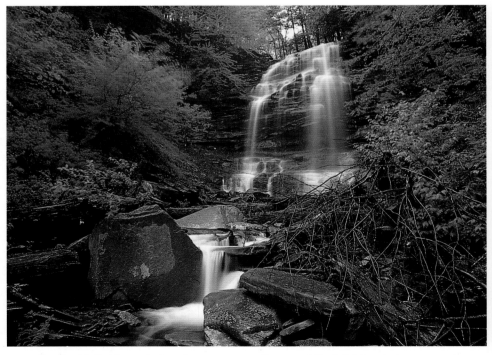

Bradford Falls. The rocks here have an orange tinge, and the falls' face lacks moss and algae. *Canon EOS Rebel Xs, Tokina 20–35, polarizer, Kodak E100VS, f/16 @ 8 sec.*

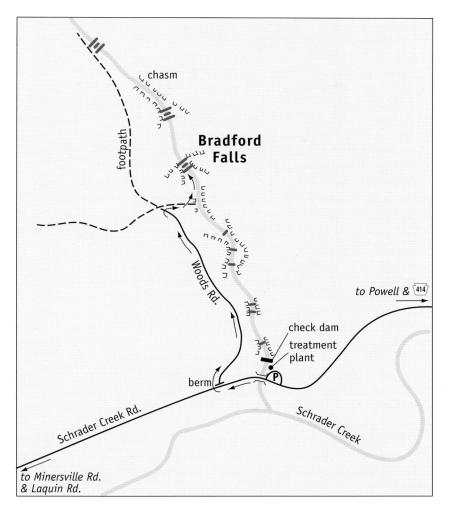

Although it's in the top fifteen of Pennsylvania waterfalls by height, Bradford Falls is not very photogenic. From a purely environmental perspective, however, Bradford Falls and Falls Creek are worth a visit. Near the parking area, look for a small sign nailed to a tree that describes the acid mine water treatment plant before you. Water is diverted into a large underground cistern filled with crushed limestone by a check dam upstream. There it flows through the acid-neutralizing stone and returns to the creek via a section of white plastic pipe. The acidic water dissolves the limestone in the cistern, and a logbook nearby notes that between 120 and 160 shovelfuls of stone are used every couple months. Upstream of the check dam, rocks in the creek look rusty, and below the bridge, they do not. What you are looking at is an effort to mitigate acid mine drainage emanating from an abandoned strip mine on the mountain. A few notes in the logbook left by

hikers and hunters compliment the Game Commission and Department of Environmental Protection for their efforts to control the problem, to which I offer my kudos as well.

Acidic mine water does more than just discolor rocks in the creek; it affects the plants and animals that reside in the creek as well. You won't find any wildflowers or mosses in the creek shed. The only plants there are those that thrive in poor soils, such as birches. Bradford Falls itself has no hanging moss gardens, no green algae patina to its face, and no lush algae blooms in its tail-waters—none of the things that make other waterfalls so vibrant. It is as dead looking as a garden center water feature.

There are two routes to the falls. The more difficult approach is to go straight up the narrow ravine of Falls Creek, staying to the right-hand bank as much as possible. This route is a real workout.

The other, and the one I strongly recommend, is to walk up the old Laquin Road, which is located about 100 yards west of the parking area. Follow the wide Laquin Road uphill for .5 mile to where it fades into a footpath as it crosses a narrow side drainage. Turn right and follow this narrow cobble-filled drainage channel downhill, keeping to the right-hand side. The little channel starts off level, but at about .54 mile it starts to descend, quickly becoming steeper. Turn left here and cross over to the left-hand bank. Walk away from the little channel while also continuing downhill toward Falls Creek, which you'll reach at .56 mile. This bushwhacking overland detour away from the little channel avoids a boulder slide where it joins Falls Creek. Now at Falls Creek, turn left and walk upstream on whatever side of the creek looks more favorable to you. At .7 mile, the falls comes into view, and at .8 mile you come to the base of the 63-foot cascade.

The uniformly cut hemlock logs that clog the tailwaters of Bradford Falls are the result of demands for hemlock bark, not lumber. Hemlock bark was harvested for its tannin, and the bark was cooked into a kind of tea that was refined into tannic acid used in making leather, hence the term leather tanning. Seemingly endless groves of hemlock were clear-cut to meet the leather industry's demands, and trees were felled and debarked where they lay. The logs you see clogging the creek were just considered refuse by the lumber industry. Most of the logs measure about 18 inches in diameter, which is average for a mature stand of hemlock. After the forest was gone, the ridge above was strip-mined, and that abandoned mine is the source of the acid mine drainage affecting Falls Creek.

A hike up Falls Creek provides many things for the casual naturalist to observe. The biggest surprise for me was finding two red newts. These 3-inch-long amphibians have vibrant translucent orange skin that provides a haunting look at their internal organs. Unlike the dark-colored, shy aquatic adult form, these bright orange terrestrial juveniles, known as red efts, boldly wander around the forest floor, their bright coloration announcing to any would-be predator that their skin is toxic. As I gently herded one of the

newts onto a bed of bright green moss, I realized I had no macro equipment in my backpack. Thus I missed one of those incredible photographic opportunities that favor those who are prepared.

Hike 37 Jacoby Run Falls, Tiadaghton State Forest, Lycoming County

THE FALLS

Type: falls	**Height:** 31 feet
Rating: 3	**GPS:** 41° 23.407'N, 76° 54.082'W
Stream: Jacoby Run	**Lenses:** 20mm to 75mm
Difficulty: easy to moderate	**Distance:** 3.5 miles
Time: 2 hours, 30 minutes	**Elevation change:** 480 feet

Directions: From the intersection of PA 973 and PA 87 in the town of Loyalsockville, take PA 973 west across the Loyalsock Creek, and make an immediate right onto Wallis Run Road (SR 1003). Proceed 4.3 miles to a large clearing at the Cottoner Farm Wildlife Rehabilitation Area, and park in the large gravel parking area on the right. GPS coordinates: 41° 22.608'N, 76° 55.229'W.

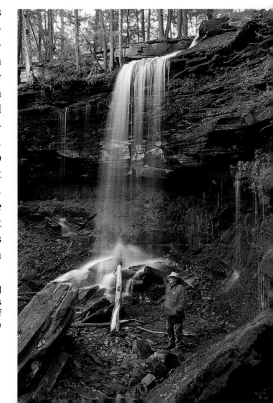

Most of the hike into Jacoby Run is along a convenient pipeline right-of-way that provides a wide path up the valley. Begin the hike from the Cottoner Farm parking area, and proceed across a narrow boardwalk into the woods ahead. Upon entering the woods, the unblazed trail turns right, becoming a wide footpath passing through a plantation of white pine. Soon after the boardwalk, look for a seep emanating from the hill on your left that dampens a wide area of rich black soil. Here I found the largest mayapples I have ever seen. A normal mayapple leaf is about as large as an open hand. These plants were the size of large dinner plates, with

Ed Lease at Jacoby Run Falls. I had Ed wear a red windbreaker so that he would stand out in this scene. He also had to remain very still because of the long exposure. *Canon EOS Rebel Xs, Tokina 20–35, polarizer, Kodak E100VS, f/8 @ 6 sec.*

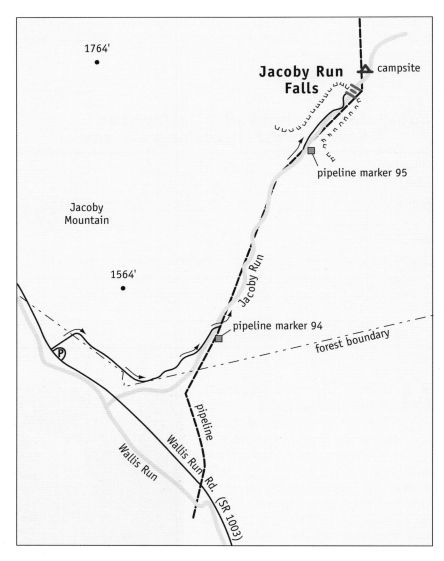

flowers measuring almost 2 inches across. Continuing past the monster mayapples, the pines suddenly give way to a healthy hemlock forest that fills the valley all the way to the falls.

Where the hemlocks begin, the trail begins a long, sweeping left turn around the nose of Jacoby Mountain to enter the valley of the run. This circuitous approach avoids a private landholding on your right with boundaries marked on trees by three ax marks filled with white paint. At .6 mile, the trail approaches the run but doesn't cross it, and a pipeline right-of-way is visible on the opposite side. Look for a metal post with an aerial viewable panel with the number 094 on it. When you see it on your return, this panel

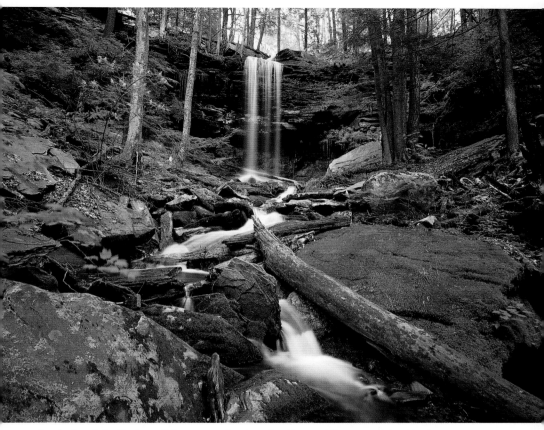

Jacoby Run Falls. The incredible green rocks of Jacoby Glen. *Tachihara 4x5, Schneider 65mm Super Angulon, polarizer, Kodak ReadyLoad Holder, Kodak E100VS, f/32 @ 8 sec.*

will mark the point where you leave the pipeline to reenter the woods. Continue up the woods path, and at .75 mile exit the woods and begin walking up the pipeline right-of-way. While the pipeline runs straight up the valley, Jacoby Run meanders back and forth. At .9 mile, make the first of several creek crossings. The creek is never more than two big strides wide, and in some places it will even disappear below the rock fill of the pipeline.

At the second creek crossing, stop and make a 360-degree sweep of the valley. Notice anything? Almost every other hike in this guide is along a creek that occupies a narrow, V-shaped ravine or cliff-edged glen, with hardwoods predominating and hemlocks found only near the ledges that head a waterfall. That's not the case here. This valley is a flat-bottomed U, the sides of which are shallow in slope. Widely spaced, nearly mature hemlocks occupy the valley, and hardwoods are limited to the heights of Jacoby Mountain. This is the opposite of the other hikes in this guide, except for those in the Delaware Water Gap, making this valley a delightful rarity.

At 1.6 miles, another aerial panel, this one numbered 095, marks the entrance to a magical little glen. It's your choice whether to follow the pipeline to the head of the falls, and then scramble down, or to proceed up the creek on the right-hand bank. I prefer the creek-side approach, since the falls slowly reveals itself from behind the cover of trees.

Once the thin veil of the falls is visible, the glen opens up into a broad amphitheater with 45-foot cliffs. The whole glen is green with moss, and its floor is carpeted in wood sorrel and snow flower. Seeps drip from the ledges all around, which are green with hanging moss gardens, and rhododendrons hang from the higher places. Despite the harsh invasion of the pipeline above the falls and along the top of the ledges to your right, this 200-yard-long glen is vibrant green and healthy. Jacoby Run doesn't carry much water due to the size of its drainage basin, so the falls is best after a very wet period or a soaking rain. In damp conditions, regardless of stream flow, this lush environment renders on film a vivid green that's hard to describe. Linger and take time to explore this little glen, and bring lots of film along too, because this is an extraordinary place to photograph.

Hike 38 Hounds Run Falls, Tiadaghton State Forest, Lycoming County

THE FALLS

Type: cascade over falls	**Height:** 26 feet
Rating: 3	**GPS:** 41° 32.215'N, 76° 53.882'W
Stream: Hounds Run	**Lenses:** 20mm to 50mm
Difficulty: moderate	**Distance:** .75 mile
Time: 1 hour	**Elevation change:** 230 feet

Directions: From the intersection of PA 154 and PA 87 in the village of Forksville, take PA 154 west for 10 miles through the villages of Estella and Lincoln Falls to the village of Shunk. In Shunk, where PA 154 turns right, proceed straight on SR 4002 toward Tomkins Corner and Ellenton for 3.7 miles. In the village of Ellenton, you come to a Y intersection. Turn left onto Ellenton/Pleasant Stream Road (SR 1013). Drive 1.1 miles to the next Y, and bear right onto Ellenton Ridge/Yellow Dog Road. Drive 5.4 miles along the descending Ellenton Ridge/Yellow Dog Road to where it crosses Rock Run, and continue for another .2 mile to where it crosses Hounds Run. Park adjacent to the bridge that carries Hounds Run under Yellow Dog Road. GPS coordinates: 41° 32.039'N, 76° 53.636'W.

There are two ways to get to Hounds Run Falls: the direct approach up the creek, or a route that follows part of an old logging road, which keeps your feet dry that much longer. To take the direct and wetter approach, go

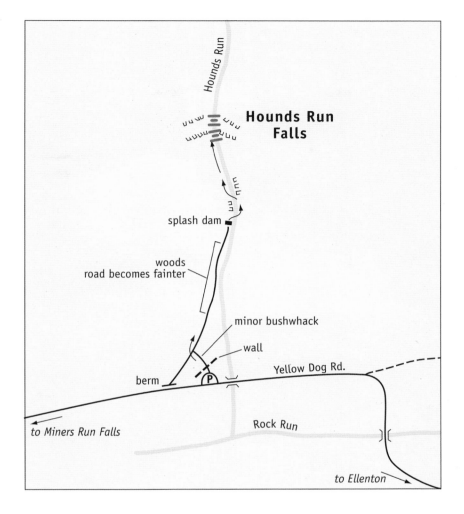

straight from the parking area to the right-hand bank of the creek, and proceed upstream .3 mile to the falls, fording from side to side as needed.

The walk up the creek is not hard; however, I prefer the drier approach. From the parking area, walk up a small rise to your left while angling away from the creek. Within a few yards, you come to low stone wall at the top of a small rise. Hop over the wall and you find yourself on an old woods road. Turn right onto this road, and follow that descending path toward the creek. At approximately .2 mile you come to another low stone wall adjacent to the creek. This is the remnants of an old splash dam, used by loggers about a hundred years ago. Shortly after the splash dam, you're forced to cross to the left-hand bank. Advance upstream several yards, and then cross back to the right-hand side when forced to. You will come to the falls at .35 mile.

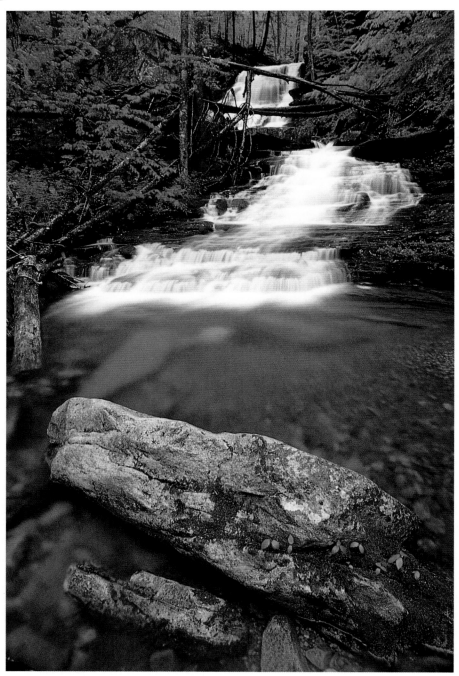

Hounds Run Falls. Even though I wet the foreground boulder, its lichen cover is still very bright. Carefully meter the entire scene, looking for highlights that might ruin the shot. *Canon EOS Rebel Xs, Tokina 20–35, polarizer, Kodak E100VS, f/22 @ 2 sec.*

About 40 feet of smooth sandstone separates the upper and lower plunges. The head of the upper plunge can be made from either side of the creek, but the right-hand bank is easier, as boulders that have fallen from the ridge above provide a convenient set of makeshift stairs.

At the base of the upper plunge are two immense slabs of coarse-grained sandstone that don't appear to be from the ledges abutting the fall. Their coarse texture, as well as the surrounding pieces of conglomerate, hints that these huge slabs came from a much higher elevation, perhaps even from the ridge 600 feet above the falls. It's probably safe to say that these car-size slabs of stone were deposited here by the Wisconsin ice sheet and have remained in this spot since it retreated about ten thousand years ago. Besides big rocks to wonder about, there are many plants to investigate. Cloverlike wood sorrel carpets large areas of the creek shed, and its pale purple bloom lends a bright note to the area. Numerous lush moss beds indicate the presence of seeps, and the types of moss indicate the flow and mineral content. Adjacent to the lower plunge, small white flowers of goldthread occupy a 4-foot-wide swath of soil, which can be used as a pleasing foreground.

Look around carefully at the second- and third-growth mixed hardwood forest to see if you can figure out its history. It has a moderately healthy understory, so not many deer are around. As with other falls in the area, the rocky head is surrounded by hemlocks, but they are not visible elsewhere. Crystal-clear water coming over the falls provides evidence that hemlock and pine do not occupy much of the creek shed upstream. What few hemlocks are found are rather small, with most being only a few inches across. Birches appear in large numbers not only in the ravine, but also on the shallow slopes of the surrounding ridges, indicating heavy soil erosion. All of this points to relatively recent logging being done here, of which the solid-looking splash dam provides some evidence. I would hazard a guess that this valley was clear-cut during the 1920s and that the ridge lay exposed to the weather for a long time before recovering naturally.

A walk up Hounds Run is full of ecological and historical intrigue that to me is actually more interesting than the photography. Don't get me wrong, this is a fun place to take photographs, and I'd recommend it for anybody's must-shoot list. It's just that I'm always curious about how a location I'm photographing came to be, and in this case I have to wonder how fantastic this place must have looked 150 years ago.

Hike 39 Miners Run Falls, Rock Run Cataracts, Tiadaghton State Forest, Lycoming County

THE FALLS

Type: cascade	**Height:** 9 feet
Rating: 2	**GPS:** 41° 30.979'N, 76° 55.014'W
Stream: Miners Run and Rock Run	**Lenses:** 20mm to 50mm
Difficulty: easy	**Distance:** 50 yards
Time: 10 minutes	**Elevation change:** 10 feet

Directions: From the intersection of PA 154 and PA 87 in the village of Forksville, take PA 154 west for 10 miles through the villages of Estella and Lincoln Falls to the village of Shunk. In Shunk, where PA 154 turns right, proceed straight on SR 4002 toward Tomkins Corner and Ellenton for 3.7 miles. In the village of Ellenton, you come to a Y intersection. Turn left onto Ellenton/Pleasant Stream Road (SR 1013). Drive 1.1 miles to the next Y, and bear right onto Ellenton Ridge/Yellow Dog Road. Drive 5.4 miles along the descending Ellenton Ridge/Yellow Dog Road to where it crosses Rock Run, and continue for another 1.9 miles to where it crosses Miners Run. Park adjacent to the bridge that carries Miners Run under Yellow Dog Road. GPS coordinates: 41° 30.930'N, 76° 55.039'W.

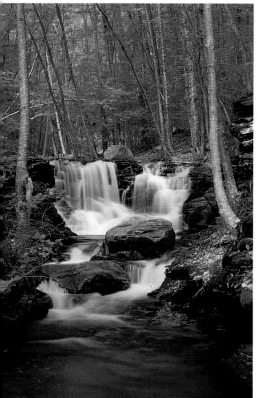

Miners Run Falls is visible from the bridge that carries Yellow Dog Road over Miners Run. Positioned pleasingly within a stand of straight white and silver birches, this small but enjoyable waterfall makes for some fine environmental landscape images. Restricting wide-angle shots are three glacial erratics, large boulders that dominate the falls' left side. One of these erratics is truly enormous, roughly the size of a large SUV.

As a photographic bonus, three narrow cataracts grace Rock Run, which Miners Run feeds into. The first cataract on Rock Run is just downstream of Miners Run, the second .43 mile upstream and the third .6 mile upstream. Private cabins stand near

Miners Run Falls. Note the extensive birch forest and lack of hemlock. *Canon EOS Rebel Xs, Tamron 28–200, polarizer, Kodak E100VS, f/16 @ 6 sec.*

each chute; *do not* park in any gated driveways. Instead, use the parking areas on the road's north side. These cataracts are very photogenic. Have some fun creating graphic compositions by exploring the interesting shapes the flowing water assumes as it twists through each chute.

Standing in the cobble-filled shallows downstream of each chute provides the best shooting locations. Very deep plunge pools sit below each chute, however, making it difficult to get close when the creek is running full. I recommend photographing Rock Run after mid-May when spring runoff subsides. Because Rock Run is a well-known trout stream and a popular summer bathing spot, the three large pools can become crowded anytime the weather is nice. But don't worry; you should be able to shoot Rock Run whenever it's cool, wet, and delightfully dreary, which always keeps the nonphotographers away.

Hike 40 Fall Brook Falls, Tioga State Forest, Tioga County

THE FALLS

Upper Falls

Type: slide	**Height:** 14 feet
Rating: 2	

Lower Falls

Type: falls	**Height:** 7 feet
Rating: 2	**GPS:** 41° 40.654'N, 76° 59.281'W
Stream: Fall Brook	**Lenses:** 20mm to 50mm
Difficulty: easy	**Distance:** .5 mile
Time: 30 minutes	**Elevation change:** 60 feet

Directions: From the intersection of PA 14 and PA 414 in the town of Canton, take the combined PA 14/414 south for 1.5 miles, then turn to follow PA 414 south 3.3 miles to the village of Gleason. In Gleason, PA 414 makes a sharp left at the intersection with SR 2021. Turn right onto SR 2021, following it for 3.8 miles toward County Bridge Picnic Area. At the T intersection of SR 2021 and River Road (SR 2014), turn left, and proceed for 2.7 miles to a large parking area on the left. GPS coordinates: 41° 40.741'N, 76° 59.370'W.

This short hike around the former Fall Brook Picnic Area isn't really a hike, it's a walk. Duck under the gate and proceed a few dozen yards to where a broad path enters a stand of pines on your left. Follow this path across a small stone footbridge along the right-hand side of Fall Brook. Handrails

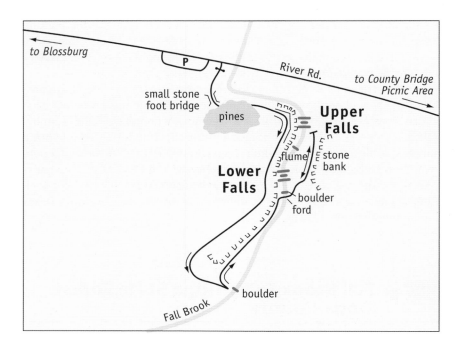

restrict you to ledges above the brook's upper slide, confining your view to just a small portion of the upper drop. The tailwaters of this wide, sliding cascade gather below the falls to rush with great speed down a canted stone slab, which creates a narrow flume, most of which is out of view.

Continue following the handrail, and where it makes a sharp left, follow a path up and over the small knoll ahead. At the top of the knoll, the path makes a broad left-hand turn and descends to Fall Brook, meeting it at a large, graffiti-covered boulder below the second falls. From here the small glen can be accessed by turning left (upstream) and walking across large stone slabs that form the right-hand bank. Ahead, the route along the brook is blocked, so scramble up the 15-foot loose slope to your left and find a boot-wide footpath at the base of the ledges (which support the handrail above). A few feet above the brook, bituminous coal can be found poking from the slope. Its presence so close to the surface is why this area was extensively strip-mined.

At the base of the ledges, proceed 30 yards upstream to the base of the lower falls. Look for half a dozen painted trilliums along the way. Two that I found right at the base of the ledge were fine, large specimens that made excellent macro subjects. At the base of the lower falls, a gnarled old silver birch makes a nice little headknocker. I thought I had ducked low enough to get by, but instead received a nice whack on the back of my head for my incomplete effort. This birch marks a good spot from which to shoot the lower plunge. With some careful rock hopping, you can easily cross the

plunge pool. A long slide exits the pool, and the swift flume of water slams into two boulders a few feet down from the crossing point.

Once across the brook, scramble up the 7-foot-tall ledges on the left-hand side of the lower plunge. The upper slide can be reached in short order, but only by shuffling along the edge of slick moss- and leaf-covered stone slabs that form Fall Brook's upper flume. *Warning:* A slip here will put you into the flume and possibly over the lower falls, so it's extremely important to stick to the soil-covered bank, even if it means crawling under low-hanging hemlock boughs. The flume's stone slabs have interesting striations and patterns to use as foregrounds. Some compositional work is needed to make an image look balanced, however, because the tall gray ledges adjacent to the falls rise only on one side.

Hike 41 Bent Run Falls, Allegheny National Forest, Warren County

THE FALLS

Type: slides and cascades	**Height:** 31 feet
Rating: 2	**GPS:** 41° 50.097'N, 78° 59.817'W
Stream: Bent Run	**Lenses:** 20mm to 50mm
Difficulty: easy	**Distance:** 20 yards
Time: 10 minutes	**Elevation change:** 40 feet

Directions: From the US 6 Allegheny River bridge at the south end of Warren, take US 6 south .2 mile to PA 59. Bear left onto PA 59, and drive .4 mile to the PA 59 cutoff in Rogertown, turning left onto PA 59 proper. Proceed along the Allegheny River for 6.6 miles to the Bent Run Falls parking area on the right. The large gravel lot is only .4 mile east of the Kinzua Dam. GPS coordinates: 41° 50.097'N, 78° 59.817'W.

It's hard to determine how tall this falls actually is, because there is no distinct precipice, although it has a well-defined base at the culvert that carries PA 59 over Bent Run. One segment of the falls' thin horsetail slide is visible from the road. Bent Run flows weakly, and its entire drainage area is defined by the forest road FR 160 between Jakes Rock and Seneca Reservoir, so this rather small, steep 2-mile-long run can be dry much of the year. Normally it's just a thin ribbon of water that's worth stopping to look at but not to shoot. After a good rain or during spring snowmelt, however, Bent Run is quite full, showing off the many twists and turns for which it's named.

At the head of the falls are several large blocks of conglomerate that have crept down from higher up on the ridge. These are same kinds of blocks seen

at a rock city known as Jakes Rocks Overlook, which is only 1.3 miles away as the crow flies but 6.1 miles by road. The large blocks that choke the head of the falls hide the watercourse until its first 4-foot slide over a sandstone slab. From there the falls twists along, disappearing and reappearing several times before bottoming out on a concrete slab in front of the road culvert.

Hike 42 Hector Falls, Allegheny National Forest, Warren County

THE FALLS

Type: falls	**Height:** 22 feet
Rating: 2	**GPS:** 41° 41.118'N, 78° 58.504'W
Stream: Hector Run	**Lenses:** 20mm to 50mm
Difficulty: easy	**Distance:** 2 miles
Time: 1 hour	**Elevation change:** 250 feet

Directions: From Warren, take US 6 east 17 miles to the village of Ludlow. Turn right onto South Hillside Road (T 315) .4 mile after crossing into McKean County, then turn left at the T intersection onto Water Street (T 314) to follow signs for the Tionesta Scenic Area. Drive .2 mile on Water Street, and make the first right onto Scenic Drive (T 471/FR 133). Shortly after crossing railroad tracks, the road begins to climb and changes from asphalt to gravel. FR 133 climbs quickly, passing a few houses on the left. At the first intersection, 1 mile from the railroad, bear right onto Cherry Run Road (FR 258), and proceed 2.1 miles to the gated FR 330 on the left. Park near the gate but do not block it. GPS coordinates: 41° 41.712'N, 78° 58.845'W.

It was unfortunate that I arrived at Hector Falls on a sunny day, when bright highlights dappled the immense sandstone blocks forming the falls. A return trip several days later was in much better light, for which I paid a hefty price. This was one of the few waterfalls that my wife went with me to shoot, and it was also the only time I didn't take raingear along, so of course a thunderstorm popped up, sending us running for the car. We didn't make it, not even close. We had to hunker down in the woods near a gas well and wait out the brief but violent storm, which spawned a tornado nearby in Forest County. There's nothing like being caught in a lightning storm with a tripod to get one's attention!

The trail to the falls is a pleasant road walk. Go around the gate and proceed down FR 330 for .7 mile. Turn left onto a rock-strewn road, and continue downhill to a blue-painted gas well head at .8 mile. From the well head, look for a series of machine-placed boulders on the south side of the open area surrounding the well. Walk between the boulders, and proceed

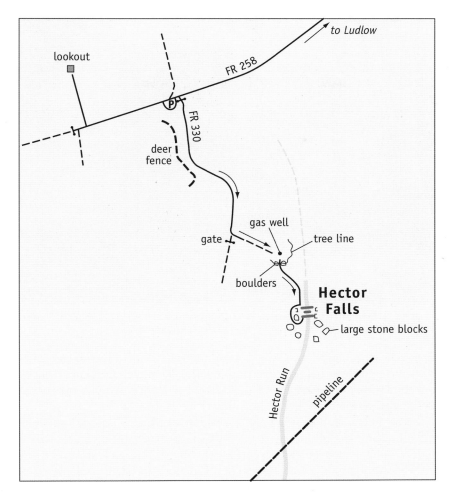

down the wide and sometimes muddy path that parallels Hector Run, which sits a few yards away to your left. Continuing down the path, at 1 mile you come to a series of house-size sandstone blocks. Hector Falls occupies a large cleft between a standing block and a well-weathered fallen block.

During the walk in, look for a tall deer fence on the right at .5 mile. Note the dense understory within the deer exclosure, and compare that with the open woods to the left. There's a dense carpet of ferns, but there are no small trees as far as the eye can see on the left side of the road. This is a prime example of why the State Game Commission, National Forest Service, and State Bureau of Forestry have joined forces to manage the deer population as a forest ecology issue. Simply put, the deer are eating Penn's Woods, and with a dwindling number of hunters and no natural predators, the deer population has gotten too large for the forest to support. With no young trees to replace the older ones, the forest is slowly dying because its ability

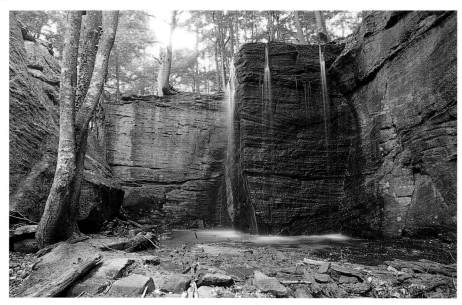

Hector Falls. Even when it runs weakly, this falls is unique and is well worth the trip. *Canon EOS Rebel Xs, Tokina 20–35, polarizer, Kodak E100VS, f/22 @ 10 sec.*

to regenerate is being eaten. The deer control issue is a hot-button subject in the state's northern-tier counties, and if you'd like more information, check out the Game Commission and Department of Conservation and Natural Resources websites.

Hector Falls is an interesting geologic feature to examine. Hector Run drops over the point of a 22-foot-tall by 10-foot-square block of sandstone, which barely touches two other nearby blocks. Blocks that have already been cleaved away from the falls area lie jumbled along the shallow flank of the Tionesta Valley. These blocks of conglomerate form a rock city, which is a periglacial feature, or a feature not directly formed by the grinding power of a glacier. As far north as Hector Falls is, the glaciers of the last ice age didn't make it this far, with the glacial front stopping north of Warren. The region along this glacial margin resembled the arctic tundra and was subject to a great deal of freeze-thaw temperature swings. The action of frost wedging split off these immense blocks of stone, which were then slowly dragged downslope by soil creep. Rock cities can be found along the upper reaches of most valleys in the Allegheny National Forest. The best known is Jakes Rocks Overlook near Bent Run Falls.

A closer look at the blocks nearest Hector Falls reveals another interesting feature: Each block has distinct layers of sediment, and the grain structure of each layer runs in a different direction. Closest to the ground is a distinctive layer that looks like weathered concrete, with the grains running toward the upper right. Immediately above, the grains run to the upper left, and this

pattern alternates in 2-foot-thick beds all the way to the top of the ledge. This is known as cross bedding. These coarse cross-bedded deposits of the Pottsville group were laid down during the Pennsylvanian and Mississippian periods between 290 and 365 million years ago and are the result of alluvial wash from an ancient, long-since-vanished mountain range called the Acadian Mountains.

Hike 43 Logan Falls, Allegheny National Forest, Forest County

THE FALLS

Type: cascade	**Height:** 9 feet
Rating: 2	**GPS:** 41° 35.296′N, 78° 9.506′W
Stream: Logan Run	**Lenses:** 20mm to 50mm
Difficulty: moderate	**Distance:** 1 mile
Time: 45 minutes	**Elevation change:** 225 feet

Directions: From Warren, take US 6 east 10.4 miles to Sheffield, and bear right onto PA 666. Follow PA 666 for 2.4 miles toward Barnes, then turn right and continue on PA 666 for another 6.6 miles to the village of Lynch. In Lynch, turn left onto Blue Jay Road (SR 1003), crossing Tionesta Creek. Proceed 1.2 miles to a sharp right turn onto Job Corps Road (FR 128), which climbs rapidly. Continue for 5.2 miles to Deadman Corner. At this five-point intersection, bear right onto FR 180, and drive 2.5 miles to a grassy parking area on the right. GPS coordinates: 41° 35.082′N, 78° 9.593′W.

Although Logan Falls is just 9 feet tall, the pleasant walk down a narrow woods path passes through lush, photogenic forest terrain, which makes the effort to visit the falls worthwhile. From the grassy parking area, plunge into the woods and proceed straight downslope toward Logan Run. You soon come to a woods path that leads all the way to the falls. If you miss the path, don't worry; just continue downhill to the run. At .1 mile large blocks of conglomerate from the 360-million-year-old Pottsville Formation appear on the left. When first viewed, they appear large, but not overly so. While moving downslope, however, your perspective changes, and it soon becomes apparent how large these blocks are. Some are truly immense and can only be described as house-size. A long line of large blocks runs for up to half a mile along the ridge, and each is more impressive than the last.

The forest floor is covered in dense, waist-high undergrowth that requires long pants for any off-trail excursion, and every flat stone surface has ferns and moss clinging to it in abundance. With rain or damp conditions, the

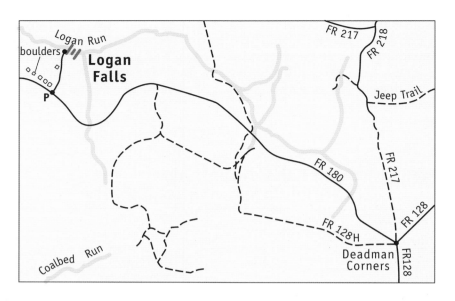

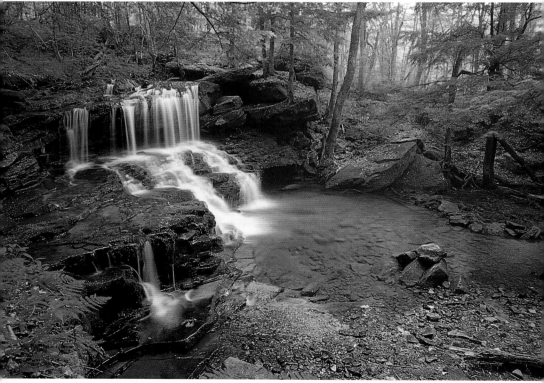

Logan Falls. Normally a cairn would be an unnatural intrusion on a waterfall image. However, I felt it was a unique element of the environment and so I decided to work with it. *Canon EOS Rebel Xs, Tokina 20–35, polarizer, Kodak E100VS, f/16 @ 4 sec.*

large conglomerate blocks, with their moss and algae covering, take on a green patina. In the failing light of day, this rock city slowly dissolves into the gloaming like the castles of Brigadoon. In the right light, the rocks seem almost to come alive. Soft breezes bring a deep damp-woods odor to the nose in subtle waves. Find a convenient boulder to sit on, and quietly observe the play of light in this wonderful place. If possible, visit during a nice thick fog to get the best images.

Between .16 and .2 mile, the woods path begins to fade and then becomes prominent again. At .2 mile a large wet area with a sizable boulder in the middle appears to block the path; pass to the right of this boulder and listen for the falls which is found at .25 mile. Near the falls, the path divides and braids. It's your choice as to how to proceed the last 50 yards. The best shooting location is on the right-hand bank, very close to the base of the falls near a tall birch tree. This small falls provides some interesting shooting perspectives, and an ultra-wide-angle lens can be quite a bit of fun to play with when set up along the falls' intermediate shelf.

Hike 44 Buttermilk Falls Natural Area, Indiana County

THE FALLS

Type: cascade	**Height:** 45 feet
Rating: 4	**Stream:** Hires Run
Lenses: 20mm to 100mm	**Difficulty:** easy
Distance: .5 mile	**Time:** 30 minutes
Elevation change: 100 feet	

Directions: From the town of Clyde on US 22, take Clay Pike Road (T 716) south to Valley Brook Road. Bear left, and proceed .5 mile to the falls parking area. GPS coordinates: 40° 25.323'N, 79° 4.086'W.

Welcome to Mister Rogers' neighborhood. The 48-acre Buttermilk Natural Area was donated to the Indiana County Parks Department by the Keystone-Conemaugh Group, which owns the nearby power generating station. Before its donation to the county in 1995, the property was owned by Fred Rogers' grandfather, Fred McFeely, from 1931 to 1956. I can imagine a young Fred Rogers exploring this amazing natural neighborhood, checking out the frogs, plants, birds, and other forest wonders with the kind of enthusiasm only a child has.

Buttermilk Falls Natural Area is open between 8 A.M. and 8 P.M. from April 1 to October 31. Currently the only facilities are the parking area, a viewing

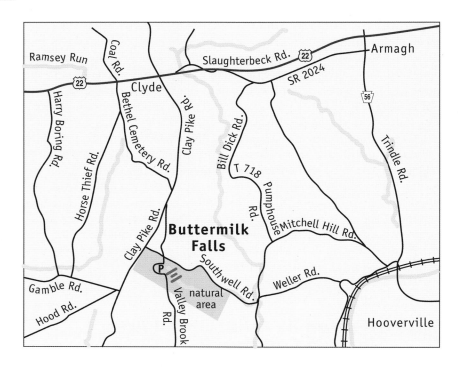

platform, and a short trail to the falls, but future plans call for restrooms and picnic facilities. This natural area is set aside for posterity to preserve the unique ecosystem that this valley supports. The best shooting location is from the viewing platform, and the falls' lush surroundings are filled with many wonderful forest landscapes. Bring the kids along; they'll love it.

Hike 45 Ohiopyle Falls, Ohiopyle, Fayette County

THE FALLS

Type: slide over falls	**Height:** 30 feet
Rating: 5	**GPS:** 39° 52.072'N, 79° 29.736'W
Stream: Youghiogheny	**Lenses:** 20mm to 200mm
Difficulty: easy	**Distance:** 100 yards
Time: 20 minutes	**Elevation change:** none

Directions: From Uniontown, take US 40 east 7.8 miles to Chalkhill. Turn left onto Chalkhill-Ohiopyle Road (SR 2010) toward Deer Lake, and follow it for 6.5 miles. Turn right onto Kentuck Road (SR 2019), and proceed 1.5 miles to the stop sign at the bottom of a steep hill. Turn left onto Dinnerbell Road (SR 2011) and go .3 mile to the large parking lot on the left. GPS coordinates: 39° 52.072'N, 79° 29.736'W.

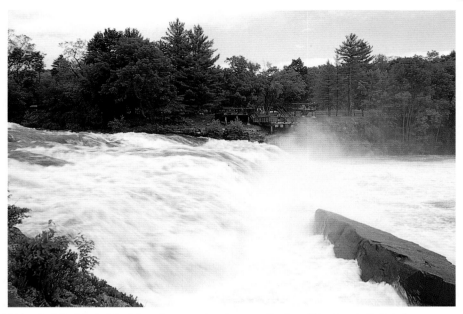

Ohiopyle Falls. I took this picture from a rock outcrop on the Ferncliff nature trail. Note how the people in red stand out. I waited for somebody in red to show up before I shot this. *Canon EOS Rebel Xs, Tokina 20–35, polarizer, Kodak E100VS, f/8 @ 1/30 sec.*

Ohiopyle Falls doesn't plunge very far, about 30 feet, but at high water, the violence of this falls is something to behold. Thunderous noise produced by pounding water greets the ear as soon as the car door opens. A constant boiling hiss of air emanates from the frothing tailwaters, adding to the relentless cacophony that becomes so loud that you need to shout in order to be heard close to the falls. River runners who come here stand in awe, fear clouding their faces, not realizing that they don't actually go over the falls and that their guides brought them to the viewing platform as a sort of practical joke. Ohiopyle comes from the Indian word *ohiopehhla,* meaning "white frothy water," which from the platform is pretty self-explanatory.

The Youghiogheny River narrows slightly above the falls, and the pale green water becomes suddenly glassy as it approaches the falls. A long slide above the falls' lower ledge creates a venturilike effect, accelerating the river so that at high flow it doesn't really drop from the bottom 12-foot ledge so much as it is hurled over it. Such is the power of 9,000 cubic feet of Youghiogheny River water per second shooting through the venturi. That's equal to 576,000 pounds of water per second, or 288 tons of water every heartbeat. No matter how you figure it, it's an impressive volume of water.

When I shot the falls in June, there had been several weeks of on-and-off rain culminating in a two-day soaker, which had the Youghiogheny running at 8.04 feet deep. This was very unusual so late in the rafting season. As a

result of so much water, Ohiopyle Falls created a spray blast that was bending saplings for dozens of yards downstream. Impressive as it was, there was too much water to get a good photograph.

Shooting Ohiopyle Falls is surprisingly difficult. The viewing platforms straddling the drop don't provide a view of the entire falls, although they do allow for interesting detail compositions. A viewing area downstream, near the restrooms, provides the best view, but quite a bit of undergrowth clogs the foreground, making it hard to keep branches out of the frame. The far side of the river isn't much better, because the only overlook on the Ferncliff Nature Trail has a big tree blocking the view. It's a tough shoot, but I encourage you try hard to get a satisfying photograph.

If the photography becomes too frustrating, then I suggest an antidote of history. The Youghiogheny River area, known as the Valleys of the Ohio, is filled with interesting stories. A very readable short history of the region is in chapter 6 of William Ecenbarger's book *Walkin' the Line* (New York: M. Evans and Co., 2000) which is a history-travelog about the Mason-Dixon line. If you're interested in architecture, Frank Lloyd Wright's Fallingwater is just north of the park, and a little west is his Kentuck Knob, which opened to the public in 2002.

The most famous American to venture into the region was George Washington. Washington's first foray in the area is often ignored by history teachers, because his experience as a military commander began rather inauspiciously. As a British officer and surveyor, Washington led a group of sixty soldiers into the area in 1754 to evict the French from British territory. His objective was Fort Duquesne (today's Pittsburgh), and he believed it was possible to get there by water—that is, until he encountered the impassable falls of Ohiopyle. Abandoning the water route, he proceeded overland and encountered a party of French soldiers out on patrol. In the ensuing battle, one Frenchman escaped and was able to warn the large garrison at Fort Duquesne. Washington concluded that he would soon be outmanned and would also have little time to retreat, so he decided to build a defensive stockade, which he called Fort Necessity, (near what is now Uniontown). French forces overwhelmed the British at Fort Necessity and Washington was forced to surrender his command to the enemy. Fortunately for us, it was the only time in his military career that he did so. So began the French and Indian War.

Colonel Washington also was a survivor of the ignominious defeat of General Braddock's brigade in August 1755. With the loss of nearly nine hundred men out of his force of more than fourteen hundred, Braddock was responsible for the worst British defeat of the French and Indian War. To hide Braddock's grave, Washington buried him in the middle of a wagon road, which is now US 40. Washington returned to the region in 1794 as commander of a fifteen thousand-man militia force tasked to put down the Whiskey Rebellion. This was Washington's last military command.

There is much to be learned about American history in the Valleys of the Ohio, and I encourage you to read more than just the short history in the state park brochure and to visit as many historic sites as time allows.

Hike 46 Cucumber Falls, Ohiopyle, Fayette County

THE FALLS

Type: falls	**Height:** 30 feet
Rating: 5	**GPS:** 39° 51.772'N, 79° 30.186'W
Stream: Cucumber Run	**Lenses:** 20mm to 200mm
Difficulty: easy	**Distance:** 200 yards
Time: 15 minutes	**Elevation change:** 60 feet

Directions: From Uniontown, take US 40 east 7.8 miles to Chalkhill. Turn left onto Chalkhill-Ohiopyle Road (SR 2010) toward Deer Lake, and follow it for 6.5 miles. Turn right onto Kentuck Road (SR 2019), and go 1 mile down a steep hill to a parking area on the left. GPS coordinates: 39° 51.772'N, 79° 30.186'W.

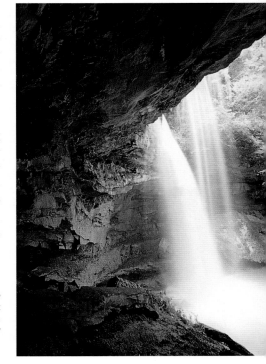

I consider Cucumber Falls the most photogenic waterfall west of the Susquehanna River. When the Youghiogheny River gauge is running above 5 feet, odds are Cucumber Run has enough water in it to fill the wide veil of Cucumber Falls. When the river gauge reads above 7 feet, bring lots of film, because it will be a wonderful torrent. I recommend spending a couple hours shooting along the run's entire length to thoroughly survey this beautiful spot. If you're lucky enough to have high water and rhododendron bloom coincide, then burn film like there's no tomorrow. With limited time, perhaps the best location to shoot from is an island in the middle of the run.

Inside the Cucumber. It's impossible to manage background highlights from behind a falls, so don't worry about it. Just make sure the rocks render on film near a middle tone, and the rest will look okay to the eye. *Canon EOS Rebel Xs, Tokina 20–35, polarizer, Kodak E100VS, f/22 @ 6 sec.*

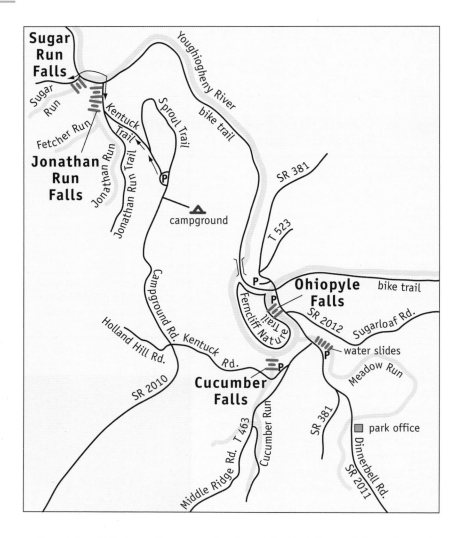

Cucumber Falls is easily accessed using stairs that descend from the parking lot. An old bridge crosses the run above the falls and leads to the Great Gorge Trail, which stays well above the run. I don't recommend any off-trail hiking to get to the base of the falls from this side; instead, ford the run near the stairs.

Being very popular and so close to Pittsburgh, Cucumber Falls' parking lot can be full for several hours a day in summer. There will always be at least a handful of people wandering around close to the falls on any day of the year, so patience is a must. Cucumber Run is a great place to bring kids. If you have a young explorer who loves to throw rocks, splash in mud, or just get wet, then this is the place to come.

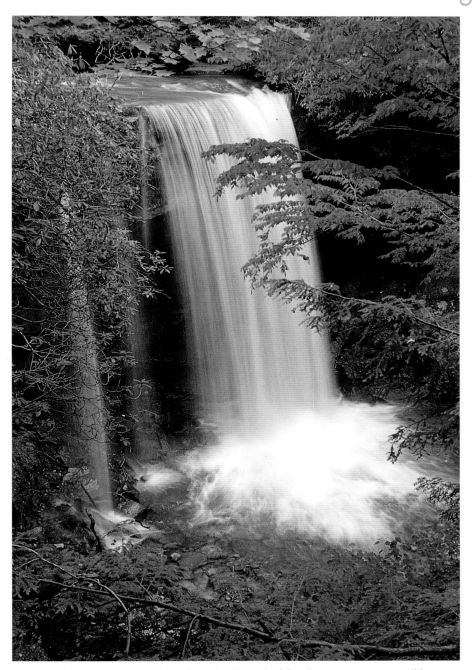

Cucumber Falls. This was taken from the stairs above the falls. There are so many possible compositions here, you should plan on spending a couple hours, and remember to just have fun. *Canon EOS Rebel Xs, Tokina 20–35, polarizer, Kodak E100VS, f/16 @ 6 sec.*

Hike 47 Jonathan Run and Sugar Run Falls, Ohiopyle, Fayette County

THE FALLS

Upper Jonathan Run Falls

Type: falls over slide over falls	**Height:** 18 feet total
Rating: 3	**GPS:** 39° 54.138'N, 79° 29.502'W

Lower Jonathan Run Falls

Type: falls	**Height:** 12 feet
Rating: 3	

Sugar Run Falls

Type: cascade	**Height:** 23 feet
Rating: 1–2	**GPS:** 39° 54.354'N, 79° 29.435'W
Streams: Jonathan and Sugar Runs	**Lenses:** 20mm to 200mm
Difficulty: moderate to difficult	**Distance:** 1.7 miles
Time: 2 hours	**Elevation change:** 520 feet

Directions: From Uniontown, take US 40 east 7.8 miles to Chalkhill. Turn left onto Chalkhill-Ohiopyle Road (SR 2010) toward Deer Lake, and follow it for 6.5 miles. Proceed straight onto Campground Road (T- 796), continuing a total of 2.25 miles, checking in at the ranger station if required, to the gravel parking area on the left just past the campground concession hut. GPS coordinates: 39° 53.836'N, 79° 29.204'W.

Hiking down Jonathan Run Trail to its two falls is easy; getting close enough to shoot them is the hard part. Jonathan Run's waterfalls occur where the run makes a right turn, and the stream bank below the trail is guarded by sandstone ledges and dense rhododendrons. The falls is easily seen through the dense undergrowth, but getting into the creek shed to photograph it requires some effort, risking a few bumps and bruises. At high flow, it can be difficult to get far enough into the run to shoot without waders.

From the parking area, take the beige-blazed Kentuck Trail downhill. At .2 mile, the dull blue-gray-blazed Sproul Connector Trail breaks off to the right; continue along the wider Kentuck Trail. From this intersection point to the .5-mile mark, look for water flowing in a ditch beside the trail or flowing over the trail. If either is happening, then Jonathan Run should be flowing with decent power. At .6 mile, the upper falls will become audible, and at .65 mile, the Kentuck Trail merges with the blue-blazed Jonathan Run Trail. Walk downhill several yards and look for the first of three footpaths that meander to the left toward the unseen but audible falls. Follow this first footpath to the falls.

Returning to the blue-blazed Jonathan Run Trail, turn left (downstream) and continue for about 60 yards, listening for the lower falls. As with the upper falls, several footpaths lead to the base of the lower falls, any of which will work. The embankment below the main trail is made mostly of clay, and it's very slick when damp, so caution is warranted as you pick your way down to the stream. The lower falls is where the run makes a sharp left turn, and the falls is preceded by a slide that adds enough velocity to launch water over the falls' ledge. Large sandstone boulders choke the tailwaters, creating four distinct exits. One boulder has a pencil-thin rhododendron clinging to a moss patch, and any composition that captures this spindly little bush in bloom would be a real keeper. Rhododendrons envelop the small amphitheaters of both falls. Bloom occurs fairly late here, sometime in July. To get the best shots of the lower falls, bring the widest lenses you own, because even a 28mm is too long to capture the tight turn in the run below the falls.

Return to the blue-blazed Jonathan Run Trail and turn left (downstream). Continue to .7 mile to the intersection with the Youghiogheny River bike trail. Turn left onto the bike trail, and walk .8 mile, turning left onto the Kentuck–Sugar Run Trail. Walk about 50 yards upstream to Sugar Run Falls.

Sugar Run is only 2 yards wide and carries much less water than Jonathan Run. It's also more seasonal in nature, so don't use Jonathan Run as an indication that Sugar Run has decent flow. The cascade of Sugar Run is nice but just not photogenic. About halfway up the cascade, a large rhododendron overhangs the stream so that the entire upper half of the falls is hidden from view. If it's in bloom, however, it's worth the effort to shoot. A small sandbar downstream provides a limited view through a tight rhododendron tunnel. You need waders or water socks to get through the tunnel for a nice shot of the falls, but a boulder-choked ledge restricts the composition somewhat. Sugar Run is a nice little falls; just don't expect much photographically. Perhaps it's best used as a picnic spot after shooting Jonathan Run.

Hike 48 Springfield Falls, Leesburg Borough, Mercer County

THE FALLS

Type: cascade	**Height:** 13 feet
Rating: 3	**GPS:** 41° 8.649'N, 80° 13.080'W
Stream: Wolf Creek	**Lenses:** 17mm to 50mm
Difficulty: easy	**Distance:** 50 yards
Time: 10 minutes	**Elevation change:** 30 feet

Directions: From the interchange of I-79 and PA 208 near Grove City, take PA 208 west for 2.1 miles toward Leesburg. At the intersection of Liberty Road, turn right, and follow Liberty Road for .4 mile to the Y intersection at Falls Road. Bear left onto Falls Road (SR 2002), and drive .9 mile to a large parking area on the left at the bottom of a small hill where Falls Road crosses the creek. GPS coordinates: 41° 8.649'N, 80° 13.080'W.

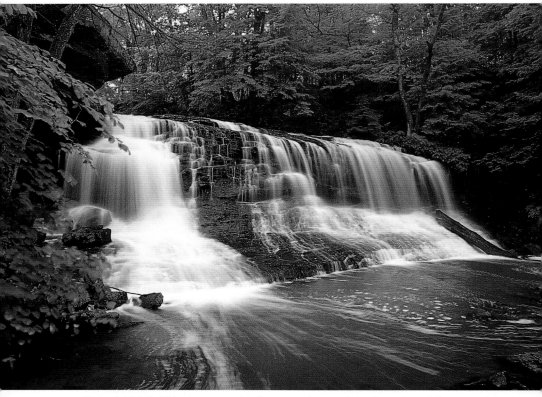

Springfield Falls. This photo was shot from very close to the stairs and carefully cropped to keep trash out of the right side of the frame. *Canon EOS Rebel Xs, Tokina 20–35, polarizer, Kodak E100VS, f/22 @ 10 sec.*

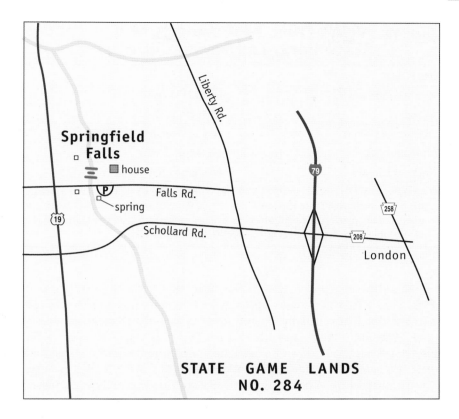

Springfield
Falls
house
Liberty Rd.
Falls Rd.
spring
Schollard Rd.
London
19
79
258
208

STATE GAME LANDS
NO. 284

A 50-yard walk to such a wide and impressive falls is hard to beat. From the parking area, cross Falls Road and look for an old concrete stair and path leading through the trees lining the road. It may feel like you're intruding into the backyard of the house seen to the right, but you're not; the path and falls are public. The base of the falls is reached by a short scramble down a steep, muddy slope, avoiding a set of old railroad tie stairs in the process.

Only 13 feet tall but more than 60 feet wide, it's surprising how narrow Wolf Creek can fan out to fill the cascade's entire width with such a consistent veil of water, but it does. It's also surprising how deep the creek is at the base of the old stairs. Take my word for it, after a good rain, it's much more than knee-deep.

Upstream of the falls, Wolf Creek passes through a residential area, so the tailwater is filled with trash, which is a real shame, because this falls is quite a nice spot. Even with all the refuse, however, it's possible to use a wide-angle lens and still keep the mess out of the frame; it just takes time and patience.

A small white building near the parking area is a public spring, which you're invited to use.

Alpha Falls, McConnells Mill State Park, Lawrence County

THE FALLS

Type: cascade over falls	**Height:** 34 feet
Rating: 2	**GPS:** 40° 57.554'N, 80° 10.153'W
Stream: Alpha Run	**Lenses:** 20mm to 50mm
Difficulty: easy	**Distance:** .2 mile
Time: 30 minutes	**Elevation change:** 50 feet

Directions: From the interchange of I-79 and US 422, take US 422 west 1.8 miles to the McConnells Mill State Park entrance at Mill Road. Turn left onto Mill Road, and drive .6 mile, passing the park office, to a small parking area on the right with a picnic table. GPS coordinates: 40° 57.554'N, 80° 10.153'W.

Alpha Falls, also known as Spill Way Falls, is listed in the park's Trail of Geology Park Guide 4 as stop 3. It's a thin horsetail cascade-over-falls configuration that runs only when water is visible in a shallow, grass-filled ditch adjacent to the small parking area. This falls makes for a quick but pleasant shoot. Walk down the wooden stairs from the parking area, and then turn right onto a wide but unmarked trail at the base of a tall rock ledge. The path hugs the cliff bottom and will take you 40 yards to the falls. Several large sandstone slabs block the view of the falls' bottom. Moss covers everything, and small hemlocks along the narrow run frame the falls nicely. Although it's primarily a vertical composition, try shooting a few horizontals.

There were no bird sounds to be heard when I arrived, but as I began to descend the stairs, I was greeted by the lilting dual-note call of a veery, whose haunting call persisted the entire time I shot and didn't end until I ascended the stairs. Perhaps I had invaded its territory, or maybe it had no one to sing to until I arrived. Either way, I enjoyed its company for the half hour I was there.

Hike 50 Kildoo Falls, McConnells Mill State Park, Lawrence County

THE FALLS

Type: falls	Height: 18 feet
Rating: 2	GPS: 40° 57.554'N, 80° 10.153'W
Stream: Kildoo Run	Lenses: 20mm to 50mm
Difficulty: moderate; steep climb from road	Distance: .1 mile
Time: 20 minutes	Elevation change: 50 feet

Directions: From the interchange of I-79 and US 422, take US 422 west 1.8 miles to the McConnells Mill State Park entrance at Mill Road. Turn left onto Mill Road, and drive 1.2 miles to Kildoo Road. Turn right onto Kildoo, and then left at the T intersection onto Kennedy Road. After less than .1 mile, park at a wide spot on the right next to a guardrail near Kildoo Bridge. There is a collapsed house on the left and a small tour stop marker on the right. GPS coordinates: 40° 57.554'N, 80° 10.153'W.

It can take several minutes to figure out how to get to the base of Kildoo Falls. Several footpaths litter the area around Kildoo Bridge, but only one really works when trying to haul gear down the steep embankment. From the parking area for the park's Trail of Geology Park Guide 4 stop 4, walk away from the road bridge and look for a large hemlock trunk being used as a parking bumper. Go over the hemlock (the first step down is the most difficult) and carefully work down the loose slope, using roots to assist your descent. Once at the base of the steep slope, turn left and walk beside exposed rock ledges to the falls.

This falls is a split horsetail, with each veil of water plunging around a large, projecting sandstone platform. This platform is part of the Allegheny Formation, which is harder than the Pottsville Formation seen below the falls. The platform of stone is heavily undercut, and it's easy to walk behind the falls to see the Kildoo Trail footbridge a few dozen yards downstream. It's impossible to shoot from this footbridge because pale blue steel bridge beams sit right above the falls. Rather, shoot this falls from the side to get a nice view of the falls' ballistic arc.

On the return drive from Kildoo, you may want to stop and shoot the old mill. Parking at the mill is at a premium; if necessary, drive past the mill and make a hard right onto McConnells Mill Road to park in a large lot at the top of the gorge. A gravel path leads to a long stairway to the mill. It's about a 130-foot descent to the mill, and it's worth the effort, because McConnells Mill is one of the most photographed mills in America. There's also a covered bridge, and between the two, it's possible to spend an entire day taking photographs.

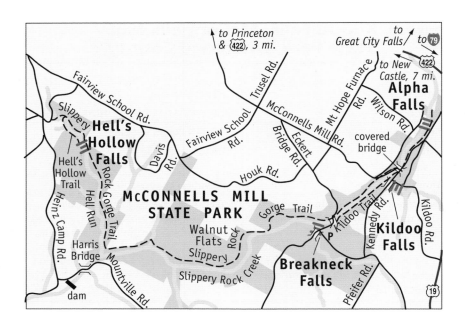

Hike 51 Breakneck Falls, McConnells Mill State Park, Lawrence County

THE FALLS

Type: cascade	**Height:** 11 feet
Rating: 2	**GPS:** 40° 57.276'N, 80° 10.724'W
Stream: Cheeseman Run	**Lenses:** 20mm to 1000mm
Difficulty: moderate	**Distance:** 1 mile
Time: 1 hour	**Elevation change:** 160 feet

Directions: From the interchange of I-79 and US 422, take US 422 west 1.8 miles to the McConnells Mill State Park entrance at Mill Road. Turn left onto Mill Road, and drive 1.2 miles to Kildoo Road. Turn right onto Kildoo, and then left at the T intersection onto Kennedy Road. After 1 mile, turn right onto Cheeseman Road. Proceed for .6 mile to a large gravel parking area on the right. Cheeseman Road is closed to vehicles in the state park below the parking area. GPS coordinates: 40° 56.256'N, 80° 10.612'W.

Because the cliffs surrounding Breakneck Bridge are open to climbing, it's pretty obvious how this waterfall got its name. It's not safe to descend to the falls from the bridge, although some people try. Instead, walk .3 mile down the closed Cheeseman Road to Eckert Bridge. At the bridge's near end,